Liberated Voices

Contemporary Art
from South Africa

Liberated

Contemporary Art
from South Africa

SCHREUDERS
CLAUDETTE SCHREUDERS
SANDILE ZULU
PAUL STOPFORTH
HHELEZI
BRIDGET BAKER
WILLIE BESTER
MBONGENI RICHMAN
DAVID KOLOANE
BRETT MURRAY
SAMSON MNISI
ISININI MNISI
NOSMNIMSON
SUE WILLIAMSON
PENELOPE SIOPIS
RICHMAN BUTHELEZI
THABISO PHOKOMPE
ZWELETHU MTHETHWA

Voices

Edited by Frank Herreman
assisted by Mark D'Amato

with contributions by:

Mark D'Amato

Bongi Dhlomo

Clive Kellner

David Koloane

Jennifer A. Law

Andries Walter Oliphant

Ivor Powell

Colin P. Richards

Kristine Roome

Claudette Schreuders

Mongane Wally Serote

Sue Williamson

The Museum for African Art, New York
Prestel, Munich, London, New York

In memory of Marianne Van Vyve

LIBERATED VOICES: Contemporary Art from South Africa is published in conjunction with an exhibition of the same title organized and presented by the Museum for African Art, New York from 17 September 1999 to 2 January 2000. The exhibition will travel to other museums.

The exhibition is supported by grants from the National Endowment for the Arts, a federal agency, with public funds from the New York State Council on the Arts, the Department of Trade and Industry, South Africa, the LEF Foundation, and Jerome and Ellen Stern.

Design: Linda Florio Design
Design Assistant: Alessia Ramaccia
Associate Curator: Mark D'Amato
Associate Curator: Laurie Farrell
Copy Editors: David Frankel, Elizabeth Franzen

Prestel books are available worldwide. Please contact your nearest bookseller or write to either of the following addresses for information concerning your local distributor:

Prestel Verlag
Mandlstrasse 26
80802 Munich, Germany
Phone (49 89) 381 7090, Fax (49 89) 381 70935

4 Bloomsbury Place
London WC1A 2QA
Phone (0171) 323 5004, Fax (0171) 636 8004

16 West 22nd Street
New York, NY 10010, USA
Phone (212) 627 8199, Fax (212) 627 9866

Library of Congress catalogue card no. 98-067695
Clothbound ISBN 3-7913-2195-1

Back Cover: Left to right: **Cat. 15**, *Untitled, by Mbongeni Richman Buthelezi, 1999. Melted plastic on wooden board. 123 x 97 cm.* **Cat. 37**, *Frontline with Centurion Models, by Sandile Zulu, 1997. Fire, water, wind, soil, metal, wire, reed. 600 x 100 cm.* **Cat. 47**, *Ma-Trix, by Claudette Schreuders, 1998. White stink wood, enamel paint. H. 80 cm. Jerome and Ellen Stern Collection.*

Printed and bound in Belgium by Snoeck-Ducaju & Zoon.

Photo credits: Catalogue objects by Bridget Baker and Brett Murray by Michael Hall, Cape Town. All other catalogue objects by Wayne Oosthuizen, Johannesburg except for cat. nos. 47 and 48 by Jerry L. Thompson. Illustrations are credited in their captions.

Contents

Preface

Art offers expression beyond words. It can convey hopes, dreams, anger, self-scrutiny, and despair with unparalleled eloquence, reflecting the human spirit, thereby articulating a social and political climate. As countries undergo fundamental change in economic, governmental and cultural conditions, art has a unique capacity to reflect these developments in powerful and unexpected ways. It is through this lens that we invite you to view South Africa today, at a unique period of transition.

Having defined themselves for decades by the oppression of apartheid, South African artists are seeking ways to reconcile their past and present in order to meet the future. This soul-searching process considers such questions as "where do we go from here?," "what does it mean to be black or colored or white in the new South Africa?," and "what emotional residue must be vented and cleared to enable harmonious living among diverse populations?"

We hope you will find that the exhibition raises as many questions as the answers it posits. It is a situation as complex—and fundamentally universal—as humanity itself.

Every exhibition reflects the dedication and care of many, many individuals; *Liberated Voices* is no exception. First, our gratitude to the artists themselves for sharing their joy, pain and hope with others, and for all of the necessary logistical assistance required to make this landmark exhibition a reality. We offer an equally heartfelt acknowledgment to Frank Herreman, Exhibition Curator and Director of Exhibitions at the Museum for African Art, for his vision and dedication, without which this exhibition and catalogue would not have been realized.

Thank you also to Laurie Farrell, Associate Curator, Barbara Woytowicz, Registrar, and Mark D'Amato, Associate Curator, for assistance with the exhibition, and Carol Braide, Curatorial Assistant, for coordinating publication of the exhibition catalogue; Lubangi Muniania of the Education Department and Andrei Nadler in Finance. Thank you one and all for your hard work and the commitment to excellence.

Elsie Crum McCabe
President

Anne H. Stark
Deputy Director

July 1999

Acknowledgments

In January 1998 I traveled to South Africa for the first time. It would not take long before I realized that the exhibition *Liberated Voices: Contemporary Art from South Africa* was going to be one of the richest experiences of my career as a curator. In June 1998, I returned for a second time to South Africa. I wish I could fully convey the enthusiasm that many South Africans showed when I spoke with them about this exhibition. Their response was extremely inspiring and I sincerely hope that it will be reflected in the show. first of all, I am most grateful to the artists who agreed to participate in this exhibition: Bridget Baker, Willie Bester, Mbongeni Richman Buthelezi, David Koloane, Zwelethu Mthetwa, Samson Mnisi, Brett Murray, Thabiso Phokompe, Claudette Schreuders, Penny Siopis, Paul Stopforth, Sue Williamson, and Sandile Zulu.

I wish express my gratitude to the contributors to this publication: Mark D'Amato, Bong Dhlomo-Mautloa, Clive Kellner, David Koloane, Jennifer Law, Andries Walter Oliphant, Ivor Powell, Colin Richards, Kristine Roome, Mongane Wally Serote, and Sue Williamson.

Before leaving for South Africa I received precious information from Robert LaGamma and Janet Stanley whom I both sincerely thank. In New York as well as in South Africa, I was guided to the artists and essayists by the expertise of a number of people who, without them knowing, were very important in my decision making process. I specially wish thank Fieke Ainslie, Allen Alborough, Jane Alexander, Rayda Becker, Willem Boshoff, Lisa Brice, Henrietta Dax, Kendell Geers, Linda Givon, Kay Hassan, Stephen Hobbs, Terry Kurgan, Pat Mautloa, Santu Mofokeng, Karel Nel, Malcolm Payne, Elizabeth Rankin, Tracey Rose, Stephen Sacks, and Joachim Schonfeldt.

All the artists generously agreed to lend their works for the show. Some of the artworks were lent from the following museums and private collectors: Lisa Brice, Christopher Peter of The University of Cape Town Works of Art Collection, Jerome and Ellen Stern, The Silverman and Stern Collection, The Schreuders and Vorster Collection, and private collection, London. A special thank you to Hayden Proud of the National Gallery in Cape Town and its board of Trustees who agreed to lend us one of the most important artworks of the collection: Paul Stopforth's *The Interrogators.*

For nearly two years, Kristine Roome has acted as the museum's representative in South Africa. I am convinced that without her daily involvement, persistence, and enthusiasm this exhibition would never have been brought to fruition. She served as the ideal go-between for the museum, the artists and the essayists. She also showed her talent as an author of several essays for this publication. All of her writing expresses her great love and esteem for South Africa, its people and its artists.

It is with very special gratitude that I with to mention Mark D'Amato. Mark's involvement as co-curator of this exhibition was very inspiring. Together we worked and developed the concept from its first to final stage.

I wish to thank the members of the Board of Trustees of the Museum for African Art who from the beginning of this adventure showed their full support. I owe a very special thanks to Robert Rubin, Co-Chairman of the board, whose daily support deserves my greatest recognition. I also wish to thank Elsie Crum McCabe, President of the Museum for African Art, and Anne Stark, Deputy Director. My gratitude goes to all staff members and volunteers of the Museum for African Art. A special thanks goes to Laurie Farrell, Associate Curator, and Barbara Woytowicz, Registrar. While writing these acknowledgments, Carol Braide is completing the final preparation of the text and images publication. As always, I am convinced that she will do this with the greatest dedication. Therefore, Carol deserves very special recognition.

Linda Florio, with the help of Alessia Ramaccia, is responsible for the elegant design of the catalog. The photographs were taken by Michael Hall, Wayne Osthuizen, and Jerry Thompson.

This exhibition would not have been possible without the financial support of the National Endowment for the Arts, a federal agency; public funds from the New York State Council on the Arts; the Department of Trade and Industry, South Africa; the LEF Foundation; and Jerome and Ellen Stern.

Frank Herreman
Director of Exhibitions

Contributors

Mark D'Amato

Mark D'Amato, Associate Curator of two years at the Museum for African Art, is currently a doctoral candidate at Virginia Commonwealth University in contemporary art and theory, including contemporary African art and art of the African diaspora. While at the Museum, he worked on several exhibitions including the recent *A Congo Chronicle: Patrice Lumumba in Urban Art.*

Bongi Dhlomo-Mautloa

Bongi Dhlomo-Mautloa, currently an independent arts consultant and curator, was the Director of the Africus Institute for Contemporary Art (AICA), Johannesburg. Her previous positions in South Africa include Coordinator of the Outreach and Development Program for the 1995 Johannesburg Biennale, *Africus: Johannesburg*, and the Coordinator and Fundraiser at the Thupelo Art Project, the Alexandra Arts Center, and the FUBA Art Gallery. She also worked as a Gallery Assistant at the Linda Goodman Gallery. Ms. Dhlomo-Mautloa did curatorial work for shows including the 1997 Johannesburg Biennale, *Trade Routes: History and Geography,* the 1995 Biennale, *Africus*, and *Contemporary Art from South Africa* at the Deutsche Aerospace, Munich, in 1994. She is also a recognized artist with work in several public collections in South Africa and Europe.

Frank Herreman

Frank Herreman, the Director of Exhibitions at the Museum for African Art since 1995, was formerly Associate Director of the Historical Museums of the City of Antwerp and a Professor of the Arts of Africa and Oceania at the Royal Academy of Fine Arts. He has curated numerous exhibitions of African and Oceanic art including the acclaimed Face of the Spirits; *Masks from the Zaire Basin*, 1994, which premiered in Belgium and traveled internationally. Mr. Herreman has lectured and published extensively on African art including an essay in the Royal Academy's major catalogue, *Africa: the Art of a Continent.*

Clive Kellner

Clive Kellner, while Coordinator of Projects at the Africus Institute for Contemporary Art (AICA), worked on the second Johannesburg Biennale, *Trade Routes* in 1997. He was selected as a Trainee Curator on *Africus,* and was an Assistant Curator for its French and Israeli exhibitions. Mr. Kellner was also one of five worldwide candidates selected to participate on the prestigious Curatorial Training Program at De Appel, a contemporary art center, in Amsterdam, the Netherlands. There, he co-curated *Crap Shoot*, an international group exhibition, in 1996. At the Civic Gallery, Johannesburg, he co-curated *Scramble*, a 1996 exhibition of local and international contemporary and seminal video art, including work by Chris Burden, Vito Acconci, and Laurie Anderson. Mr. Kellner was also Assistant Gallery Manager at the Linda Goodman Gallery in Johannesburg, South Africa.

David Koloane

David Koloane studied at the Bill Ainslie Studios in Johannesburg and earned a degree in Museum Studies at the University of London. He has served as a curator for the 1996 *New Prospects* show at the Newton Galleries, Johannesburg and as a co-curator for the exhibitions *Seven Stories about Modern Art in Africa*, Whitechapel Art Gallery, London, 1995, and *Art from South Africa*, Museum of Modern Art, Oxford, 1990. As an artist, he participated in many solo and group shows and has his work in several private and institutional collections in Africa, Europe and the US. Mr. Koloane is also an accomplished writer who has written articles for many leading South African and international catalogues, journals and magazines.

Jennifer Law

Jennifer Law is currently a doctoral student at the School of Oriental and African Studies, University of London and is focusing her research on installation art in post-Apartheid South Africa. Having conducted field research in South Africa, she took part in several cultural events as forums to the Truth and Reconciliation Commission. Ms. Law has received awards for her studies and has taught at the University of London, the University of Witwatersrand, and University of Cape Town. Her publications include the forthcoming *Divisions and Diversions: The Visual Arts in Post-Apartheid South Africa*, co-edited with John Picton.

Andries Oliphant

Andries Walter Oliphant is a writer and critic who lectures on Theory of Literature at the University of South Africa. A former editor of *Staffrider Magazine*, he currently chairs the Arts and Culture Trust of the President. He is recipient of numerous awards including the Thomas Pringle Award for Short Stories and the 1998 Book Journalist of the Year Award.

Ivor Powell

Ivor Powell is currently a Specialist Writer with the *Mail and Guardian*, South Africa's premier independent newspaper. Formerly acting Political and Foreign Editor with the South African Broadcasting Corporation's Television News, he started out as an academic art historian before becoming art critic for the *Weekly Mail* (the precursor to the *Mail and Guardian*) from its inception in 1985 until 1990. He has also worked as a political reporter and correspondent on various newspapers. Mr. Powell has published widely on cultural and political topics in South Africa and internationally and has authored numerous exhibition catalogues and catalogue essays, as well as a book on Ndebele Culture and Politics published by Struik.

Colin Richards

Dr. Colin Richards received his doctorate from the University of Witwatersrand and is currently a Senior Lecturer in the Department of Fine Arts at that university. With extensive publications on contemporary South African art, he has served on the Editorial Advisory Board of *NKA: Journal of Contemporary African Art* in 1996. Dr. Richards has curated many exhibitions in that country, culminating in his most recent show *Graft*, part of *Trade Routes*, in the second Johannesburg Biennale.

Kristine Roome

Kristine Roome, a doctoral candidate in applied anthropology at Columbia University, New York, has a Certificate in African Studies for the Institute for African Studies, Columbia University. She is currently a Visiting Lecturer in the Department of Social Anthropology at the University of Witwatersrand, Johannesburg, South Africa, and the Rand Afrikans University in Anthropology. From 1994 to 1997, Ms. Roome was the Director of the William Wright Gallery, New York, where she curated exhibitions of contemporary and tradition-al African art. She was the Assistant to the Director of the Africus Institute for Contemporary Art (AICA) for *Trade Routes*, 1997.

Mongane Wally Serote

Dr. Mongane Wally Serote, who is primarily known as a poet, has been for the past five years a Member of the Democratic Parliament of South Africa, a Chairman of both the National Assembly Committee for Arts, Culture, Language Science and Technology, and the National Steering Committee for Indigenous Knowledge Systems. He is an active member of the African National Congress and has held several responsibilities in the party over the years. Dr. Serote received a Master of Fine Arts degree from Columbia University in New York and has received two Honorary Doctorates in Literature from the Universities of Natal and Transkei. He has published several epic poetry books, two novels, and a book of essays.

Sue Williamson

Sue Williamson studied for two years at the Art Students League in New York and received an Advanced Diploma in Fine Art from the Michaelis School of Fine Art in Cape Town. Her work has appeared in many solo and group exhibitions including *Colours* (Haus der Kulturen der Welt, Berlin), *Insight: Four Artists from South Africa* (Wright Gallery, New York), and *Africus*, in 1995. Ms. Williamson is also the author of two important books on con-temporary South African art titled *Art in South Africa: the Future Present* in 1996 and *Resistance Art in South Africa* in 1989. Her work is in public collections in Africa, Europe, and the U.S. including the Johannesburg Art Gallery, The University of Cape Town, Birmingham Museum of Art, and the CAL Foundation, Holland.

Lenders to the Exhibition

Lisa Brice Collection
The University of Cape Town Works of Art Collection
Private Collection, London
Hildeke Schreuders and Andre Vorster Collection
Silverman and Stern Collection
South African National Gallery, Cape Town
Jerome and Ellen Stern Collection

Liberated Voices

Mongane Wally Serote

Art is the voice of a nation. It expresses the state of the soul, the state of the spirit of a people. It is, this art thing, a record of the past, present, and future of the people, articulating their culture and the culture of the nation. And in the final analysis, art expresses the spirit and state of civilizations. In other words, when generations have, as with writing on the sand, come and gone, what remains of who they were, what they did on earth, and what we should remember about who they thought they were (and who they really were) are enshrined in and engraved by their art.

What does the fact that humanity has been around on the earth for about 3 million years say to us, then, about the journey made by human life? Where is art's record—in the rock paintings? The rock paintings, the mask from Mpumalanga, and other artifacts and implements that date far back in time, when the means for recording and portraying life were rudimentary but enduring, say that right at the beginning, art was already expressing consciousness, action, and the life activity of human beings. If history maintains that Africa is where life began, those millions of years ago, already then, in my view, art had become not only a means of self- or community expression but the way human beings liberated themselves. This is what they expressed and this is what they acted out through the creation of art.

The bead ring, bangle, or necklace, the seed necklace or beadwork apron or carved wooden earring, the dress, wrap, or shoes, perhaps adorned in dappled colors, patterns, and forms derived, at times, from colors or patterns on animals, in the environment, or in the imagination—these things enhanced the bodies of men and women and children, identifying their origin as people and telling all sorts of stories about who they were, what they thought about themselves, what their culture spoke about them. And it wasn't only what was on their bodies, including traditional marks on foreheads, cheeks, arms, and, legs; it was also their tools, furniture, walking sticks, masks, baskets, bags, weapons, and the many other implements that life continuously demanded, as a means to overcome, tame, use, and blend into nature.

I mean that there was already, even in those early days, an intimate, close, pedagogic, and pragmatic relation between art and life. This intertwined relationship was always a means created by the human imagination, consciousness, and vision to liberate the human mind, spirit, and body. Something about aesthetics liberates the beauty of things, the essence and spirit of things, and sets us free. Freedom is enshrined in creativity, imagination, and dreams, and we seek it in literature, in films, in art, in music, in theater, as we either cry, or laugh, or are sad. We seek it in what liberates life! Or: we express the journey of life through it.

Not so long ago, a friend, a comrade of mine, told me that at funerals and in church when hymns are sung, he found himself weepy and weeping. He also said that revolutionary songs did the same thing to him. When he was little, he said, his grandparents and parents would take him to the

rural areas during the festive seasons, and he would stay there for the festivals of songs sung by children, young people, adults, and elders. For over two weeks, every night, under the moonlight, he would listen to song after song, and to the clapping of hands and chanting, and would watch the vigorous dancing. Struck once by his precise sense of rhythm, I had to remark on it: when listening to music on the record player, he would imitate the drum, then switch to imitating the guitar, the piano, the trumpet or trombone or voice, all accurately, all in time and in the tone of the instrument. He would do the same thing while he was painting or drawing, both of which he could do with great skill indeed. He loved music with all his heart. He loved painting with all his heart.

In 1985, the day after the South African Defence Force attacked Gaborone, the capital of Botswana, Graig Williamson, the chief assassin of the apartheid system, told the South African nation on television that they had killed Thami Mnyele because he was a communist propagandist. I wondered how Williamson would have reacted if he had heard Thami speak about painting, theater, dance—about what art is. What would Williamson have done if he had heard Thami sing, and if Thami had told him how he reacted whenever he listened to hymns at a funeral or in church, or to revolutionary songs? After what Graig Williamson said at the Truth and Reconciliation Commission, fourteen years later, where he sought amnesty for gross violations of human rights, I know the answer to that. I do not think that he is repentant at all.

But then Graig Williamson reminds me of another terrible issue of liberation. In Europe and in the United States I have visited museums where I saw artworks that belong to Africa. Some of this artwork, I thought as I looked at it, perhaps spoke to the terrible era of enslavement. Those masks and wood carvings that one moment take human form, the next the forms of animals or ghosts, have always catapulted my mind to that time when young men and women, as well as older people with skills, were hunted, bound, and loaded on ships for long trips across oceans. How long did this go on: three centuries? Four? How many people were taken from Africa: fifteen million? Thirty? Is it really true that this trauma of the people of a continent was never recorded? The people of that continent were masters of art. Where is that art? What does it say about that long nightmare? I asked such questions as I visited the countries that had enslaved those people, and had also pillaged the artworks that might speak to that time, a trauma from which humanity remains to be fully emancipated.

When Graig Williamson called Thami a propagandist, he showed some of Thami's artworks, which they had taken from Gaborone after they killed him. He showed them on television. It must have been the best exhibition Thami could ever have had in South Africa, but he was not alive to see it.

In my days of exile in America and Europe, I was obsessed with the issue of slavery. And now I remember how in my thirties, for the first time in my life, I visited museums. I try to think about the African art I saw there, and about the descendants of the slaves, and Europe, and the United States, and civilization. After slavery, colonialism engulfed the African continent. It permeated most of the land; it subjugated most of the people, and denied who they were, and initiated processes to "civilize" them; and then came neocolonialism, and in South Africa, apartheid.

Two people opened my eye to the liberated voices of art in South Africa. One was a school teacher, Mr. Phefadu, the other a painter and sculptor, Dumile Feni. Phefadu was my English Literature teacher. We fifty students, boys and girls, growing up in a place, Alexandra, that had nothing to do with education let alone art, always looked forward to our forty-five minutes with Mr. Phefadu every week: poetry, novels. In that class, England, France, Russia, in a word Europe, and even the United States, were lived and relived. We read a poem or a passage in a novel, and Phefadu spoke to it, interpreted it, drew parallels between places our minds shattered against as we struggled to imagine them, and Alexandra—dirty, crime infested, crowded. He always reverted our minds to that indestructible particle of human life: hope. Or he would take us on a mental journey with the soldiers of Napoleon, experiencing victory and defeat, and learning the harshness of life in wartime.

Then we would debate the situation in South Africa against this background. We did so understanding that we were conspiring against something powerful, almost omnipotent, yet rebelling against it anyway. I often wonder where Mr. Phefadu's voice of liberation is now.

And then Dumile: I can hear and feel the jacaranda flowers popping under my feet as I walked along Jubilee Street in Parktown to Bill Ainslee's house, where Dumile lived. Bill's was the house of art in Johannesburg in those strange and dangerous days in the mid '60s and early '70s, the days of passes, permits, trespasses, the Immorality Act, the Group Areas Act—prohibitive laws skillfully, consciously, deliberately put in place to subjugate black people. You walked the streets and felt hunted. The police were everywhere then, looking for black men to arrest for failing to produce a passbook, or for some fault in it. We devised ways to live, to survive, and to overcome.

The evidence of this lay in the house of art. Initially, it was the endless discussions with Dumile. Later, when Dumile went into exile, where he died, it was endless discussions with Bill, and with many other writers, playwrights, filmmakers, painters, sculptors, singers, actresses, models, and intellectuals of all colors. I am speaking of the generation after Gerald Sekoto, George Pemba, and others like Henry Mancoba. These men and women painted, sculpted, sang, played, danced, and acted the nation out of the frontier

wars, into nonviolent mass actions, into the formation of the underground and the people's army, into detention, bannings, banishment, prison, and exile. They severed us from a past when most chiefs who were captured were beheaded. They pondered Europe, dreaming dreams of equal freedom alongside that continent's.

We had entered another era, become a new generation, after the generation symbolized by Nelson Mandela, a generation that was literally being removed from society. The apartheid system was being implemented with impunity and defiance. It was criminal to be a black person in those days, long days that nevertheless gave birth to a new generation of artists: Dumile Feni, Julian Motau, David Koloane, Ezrom Legae, Winston Saoli, Louise Maqhubela, Sydney Khumalo, Ben Arnold, and many others. They constituted, those days, a long moment when South Africa had become a gas chamber for black people. We lived in ghettoes, prisons, exile, banishment, under house arrest. We became insane or just died. The shebeens were places of sanctuary, as were the churches and streets of our townships. Life, the art of this time says, was lived in full, in danger, was brutal and cruel, was lived and died quickly. Most of the artists of Dumile's generation are dead. It is their art that has endured the worst—has endured what frail human flesh would not endure.

"Why," my grandmother used to ask, whenever I showed her photographs of the works of some of these artists, "Why do these people distort the human form like that?" And my mother used to say, "Why are you people so bitter!" Something was very wrong, the art of this generation will say to us. But it will also say that there is something in human beings that is enduring, that is relentless, that is determined. This is what must also be depicted and portrayed by that art of the Middle Passage. Were it possible, really, we should pass this cruel trial. Life is very brief. At the best of times, all we need from life is to drink, eat, take shelter, procreate, know, plan, and work. That is all. As simple and reasonable as these things sound and are, they are a scarce commodity.

The current generations of artists, after Dumile—the Thami Mnyeles, James Moleyas, Lucky Sibiyas, and others of their generation throughout this country—have begun to record, in the brightest of colors, and in so many different and varied forms, the plight of being African. When the artists of the African Renaissance begin to walk the streets, sit on benches, sleep on beds, plan, work, and speak to the world, we must then review: what of the liberated voices? "Those days" are not so long ago; they ended, in South Africa, only in 1994. And even the African countries that achieved independence in the 1950s did not, as the world knows well, necessarily achieve freedom at the same time. Economic bondage means poverty, disease, illiteracy, subjugation, oppression, and exploitation for countless Africans on the continent. What this means in terms of the

subject I deal with here is: if slavery started in the fifteenth century on the African continent, Africans have not known freedom for five centuries. And now they enter the twenty-first century.

It is against this background that I always have to review the voice of liberation in South African art. What is the difference between the fifteenth-century slave master, entering the village looking for people to capture, and Graig Williamson, who, with impunity, disregarded the sovereignty of African states, bombed, shot, killed, maimed, destroyed property, kidnapped, and looted? He did this in Gaborone in 1985, when they killed Thami and stole his paintings, and also killed eleven other people, including a child. I am currently in touch with a Truth and Reconciliation investigator who is trying to locate Thami's work. It is very hard to find, but we are slowly making progress. I am also in correspondence with the Minister of Safety and Security in search of poems, essays, and other writings by, for example, such authors as James Matthews, which were confiscated by the security police of the apartheid era. And now it is 1999.

Liberated voices—what does this mean? I suppose by this we mean artworks liberated from the backdrop I keep painting as I explore these voices. Well, first let us identify its whole body.

Beadwork, baskets, stone and wood carvings, dresses, shawls, sandals, basins, calabashes, et cetera, and sculptures, drawings, designs, and such, including masks and acting costumes, facial decorations, and so on—all these, if they come from nonwhite, indigenous people of the world, are called tribal art or crafts. Why is it tribal and why is it crafts? When this code was applied in South Africa, I suspect it was to put this art into bondage along with its creators. And when I look at the beadwork of the Eastern Cape, KwaZulu Natal, Venda, Mashangana, Batswana, Bapedi, Maswati, MaNdebele, I find it hard to differentiate between it and jewelry. It is difficult for me to see why this beadwork cannot be on the catwalks of the global fashion world, why it cannot be seen as material for interior design, why it isn't on the walls of office foyers and public buildings so that the public eye and consciousness can behold it—so that it can free the beholder and the beholder can free it in turn.

I know: a generation after me will perhaps be witness to a moment when art from my country will be art from the African continent. It will be freed from being "black" art, or "township" art, or "tribal art," or "craft." But this can only happen when Africans themselves free it and themselves. This is the tallness of the order that liberation voices are called on to fill. It is when this art contributes to liberation, to a rebellion, to a reawakening of the African, and when the African claims and freely creates an art that expresses this freedom, that art will be liberated.

How must Africa reclaim its art? In trying to answer this difficult and complex question I have had to retreat, to retrace and review and explore the art of Africa back to the fifteenth century and perhaps before. I recall here the exhibition catalogue *Africa: Art of a Continent* (1995) which manages far better and more competently the retreat, retracing, reviewing, and exploration of the liberated voices of this continent. The time span it covers is mind-boggling; the art it contains by African intellectuals is an indictment to all of us who did not recognize it; their stories have now come back to us, to haunt us and, like ghosts, to remind us of the unfinished business that our modernity created. I am an African. I begin here like many, I am sure, before me, who have reclaimed this art as a voice of people who have, like everyone on this earth, lived, loved, laughed, cried, and said so with the hope that they were doing so to other human beings. They thought, they pondered life and all of its events, and they deeply wished to share their thoughts with humanity. They may have suspected that their efforts would be despised, but as human beings they must also have hoped that despite their suspicions one day this art would claim their humanity through their posterity.

I am that posterity. I share here a deep-felt African agony and anxiety. I wish, we wish like all human beings, to be free. We shall do everything in our power to ensure this. If only simply because we are human we will be relentless in seeking our freedom. No human being will ever accept subjugation. Here, then, is a small voice, from a large continent of perhaps 600 million people. I wish here, humbly, to add to their liberated voice. That voice is five centuries old.

Part of that voice comes from the San and Khoe paintings—the so called rock paintings. These paintings cover far-flung distances on the southern African land-scape: Namibia, South Africa, Botswana, Zimbabwe. They are frighteningly fragile and brittle. They lie on different types of rock surfaces, and at various heights. They claim space and time and make a presence in history and culture of this one time-troubled subcontinent. The paintings portray everything—landscape, people, animals. On that harsh rock the serene and peaceful landscape of the artists' time emerges: it sings, dances, goes into speed or trance or whatever it was the community used to induce it. You see a rhino, a leopard, or a hyena charging, or men and women dancing, walking, or with taut bow and arrow. In other words, the life, the being of those people of that far time, is lived on those rocks. You sense the geography and geometry of the paintings. The patterns and forms, which may have been educated and informed by the patterns and forms and colors of the environment, of animals, or by the imaginations of their creators, seem to give you the smell and touch of the time. Who taught these creators? Why did they think it necessary to portray their lives in this manner? To whom were they portraying it? The paintings have a voice, and this voice enters into a dialogue with you.

Once, not so long ago, I was flying from Harare to Gaborone. Before I caught my flight, I had been to visit the rock painting site outside Harare. As I flew to Gaborone, there down below was the harsh southern-African land-scape. It was during a period of fierce fighting for freedom, by Zimbabweans, by Angolans, by Mozambicans, by South Africans. The paintings harnessed and captivated my imagination into the time of the San and Khoe. They lived in and on the landscape below. That landscape is now their grave-yard. It was on that landscape that they fell and died, and hopefully it was there that they were buried. Genocide: that is how colonialism as a system related to the creators of the rock paintings.

Eyeball to eyeball with the paintings, I wondered how the creators portrayed this experience on the rocks. They were hunted. They were killed. There was a deliberate policy to exterminate them. They must have heard about this, it must have become a rumor, and then the reality of being hunted—when a child you had made was killed, when a lover or brother or sister or relation or hunting comrade was captured and killed, you had to imagine, and one day you were fatally wounded, surrounded by the killers with their guns, speaking in a language you had never heard before—what would happen next, when would it happen, how would it happen?

Do the rock paintings portray and depict this? Is it possible that the creators of these paintings depicted everything but this? These free people, their domain the open sky, the open and varied landscape, the many and different animals and nature, of which they were part and which was part of them—were they not afraid, not devastated by this knowledge? This in my view is the question the paintings raise about the San and Khoe. Would they not have been creative about the genocide that was being systematically carried out on them? Is it true that the settlers, initially main-ly men, did not see or react to the San and Khoe women, whose lives were so free that they wore few clothes? Is it true that these San and Khoe women did not see or react to the things that happened to them? These are the issues that the rock paintings must now raise with us, in the time of freedom on the vast southern-African landscape. These paintings are the old liberated voices.

The rock paintings and, I suspect, the many carvings created during the era of enslavement will soon put on the human agenda the pain and trauma of those people of a long-ago past. The brutalized will claim from us their freedom, as also they must claim from us, the most civilized, their humanity. If we examine their lives, and in doing so examine our own, we will remove from our souls, spirits, and being, still traumatized by this unfinished business, the bondage that up to now has entrapped us in prejudice, injustice, discrimination, racism, sexism, and abject and ruthless exploitation of the vulnerable and weak. If we stint on this examination, if we postpone the emancipation of

those we so brutally and ruthlessly decimated, their voices of liberation will become louder and louder, and our nightmare longer, as they haunt us.

The descendants of slaves and of the San and of the Khoe are already asking humanity questions. Not only their ancestors' art but they themselves are here with us. Recently, in the Northwest Province of South Africa, in Taung, I was invited to a "Cultural Calabash" where I met young San and Khoe boys and girls. They had come to the Calabash as a dance troupe. They were barefoot. They were scantily dressed. They seemed extremely shy, and kept to themselves. But when their turn came, and they took the stage and began to dance, there was an unfamiliar electricity in the hall. The way they clapped hands, sang, and slowly, deliberately, began to dance, using their ankles, their knees, their hips, their shoulders, their necks, and each other—I had never before seen people dance like that. The hall was captivated. The little bodies on the stage were transformed: they became large, intimate, expressive, they exuded warmth and affection and compassion. The girls danced differently from the boys—now you saw a cock, now a hen in their dance, or doves, or the muscle tension that told you how disciplined the body had to be to move that way. The dances were careful, teasing, and full of humor.

I had never, as I said, experienced such dancing in my life; nor, I thought, had I ever heard the language of these peoples spoken. Yet it influenced the clicks in Sesotho and isiXhosa; and I am of the San and of the Khoe. Those who escaped genocide took sanctuary by reproducing themselves from among other Africans and even from within the settlers; the so-called "coloreds," who are descendants of Africans, Europeans, and Indians, are also posterity of the San and of the Khoe. It is, then, in this lineage also that the voice of the San and of the Khoe will soon be heard.

This land, southern Africa, like the rest of the African continent, has given to its winds, to its ghosts, and to the quiet of its far-flung distances its wishes and its desires and its voices. I await the West's acknowledgments of what Africa, through its portrayal of the nude in its art, has contributed to the exploration of the humor, the awkwardness, the delicateness, the fragility, and the sensuousness of the human body. But more: I also await to hear about the unique merit of the African nude, which liberates sexuality and makes it an issue of intellectual discourse, a matter to be acknowledged not only as a reality but also as the essence of life. African art lays this subject bare, in its masks, carvings, rock drawings, even its body adornment. It is made to broaden the vocabulary of visual art. It may be vulgar, sacred, secret, or articulate in its beauty and its fathomlessness; or it may be all of these things. None but the elders and intellectuals of that distant past were so skilled as to capture all this in a single, delicate line, on a rough surface of rock—and forever.

Postapartheid Expression and a New Voice

David Koloane

The Truth Commission

A significant event has been taking place in South Africa in the past few years: the hearings of the Truth and Reconciliation Commission, constituted to investigate human rights violations committed during the apartheid era. Skeptics from various quarters dismissed the commission as a witch hunt against former adversaries, or else a mere show of pomp that would accomplish none of its objectives. Still others felt it was a waste of taxpayers' money, which could have been channeled to an essential need such as housing. The major role-players in the commission were often those, from both ends of the racial divide, who applied for amnesty. The primary precondition for the granting of amnesty was a full disclosure of the details leading to the violations: the truth about the circumstances surrounding the deed were to be revealed to the last detail.

The perpetrators of the violations included both those who had served the erstwhile nationalist government, which had institutionalized apartheid, and members of the African National Congress and the Pan African Congress, liberation movements that had been banned and compelled to operate in exile and underground. Between 1976 and the late 1980s, political activists from various student organizations and groupings had secretly left the country to join liberation-movement armies in neighboring countries such as Zambia, Angola, Zimbabwe, and Tanzania. During this same period—the period of the total-onslaught policy of the apartheid government—numerous activists went missing and disappeared into a long black night. Then there were the notorious deaths in detention.

If pressed I could try to slip on a bar of soap, but the board of Jewish deputies is as frightfully touchy about bars of soap as over tattooed lampshades (Oliphant and Vladislavic 1991:177).

Steven Biko

A case that immediately comes to mind is that of Steve Biko, whose death in detention in 1977 caused an international outcry.

The leaders of the white community had to create some kind of barrier between Blacks and whites so that whites could enjoy privileges at the expense of Blacks (Steve Biko in Malan, ed., 1997:1).

Biko, founder of the Black Consciousness Movement in the 1970s, had preached the gospel of unity and self-reliance within black communities:

Black consciousness is an attitude of mind and a way of life, the most positive call to emanate from the Black world for a long time. Its essence is the realization by the black man of the need to rally together with his brothers around the cause of their oppression (Steve Biko in Malan, ed., 1997:21).

Detained on August 18, 1977, Biko was certified dead on September 6, after days of interrogation and torture. He was left naked and shackled during incarceration. When he

The five works reproduced here are part of a series of works on paper, titled The Journey, the artist made on the arrest, interrogation, and death of Steve Biko. These drawings were created after the police officers involved applied for amnesty at the Truth and Reconciliation Commission hearings.

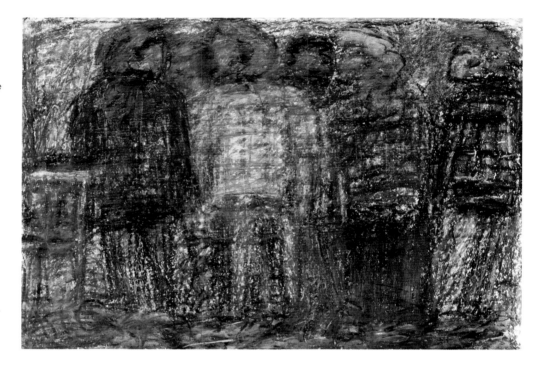

CAT. 1
The Journey.
By David Nthubu Koloane, 1998.
Acrylic and oil pastel on paper.
A series of twenty drawings,
each 29 x 42 cm. unframed.

reached a state of total collapse after the beatings, he was driven in the back of a Jeep, in the same physical condition, the 1,200 kilometers from Port Elizabeth to a state hospital in Pretoria.

> *He was deprived of even the negligible rights he had as a Section 6 detainee. His clothes were removed and he was left naked in his cell* (Malan 1997:58).

An inquest into the death elicited a web of lies, deceits, and denials. The then Minister of Police Jimmy Kruger made the infamous statement, "I am not glad. I am not sorry about Mr. Biko. It leaves me cold" (quoted in Malan 1997:63).

Biko's death inspired creative practitioners in the visual and performing disciplines from different corners of the world to produce plays, films, drawings, and works in other media. As the curator of the South African section of "Seven Stories about Modern Art in Africa," 1995 (a component of the Africa/95 season in Great Britain), I conceived an exhibition around a central installation of work by different artists on the Biko tragedy. Paul Stopforth, a South African artist presently based in Boston, Mass., produced a series of graphite drawings from autopsy photographs he had managed to obtain at the time. In 1981, the South African government had banned the work from being displayed as part of its representation at the Valparaiso biennial in Chile. The unsatisfactory findings of the Biko inquest still hang like a dark cloud over the judiciary system of the time.

> *The available evidence does not prove that any act or omission involving or amounting to an offence on the part of any person brought about the death* (Inquest report, quoted in Malan 1997:70).

One of the most potent images in all of the various displays in "Seven Stories" was Sam Nhlengethwa's collage painting of Biko's corpse in a cell. Nhlengethwa's work evoked the essence of fragmentation through the collage technique of piecing together a composition out of diversely shaped components, a creative jigsaw echoing the dismemberment of the human psyche. In all the exhibition reviews of "Seven Stories" in Great Britain and Sweden, this image was the most often reproduced. It has recently been included in a book on the most powerful images of the twentieth century. (Barnes et. al 1996)

After twenty-one years of an eerie and pregnant silence around Biko's death, a paradoxical shift occurred: a group of security policemen who claimed to have been responsible for interrogating him applied for amnesty to the Truth and Reconciliation Commission. This unexpected turn of events in a sense endorsed the moral conscience of the commission, to say the least.

Social Realism

> *Art from the urban black artist has too often been dismissed under the pejorative label of township art and frequently criticized for irrelevance and repetitiveness* (Burnett 1984: n.p.).

Under apartheid, various artists residing in the segregated settlements officially known as "townships" produced a form of social realism revolving around the social conditions in which those communities existed. The Polly Street group of artists—the first professional wave of black urban practitioners—had the unenviable task of establishing a visual

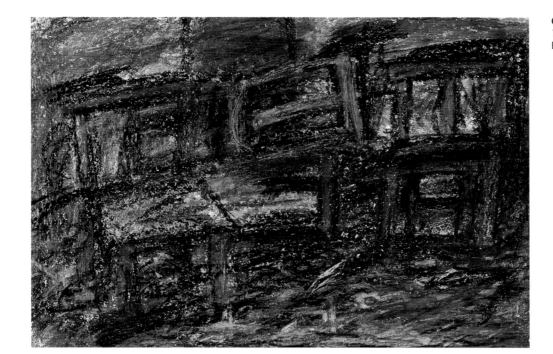

arts tradition within the black African community. Their novel expression soon developed a submarket for itself within the mainstream South African market in the late 1960s.

To most artists, the primary objective was to sell their work, not only as a means of subsistence but as a token of success. It is not hard to see that most black African artists, because of a lack of formal art education, will often regard their skills as no more than a means of survival. The more complex aspects of aesthetic discourse, as undertaken at a theoretical level of competence and eloquence, will often be of minimal or no significance to the artist.

Many white artists in South Africa are not only sophisticated in their skills and ambitions but are also well informed about the drift of art developments in other parts of the world (Burnett 1984: n.p.).

It therefore follows that the nonpracticing fraternity in the visual-arts infrastructure will be constituted by an all-white network of gallery owners, dealers, historians, consultants, reviewers, and so forth. What this imbalance implies is that communities that have been denied basic human rights over decades have in effect become bystanders in the visual arts, lacking the resources to feign knowledge in that domain. This fundamental imbalance will often inspire a white housewife with a passing knowledge of art to become a corporate consultant on the work of black African artists. Since the new governmental dispensation, in fact, there has been an upsurge in the number of authorities, consultants, writers, and researchers on African art-people who have taken it upon themselves to assess, analyze, classify and reclassify, locate and relocate, bisect and dissect, visit and revisit this form of expression, as if it were some rare specimen under a microscope.

The Art Market

This exclusivity has dictated that official art and culture is white and orientated towards Europe. Ambitions for art and expectations with regard to art are pervasively defined in these lights (Burnett 1984:n.p.).

It is important to note that most commercial galleries opened their doors to black African artists during the apartheid era. As a result of this accession, relationships were formed among artists and dealers, And, as mentioned earlier, a submarket of "African art" developed—and attracted a host of unscrupulous dealers out to make a quick buck.

Several galleries specializing in the work of black African artists surfaced between the 1970s and the 1980s. The boom period for this novel expression, however, was in the early 1970s, when most of the first urban professional artists had sell-out exhibitions. The success of this urban expression was largely due to its novelty and to its vigorous and crowded compositions. For the first time, white viewers were seeing how segregated communities existed in the neighboring townships. Given the composition of South Africa and its racial policies at the time, the emergence of the "township art" label is easy to understand. White artists based in the suburbs were not referred to as suburban artists, nor was their work referred to as suburban art.

The success of black African practitioners within the mainstream market affected succeeding generations. Some of the younger artists of the late 1970s thought they could emulate the success of the Polly Street artists, with rather dismal results. Unscrupulous dealers and galleries also

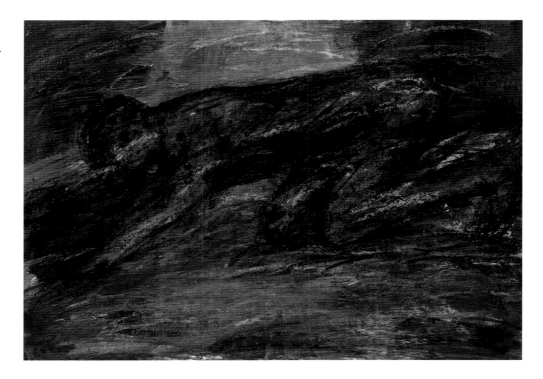

Cat. 1
The Journey.
By David Nthubu Koloane, 1998.

demanded a certain type of work: it had to be marketable, and therefore had to follow a specific stylistic formula popular with potential buyers. Some of the artists with a less innovative flair and skill fell victim to a vicious cycle of repetitive production.

> It is not difficult therefore to realize that artists who fall victim to this cycle become programmed to the dealers' dictates and their work is often reduced to a crafty thematic formula (Koloane 1989:100).

Artists producing for this subsidiary market were often making work in an assembly-line format in order to fill orders placed by the dealers and their network. These artists were not expected to deal with unpleasant and painful aspects of their community's existence, which could upset the buying public. To be successful, the artist had to produce sanitized, virus-free variations.

> Black artists are generally not expected to venture beyond a certain threshold in their work, the reason being the fear mostly from art dealers that they will lose their indigenous identity or their roots as the sentiment is popularly expressed (Koloane 1989:100).

The visual arts in South Africa have been invaded by pretenders over the years, their credentials often no more than the color of their skin. Fortunately there have also been mutually beneficial relationships that have benefited artists and enhanced their skills.

The Community-Based Art Center Concept

> The development or underdevelopment of the visual arts in South Africa in this century was shaped by factors which wield political power (Burnett 1984:n.p.).

The concept of the community-based art center, which came into being in the 1970s, entailed the informal tuition of township-community students in the visual and performing disciplines of music, theater, and dance. The Black Consciousness Movement, heralded by Steve Biko, was influential in the communities, initiating projects and education programs intended to make them self-reliant. Evidence of this influence in the creative sphere pervaded the music, theater, and visual arts produced at the time.

> Thus a lot of attention has to be paid to our history if we Blacks want to aid each other in our coming into consciousness. We have to rewrite our history and produce in it the heroes that formed the core of our resistance (Biko, in Malan, ed., 1997:30).

The arts centers were independent structures, entirely reliant for funding on the local business sector and foreign funding agencies. They were few in number and catered to large numbers of students. Yet despite their poor resources and often underfunded condition, they produced some of the best artists in visual art, music, and dance. Some of them aligned themselves with the struggle for liberation and with liberation movements, and they formulated their own aesthetic principles. Centers such as the Open School produced calendars and other publications based on the struggle for liberation, works illustrated by the students.

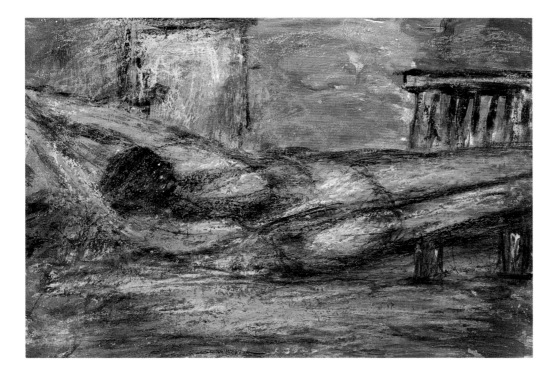

Cᴀᴛ. 1
The Journey.
By David Nthubu Koloane, 1998.

To summarize the repressive political conditions which favored the emergence of culture as a shield for antiapartheid political struggle, the absence of training initiatives geared at Black communities and availability of funding, essentially foreign, contributed to the initiation of community-based education projects in the late eighties (Williams 1991:n.p.).

Some of the centers became crucibles of resistance. These included the Community Arts Project in Cape Town, the Funda and Mofolo centers in Soweto, the Federated Union of Black Arts (popularly known as FUBA) in Johannesburg, the now defunct Alexandra Art Center to the north of Johannesburg, and the Johannesburg Art Foundation in the northern suburbs of the city, the latter a unique initiative started by the well-known artist and teacher Bill Ainslie.

Bill started the Johannesburg Art Foundation out of his own home, in the northern suburb of Parktown, as a teaching practice for a few students. He later moved it to Saxonwold, where the Johannesburg Art Foundation is presently located, having developed into an established nonformal institution. The irony is that it first operated in a white residential area, defying the Group Areas Act and a host of other discriminatory laws. This art center was one of the first to admit students of all races.

The community-based art center provided students from segregated townships with alternative curriculums to the formal European-model teachings of the state institutions.

Besides these [state] institutions were content to continue serving the aesthetic interests of the white minority, and even when Blacks were actively recruited by liberal university-based drama departments for example they were educated and trained on the terms and within the value and paradigms of essentially white teachers and for the needs of conventional or established theater (Elliot 1990).

The theoretical underpinning of some of the centers was the aesthetic of political resistance rather than formal education. Some of them conducted workshops for the trade union movement on the production of posters, banners, and related publicity material.

Drawing and Dumile Feni

Most of the work of the Polly Street artists was based on the use of color and produced in the media of watercolor, gouache, pastels, or oils. The compositions were vibrant, crowded with vigorous movement. In the 1970s, however, a younger generation of artists took a more somber approach, developing a graphic technique based on pencil, charcoal, conté crayons, and pastels. Their compositions were sparser and starker than those of their predecessors, as if they had isolated details from the older artists' crowded compositions. Their work, then, was more forthright, and more economical.

In some instances, in fact, this aesthetic was clearly compelled by economic constraints: the artists simply could not afford to use more expensive materials, such as oils with their attendant accessories. Visual-arts materials such as easels, studio space, canvas, brushes, palettes, and cartridge or watercolor paper have always been out of

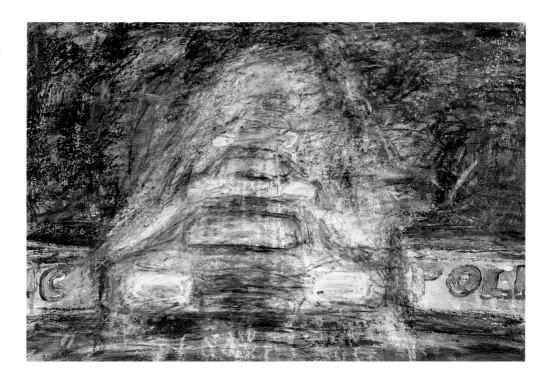

the reach of most black South African artists, even sometimes those at a professional level. For white artists, the very idea of operating without these conveniences would be regarded as sacrilege. But given the social conditions imposed on black African communities by the apartheid system, these communities have always been compelled to improvise their life-style.

The townships' monotonous four-roomed houses, popularly referred to as "matchboxes" in the communities, are devoid of basic facilities such as a bathroom or indoor toilet. (The toilet is usually in an outhouse a distance from the back of the matchbox.) Effectively there are two bedrooms, one of which might serve as a lounge during the day. The number of family members occupying each house was irrelevant to the authorities of the apartheid era. In order to organize their lives to a reasonable degree, communities had only one option, to improvise—often by either adding a room or two at the back or extending the house in front or at the back.

Such conditions also affected the artists of these communities: lacking studio space, they had to improvise their working methods. They also had to choose a material and techniques that would not require much studio space. Most black African artists, then, operated under inadequate conditions and employed poor materials and tools. In working to overcome these problems, they improvised a great deal.

The most outstanding artist of the younger generation that followed after the Polly Street group was Dumile Feni, who recently died in exile in the United States. An iconoclast in several respects, Dumile had no training, whether formal or nonformal, as most of his colleagues did. He was one of the first artists whose work was confrontational and uncom-

promising. His draftsmanship looked crude, but was innovative in its essence, and transcended the sentimental or self-pitying expression of some of his colleagues. In the late 1960s Dumile produced a large-scale reinterpretation of Picasso's Guernica, a tour-de-force for an artist who had only seen this landmark work in reproduction. Nor was his homage a pale imitation of Picasso's work, as some critics claimed when it was shown in the "Seven Stories" exhibition in London in 1995.

> In Dumile's Guernica the layering and composition
> are so strong before you even see the drawing.... The
> Picasso and Goya references are stunning but so are
> Malangatana and Hassan Musa (Court 1992).

The imagery and symbolism of Dumile's Guernica refer to the Sharpeville massacre in South Africa in 1960. The work has had a tremendous influence on younger artists through its economy and power of line.

The Market Theater Complex

The Market Theater Complex in downtown Johannesburg was founded in 1976 as an alternative to the mainstream venues such as the Pretoria State Theater, the Johannesburg Civic Theater, and other such institutions. The early plays of Athol Fugard, the doyen of the South African stage, were performed at this seminal theater, which also mounted responses to the Soweto uprisings of 1976. The playwrights included Maishe Maponya, Zakes Mofokeng, Matsemela Manaka, and Dukuza Ka Macu. Apartheid security agents hovered like vultures over the theater, ready to pounce, detain, and interrogate, and to censor anything they considered subversive. In the visual arts, the upstairs gallery at the

Market Theater attracted rebel practitioners such as Michael Goldberg (now resident in Australia), Stopforth (now resident in Boston), and Wolf Weineck, who introduced the flea market as a component of the theater.

The schism between state-sponsored productions, which were regarded as art-for-art's-sake indulgences, on the one hand, and alternative productions from the Market Theater, which was independent and gave voice to resistance practitioners, on the other, became more unbreachable by the day. The dance and ballet companies and the symphony orchestra pandered to the dictates of the state and in return received ample funding grants. The sports and cultural boycott intensified in the 1980s, helping to isolate South Africa further. Illegal rebel rugby tours and exhibitions were sent to those countries sympathetic to South Africa, such as Chile.

In 1981, Lucas Seage had a groundbreaking exhibition in the Market Theater gallery. Seage was one of the few artists to transcend the stereotype of black African expression, following in the footsteps of Dumile Feni and Louis Maqhubela, of the Polly Street group. Lucas commenced his art training in the Mofolo Art Center, one of the few art centers based in Soweto. The center provided the most basic training, with minimal resources and space. Lucas later enrolled at the Bill Ainslie Studios, which would eventually be transformed into the Johannesburg Art Foundation. The foundation provided a relatively advanced tuition program compared to the township-based centers.

Bill Ainslie was one of those rare and intrepid personalities whose role as a catalyst in the creative sphere has transformed the lives of individuals, organizations, and communities.

> He enriched everyone he encountered. History will no doubt show in time how great was his influence, how much he also enriched the South African culture, how different the country is because of Bill (Williams 1991:n.p.).

Bill was instrumental in the formation of the Alexandra Art Center and, together with this writer, of the Thupelo Artists Workshop.

Lucas's first solo exhibition at the Market Theater Gallery was at the cutting edge of South African expression of the time. The irony was that he had employed inexpensive material, requiring no equipment such as paint and brushes; he was one of the first South African artists to recycle found objects and transform them into a personal vocabulary, his sources being the waste dumps and junkyards of the city. At one stage he also incorporated his identity documents, called the dompas (officially called a "reference book"), in his work. Although primarily for purposes of identification, this document was a symbol of racial restriction and classification. In employing what was supposed to be state property, Lucas risked being charged with the use of state property for an unlawful purpose.

> My message is directed to the man in the street hence I use symbols he can easily identify with such as a reference book, a bible, chains, a primus stove, and so forth. I regard art as a weapon against injustice (Koloane 1981:18).

In 1981, Lucas's innovative work won the Konrad Adenauer Prize. The award-winning piece was an assemblage comprising a wooden bed-frame with scattered shards of molten glass on its base. At the head of the bed, to the right, was a rolled blanket of a type used mostly by migrant mineworkers. Next to the blanket in the center was an open Bible, tied with a chain to the bed. Lucas had a high school level of education and was naturally inquisitive. This prize and the facilities at the Johannesburg Art Foundation—the library, and slide lectures on artists and art movements—accelerated his creative ascendancy. Through the library he became familiar with the Dada and Surrealist movements, and fell under their spell. As part of his prize, Lucas studied in Germany for about two years under the Conceptual artist Joseph Beuys.

It is important to note that very few black African artists have access to tertiary-level education, and that the reading ethic that is common among white artists is almost nonexistent among their counterparts in the townships. If one tries to promote an aesthetic dialogue between these groups of artists, it soon becomes apparent that they often operate at different levels. At the other end of the equation, one also finds artists who do not require the prerequisite of any form of training. Life itself appears to be their theater of inspiration.

Jackson Hlungwani has been classified as a visionary, a shaman, a primitive, a prophet, a naive, a transitional. His creative force seems intuitive; he is endowed with a visionary conception of form.

> Hlungwani embarked on his heavenly work in obedience to the divine calling (Picton 1997).

Jackson lives in an isolated rural area. He has had no formal training but is deeply religious; he is essentially the spiritual leader of his village in Mbokoto. Jackson is a staunch adherent of the Old Testament, and drinks deeply from its wisdom. He has spent numerous years building a shrine in Mbokoto that he calls the new Jerusalem. An awesome monument on a hill overlooking a valley, the shrine comprises monumental wood figures of Jesus and the angels, a large wooden cross, some found metal objects, huge boulders, smaller carved ornaments, and more. The largest carving is about eight feet tall. Jackson bestows a sense of monumentality on even minor artifacts.

The shrine has been steadily depleted as Jackson's works have been commodified on the altar of the art market. He is presently creating a smaller shrine in Klein Letaba, where he was born. The site-specific spectacle in Mbokoto was a visionary tour de force, anticipating the postmodernist conceptual expression so fashionable today. Jackson's materials came from the very soil that had nurtured him and his community; they were materials characteristic of Mbokoto.

Instead the artist keeps advancing in his undertakings like a wheel which can only go forward by firmly touching the ground (Picton 1997).

Had Jackson Hlungwani been educated, well-to-do, and articulate in his aesthetic comprehension, the Mbokoto shrine could have been accorded museum status. The notion of a "museum without walls" has become the novelty of international museum conferences; Jackson long anticipated the idea.

In 1982, the Medu group, a cultural component of the then banned African National Congress, convened a conference on "Culture and Resistance" in Gaborone, Botswana. The conference became a forum for unifying artists in various art forms, both inside the country and in exile. It also brought black and white artists together to present a united front against the apartheid system. The Gaborone conference intensified the politicization of artists, helping to align them with the struggle for liberation. Creative practice was declared a weapon against apartheid. Many whites at the conference realized for the first time the anger and polarization that the system had created within the black communities. The participants came from varied cultural structures, inside and outside the country; there were also representatives from numerous international organizations.

There are certainly ways of improving our work of destroying the negative image. We must change our understanding of the profession. We must read, study, travel and practice the profession in community development projects (Thami Mnyele in Oliphant and Vladislavic 1991).

The Workshop Concept

In 1985, at the height of the cultural boycott and repression in South Africa, the first artists' workshop was convened in Johannesburg. This was also, incidentally, the year in which the South African army invaded the town of Gaborone and massacred exiled activists whom they claimed belonged to a terrorist cell. Among those killed was the visual artist Thami Mnyele, a member of the Medu cultural ensemble. and one of the organizers of the "Culture and Resistance" conference.

Cofounded by the late Bill Ainslie and the present writer, the Thupelo Workshop was held in seclusion to maximize its intensity. The event was a milestone, bringing together artists from different parts of the country to discuss com-

mon problems. The primary objective was to give artists the opportunity to create without inhibition or distraction for two weeks. This allowed them to explore and incorporate different materials and objects in their work. The freedom that the workshop artists most cherished and enjoyed was that of finding and identifying objects to incorporate in their work. They grew as animated and enthusiastic as children in a junkyard.

Most of the materials found in art-supply stores are imported brand names such as Grumbacher or Winsor and Newton. For most black African artists who are not yet established and have no source of income, they are too expensive to buy. Nor will this change in the near future; few artists will be able to afford tubes of paint, meters of canvas, brushes, palettes, pencils, and turpentine and other solvents. Their only alternative is to search out new ways of expressing themselves.

Artists in southern Africa can be painfully isolated, and not only in the vast distances, so the workshops provide a dizzying blend of like minds, new insights and opportunities for experiment (Williams 1991:n.p.).

The Thupelo Workshop project is now a tradition, being convened annually for a two-week period. Funding acquired from local and international agencies supplies food, lodging, materials, and transportation for local artists, and also for invited international guest artists. During the evening, after the day's work is over, artists show slides of their work as a way of introducing themselves to fellow participants. The concept has transformed the creative ability of some of the artists who have embraced the program. The workshop has also served to bring together artists from different corners of the country and beyond. The concept has been introduced in neighboring countries—Zimbabwe, Botswana, Namibia, and Zambia—that are confronted by similar problems of a lack of infrastructure and resources. Some of the most prominent artists who have participated in the workshop programs include Sam Nhlengethwa, Pat Mautloa, Kay Hassan, Sifiso Mkame, Thami Jali, and Helen Sebidi.

Although temporary, lasting only two weeks, the workshop has introduced alternative possibilities in South Africa, allowing the artists to create spontaneously without the pressure of producing only marketable work. It provides the artists with new insights and the incentive for reinventing their working methods in relation to space. The possibility of employing and incorporating disparate objects and substances such as sand, hessian, rope, wire, metal, and cut-out shapes has enhanced creative expression in South Africa.

An art workshop should be a place where one concentrates on the work, where distractions are eliminated, where one learns to detect the traps that inhibit creativity (Williams 1991:n.p.).

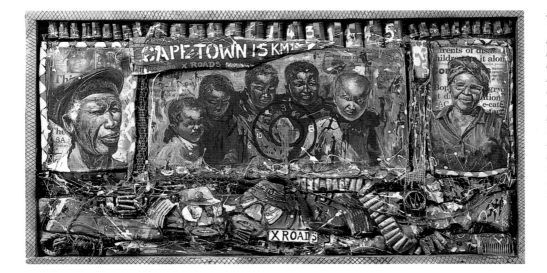

Since the end of Apartheid in 1994, Willie Bester's work reflects on the socio-economic inequities of the Apartheid era that the current government has yet to address. The images derive from Bester's photographs of a sampling of township residents: a man too old to work, groups of children who surround visitors, an African matriarch. Bester's work shows that in spite of economic degradation, the spirit of humanity still triumphs.

Cat. 2
X Roads. By Willie Bester, 1994.
Mixed media: oil paint,
photographs, wire, tin cans,
newsprint, etc. 89 x 167 x 11.4 cm.
Silverman and Stern Collection

Preparing Ourselves for Freedom

The conflict between the European model of creative expression pursued by most formal institutions, and by state-subsidized opera, ballet, and classical-music companies such as the Johannesburg Symphony Orchestra, came to a head in the mid-1980s, when nonformal organizations in the various art forms took an unequivocal stance against the apartheid system and resolved to produce work that would resist oppression. This intensification of resistance by diverse cultural components around the country was a direct response to the higher level of repression exerted by the state, which had adopted an "onslaught policy" intent on destabilizing neighboring states such as Zimbabwe, Namibia, Botswana, Angola, and Mozambique. Within the country, meanwhile, internecine struggles between proapartheid forces and resistance structures resulted in the deaths of various activists. Funeral ceremonies became political rallies, where flags and banners were defiantly flaunted in public.

Another phenomenon that emerged during this period was a mock guerrilla army of youths wearing camouflage uniforms and cradling toy AK-47s and other varieties of submachine gun carved out of wood. Some of these creations of destruction were constructed from found objects and other bric-à-brac such as charred or wrecked automobiles—a permanent feature of the townships.

In 1990, Albie Sachs, a member of the African National Congress, wrote a discussion paper, "Preparing Ourselves for Freedom," which stimulated vigorous debate within the creative communities. Albie proposed that creative expression should no longer be employed solely as a weapon of the struggle; other aspects of life should be articulated as well.

> *The power of art lies in its capacity to expose contradictions and reveal hidden tensions, hence the danger of viewing it as if it were just another missile firing apparatus* (Sachs 1990).

Willie Bester

Willie Bester is an artist based in Cape Town. In the 1980s, at the height of community militancy around the country, he was a student of the community art project. Though originally a collage painter, Willie is best known for his grotesque constructions made of the detritus of township dumps.

A paradox of apartheid policies was that at the same time that the black communities were moved kilometers from white residential areas, industry dumped its waste within township confines. Willie's studio became the center of a recycling process, a laboratory in which he assembles metal animal forms that had medical drips attached to them.

> *The No Jobs sign on the factory wall is part of the language of the bosses. [Bester's] compilation of a factory out of an aerosol can, spark plug and birdwire is the language of those who have to make do* (Magnin and Soullilou 1996:n.p.).

Through his work, Willie has paid tribute to many leaders of the struggle for liberation, including Nelson Mandela, Steve Biko, and Chris Hani, among others. His work has become iconic, and recalls the found-object assemblages of metal,

the toy AK-47s and submachine guns that were often paraded in the funeral ceremonies of the 1980s.

The Biennale Concept

After the first democratic elections in the history of South Africa, in 1994, Nelson Mandela was elected president and was inaugurated accordingly. The pariah status of South Africa as a nation ceased, the sport and cultural boycott was revoked, and South Africa resumed its membership in the United Nations. It is evident that there were those in the creative communities who would seek to capitalize on these unique developments.

The Director of Culture in Johannesburg, Christopher Till, took advantage of the euphoria of independence to mount the first Johannesburg Biennale after he and a colleague went on a fact-finding reconnaissance of existing biennial sites including Venice, São Paulo, and Dakar. The mission statement of the Johannesburg Biennale was that of the celebration of South Africa's readmission to the international fold. The Biennale was mounted in 1995, with almost all the venues located in the so-called cultural precinct around the Market Theater Arts Complex, an arts complex of theaters, galleries, jazz clubs and dance studios.

A contingent of about forty or so international curators was flown into South Africa and notices were dispatched to major art centers and museums. The artists in the different areas were informed of the dates and times on which the curators would view artwork, individually, at specified venues. It sounded like a doctor/patient consultation in which the poor patient had no choice whatsoever. Predictably, the consultation was limited to consenting parties, and did not include the activists and communities who had sacrificed the most. In an attempt to emulate major events such as the Venice Biennale, individual countries were allocated pavilions; African countries were included as an afterthought.

In international events such as the Biennale, there will always be positives and negatives, optimism and pessimism, order and chaos.

> *This exclusivity has dictated that official art and culture is white and orientated towards Europe. Ambitions for art and expectations with regard to art are pervasively defined in these lights* (Elliot 1990).

The positive aspects of the Biennale comprised the display, for the first time in South Africa, of work by practitioners beyond the boundaries of southern Africa, northward to the Mediterranean. The visual panorama provided by these varied countries, cultures, and backgrounds was a panacea for local artists, who were exposed to forms of expression that had previously been radically unimaginable, ranging from conventional artworks to site-specific displays and conceptual- and installation-type expressions. The

site-specific installation of work by Angolan artists expanded the frontiers of sociopolitical expression to a new dimension, recycling war debris and symbols from past atrocities into a creative monument. In texture and mood, the installation was redolent of pain, fear, anger, futility, and compassion. The irony was that at the time of the exhibition, war was still raging in Angola.

Other exhibits of interest to local artists included the Benin Pavilion, where artists extended traditional rituals and works employing found makeshift objects, transforming these into masks and human figures.

> *The figure takes its form from the central mechanical part while the limbs may often come from fragments of machine parts* (Magnin and Soullilou 1996:n.p.).

The first Johannesburg Biennale did not command the attendance expected of an international event. Nevertheless, a second Biennale was convened, in 1997. To ensure proper control of resources, the Biennale organizers, rather than give the concept a local character and poise, advertised for the position of artistic director. Well knowing that few local black African candidates would qualify so soon after the end of the cultural boycott and the apartheid system, Okwui Enwezor, a Nigerian curator based in the United States, applied and was appointed.

The Biennale display itself comprised mostly small, dimly lit cubicles parading the latest conceptual "abracadabra" of video marvel. There was almost no conventional display of two-dimensional expression—painting or drawing. Again, despite its inflated "push-button" sophistication, the Biennale showed local artists that the language of creative expression was expanding, that a conceptual approach was now bridging the gap between art and life, and that the old approach of employing only standard products and techniques was fast becoming passé.

Signposts

Dumile Feni, Lucas Seage, Jackson Hlungwani, and Willie Bester are radically different personalities with different artistic concerns. The common element that unifies their disparate individual production is their innovative spirit and their transcendence of their social conditions.

Dumile never received any formal training, but was not what one could refer to as an autodidact. He associated with other visual practitioners, writers, and musicians, and was effectively conversant with aesthetic concerns and with the work of other artists in other art forms. Facing the restriction of having to work on a small scale because of his limited studio space, he improvised ways of circumventing the problem. Unsurprisingly, he chose to explore the graphic techniques of pencil, charcoal, conté, and so forth. Dumile's work was harsh, stark and potent. The Guernica drawing was a testimony of his prodigious skill.

Jackson Hlungwani is another self-motivated artist who has fused his belief system with his work: he was one of the first South African artists to produce site-specific work, with his New Jerusalem shrine and Kanana shrine near his birthplace. Lucas Seage's assemblage work was ahead of its time in the early 1980s, when most black African artists were still coming to terms with social realistic expression. His influence on younger artists is only beginning to surface.

Willie Bester, on the other hand, has firmly asserted his influence, providing artists with numerous possibilities. Willie has become the doyen of assemblage, producing numerous apartheid monsters in machine and animal form. The contribution of each of these artists in transcending the confines imposed on their communities has facilitated the role of younger contemporaries who can now follow the signposts they created.

Jackson declared his rural environment and surrounding as his studio and his site-specific shrine as his museum.

> *Finally in Hlungwani's crossroad theology dreams and visions possess a normative value. They form the basis of his prophetic consciousness* (Magnin and Soullilou 1996:n.p.).

Dumile introduced an economy of graphic expression within black African communities in which artists could not afford the standard equipment. He also improvised methods of transcending the limitations of space by forming relationships with white counterparts who could provide a facility. Lucas and Willie revealed city waste dumps as treasure troves for assemblage, collage sculpture, and site-specific constructions.

The workshop concept was another signpost. Most of the leading and innovative artists today in South Africa have participated in some or most of the workshop programs. Albie Sachs's discussion paper, also, was presented at an appropriate and historic moment when a new dawn was being heralded and vision of a new reality was on the horizon.

> *Apartheid is dying. If we become overly preoccupied with it we run the risk of inheriting the stench of a corpse* (Elliot 1990).

The paper stimulated debate, in institutions of tertiary education, intellectual circles, newspaper columns, and radio programs.

Artists on the gallery circuit, and newly invigorated by the successive Biennales, felt the need to confront the challenges posed by these accumulating developments. A new horizon spelled out new possibilities and beckoned in challenge. There also appeared at this stage a phenomenon integral to any exhibition, and without which an exhibition would be like a symphony orchestra without a conductor:

the phenomenon of the "curator," without which no Biennale would earn international credibility. Numerous curated exhibitions were mounted, and they traveled to different countries. Some local artists began to try to please foreign curators so as to win international recognition. And the curators themselves were to present exhibitions that would meet an international standard. The problem with some of these projects, however, is that they can create a false impression on the part of some of the artists, who, after being included in one or two exhibitions, regard themselves as being of international caliber.

> *The concerns and achievements of white artists are many and various* (Burnett 1984:n.p.).

Some of the better exhibitions for export can be viewed positively on the local level, in that they provided a panoramic view of the potential character and diversity of South African expression. Yet the opportunity for local artists to display their work internationally has created its own problems, including the possibility that the artists whose work is deemed appropriate will be featured ad nauseam on the exhibition circuit, to the chagrin and disadvantage of those considered inadequate.

A New Voice

> *Opening several fronts at the same time it announces a break with that conventional image that held it hostage to tradition and made it a wallflower in the dance of modernity* (Magnin and Soullilou 1996:n.p.).

The new developments unfolding in South Africa have affected creative practice. Playwrights are assessing and reviewing their contribution to the protest continuum. Writers are shifting the focus of their lens away from the tributes and AK-47 rhetoric of Sharpeville and June 1976. Visual artists are discarding the easel and reassembling the rituals of their traditions away from the confines of perspectival conformity. Artists of the new breed are young, relatively better educated, articulate, and zealous about their work and their profession.

Zwelethu Mthethwa is a young lecturer at the Michaelis School of Art in Cape Town, a prestigious institution with a predominantly white student body. Zwelethu, in fact, is one of the first black African lecturers in the history of the fine arts faculty. He is originally from Umlazi, in the Durban area on the country's east coast. After early tuition in a local nonformal art center, he enrolled at the Michaelis School for his fine art degree, and later won a Fulbright scholarship to study for a masters degree at the Rochester Institute of Technology, New York, majoring in photography.

Zwelethu's work presently comprises drawing. His education has enabled him to draw in diverse captivating perspectives, using high-toned chalk pastels to transform day-to-day humdrum existence into a concerto of color.

One conservative reviewer has chided Zwelethu's arbitrary, stringent color; "nobody has a purple face," she complained. The drawings are quite large, an echo of Dumile Feni's pioneering work.

Zwelethu has studied the patterns on the checkered traveling rugs that elderly women wear over their shoulders like a shawl. He has also looked intensely at the design and decoration on the headdresses that adorn Zulu women, and at their colorful flowing robes. The color in his work unifies the urban with the traditional—there is always this fusion of the old and the new. In his latter body of work he explores the colorful rituals of the independent religious sects that are common in many communities. Each sect adorns its members in colorful robes of yellow, green, blue, red—whatever color is agreed upon by the sect. Most of the sects do not worship in a church building but simply congregate in any available space under the sky. They classify themselves "Zionist," a label implying no connection to Jewish culture and belief, but rather the reading of the Old Testament in the Bible.

This the fire that has triggered nerves / in the street that map the land / burning at every street lamp / bristling at every fire place (Couzens and Patel 1982).

Sandile Zulu is one of the young breed who have developed a new artistic language. Sandile is also from the Natal area. He received his early training from the Rorke's Drift Ecumenical Lutheran Church Center, a Swedish-mission-funded project set in an ideal environment in the rural area of Dundee. Initiated in 1972, Rorke's Drift produced some of the best black African graphic artists, and was the only such center in the country to offer board and lodging to its students. Artists who studied there include John Muafangejo, Leonard Matsoso, Dan Rakgoathe, and Azaria Mbatha. The center also incorporated weaving, pottery, and tapestry workshops.

Sandile later obtained a fine arts degree from the University of the Witwatersrand in Johannesburg. Here both the student population and the teaching staff in the visual arts section were predominantly white. The university has produced some of the country's best artists.

Sandile's early works comprised a series of "fire paintings," in which he scorched the canvas or other surface with a blowtorch, or similar device, to create form, texture, line, and tone. The use of and allusion to fire points in many directions: to the 1976 students uprising, when the artist was probably still in high school; or to the volatile situation in Natal, where there has been fierce political rivalry and sporadic faction fights over the years. With their scorched, scarred, and bruised surfaces, the paintings suggest the aftermath or the detritus of a tragedy.

A local reviewer of Sandile's work has charged that the artist's process is somewhat old, as it was done by the

French conceptual artist Yves Klein in the 1950s. Having the benefit of a good education and being conversant with international trends, the writer seems to take those privileges for granted, as if they were enjoyed by everybody, and as such undermined the artist's creative potential and ingenuity.

Sandile's latest work entails different varieties of grass, which he spreads like a lawn over the allocated space. In places the grass is scorched, recalling the winter ritual of farmers scorching their fields. Elsewhere the grass suggests lush green summer harvest. Sandile also combines the grass with roots, herbs, and bulbs. The harvesting of such plants for healing purposes is common in rural areas, a knowledge passed down from generation to generation. Herbalists who dig for herbs and roots will often make displays of their wares. Sandile's installations evoke a sense of healing and the potent force of nature. The found object for him bears an affinity with nature, and is not just a mere symbol of something else.

Another young practitioner, Samson Mnisi, trained at the FUBA Academy in Johannesburg, where he also received tuition in the performing art forms of music and theater. The center was situated within the ambience of the Market Theater Complex and the Kippies Jazz Club (named after a well-known South African jazz musician). Samson's creative quest is daring to a point unusual in the South African context: he takes over empty sites that he feels should be employed. Recently he and a colleague mounted an exhibition in a vacant office space. The building also housed the local stock exchange. In his plight for space, Samson has assumed the role of lobbyist, bringing to the attention of the present government the lack of studio space and related problems in the sphere of visual arts, in both rural and urban areas. A former student activist himself, he is acutely aware of the workings of the bureaucratic grind in any government.

Samson's early site-specific work was imbued with the aura and artifacts of worship, adopting the wooden staffs, cowhide drums, and brass crucifixes used by most of the independent Zionist sects. These objects have become commodified artifacts, often sold in bulk in Indian-owned bazaars.

The church promised to follow them and care for them in times of trouble. Its fellowship brought its members warmth and comfort in the bitter world of strangers and poverty (Callinicos 1987:n.p.).

In Samson's installations, little shrines, staffs, and crucifixes were dispersed at intermittent intervals around the space. Candles were placed around the shrines, and drawings in mixed media were mounted on the walls. Samson is a collaborative artist who is always willing to share the joy of creating with fellow artists. The collective spirit entrenched within communities by liberation movements has influenced his life-style and thinking.

It is perhaps fitting to start by examining why it is necessary for us to think collectively about a problem we never created (Biko, in Malan, ed., 1997).

Thabiso Phokompe is a colleague of Samson's who trained at the Johannesburg Arts Foundation and at FUBA. He has participated in several workshop programs in Botswana and also in Norway. His early works comprised ethereal human forms reminiscent of the rock drawings of the San artists. By incorporating found objects in their site-specific explorations, Thabiso and Samson have liberated their work from the restrictions of two dimensions. Their work has become exuberant and vital, a shout of joy to the Almighty.

> *Thus the free and emotional singing, praying and dancing of the independent church services provided an outlet for people's pent-up feelings* (Callinicos 1987).

Richman Buthelezi too uses found objects, having decided to transform junkyard wastes into aesthetic terms. Richman, who was born in the urban area east of Johannesburg known as Springs, uses an incineration technique that echoes Sandile's. He flattens multicolored plastic sheets on the floor and scorches them; the sheets curl up into various shapes and textures. Then Richman shapes them into the required form and image. His work is luminescent with color and textural transparency—it has the richness of a tapestry. Most of his work is in the social realistic genre.

> *The assumption is based on the increasing quantity of waste in proportion to technological acceleration in urban areas; it also appears that the very designs industry employs in the mass production of consumer produce are designs for waste as well* (Koloane 1984:n.p.).

The retail business in South Africa, down to the street-hawker level, dispenses batches of colored plastic packaging, which has become both an environmental hazard and a domestic dilemma. These shopping bags come in different sizes and colors. City streets are choking with them, but the problem is rural as well. They adorn pavements like petals from a gigantic tree. On a windy day they perform a twisted, macabre airborne ballet, like a festival of kites. They embrace telephone and telegraph poles and wrap around the wires. They perch on rooftops like flocks of birds. In the Eastern Cape, plastic waste is called the "lily of the cape," because nothing grows faster. Some women's projects around the province recycle the waste into functional artifacts, such as colorful floor mats and plastic flower decorations. A recycling industry has sprung up to provide some relief from the throwaway products of consumerism, and artists like Richman have begun exploring processes and forms of expression that will both eliminate the plastic waste and move art away from its standard techniques.

Richman is also among those artists who have decided to impart their skills to the younger generation of potential practitioners. Most of the community-based-art-center projects employ artists as tutors, so that they can teach by example. The centers also do this because they are entirely dependent for funding on donations from the private sector, and cannot afford to hire qualified teachers who would expect market-related salaries. But many artists have come to see teaching in the centers as a form of community service.

Black African communities are still going through a transitional phase after shedding the mantle of oppression. The decades of discriminatory legislation intended to lull communities into oblivious servitude have been transformed from a seemingly irreparable situation to the glow of a new horizon. In a similar fashion, the new breed of art practitioner is transforming the debris of the discarded paraphernalia of junkyards, turning the shrapnel of painful memories into creative monuments of reconstruction.

Looking Back, Looking Forward:
An Overview of South African Art

Sue Williamson

"If it seems at all strange for a New York curator to glimpse the future of contemporary art at the southern tip of Africa, perhaps that is because no seismic changes can be registered at the center any more. Rather, the kinds of artistic change promised over the past decade must take place through a slow process of assimilation, by which the center learns of its own peripheral status through the gradual shock of a more equitable system of universal recognition."

–Dan Cameron, "Trade Routes: History and Geography," Johannesburg Biennial, 1997 (*Artforum*, December 1997)

Before 1993, the year South Africa was once again invited to the Venice Biennale after an absence of twenty-seven years, the art of South Africa was almost completely unknown to the outside world. Not only had apartheid provoked the international cultural boycott of the country so that even so-called "resistance art" was little seen outside the borders, but geographical isolation had also played a part. Before the 1990s and the new vogue for internationalism and "multiculturalism," the art of peripheral and developing countries fell outside the spotlight of New York and Cologne. Most international curators, had they thought about it at all, would probably have doubted if there was any art of much interest in South Africa beyond regional curiosities and genre painting. Ten years ago, William Kentridge walked around New York City trying to persuade art galleries to look at his slides without success. Today, South Africa is recognized as one of the leading venues for the global art market: It has mounted two biennials in Johannesburg, and South African artists exhibit in galleries and museums worldwide. In this essay I will attempt to ascertain how this change has come about, and in what way the complexities of South Africa have informed the work of her artists, and whether there are, in fact, characteristics that distinguish the work of South African artists from their peers in other countries.

Liberated Voices: Contemporary Art from South Africa opens at the Museum for African Art in New York a few months after the second democratic election was held in South Africa, and after the first black president, Nelson Rolihlala Mandela, has left office after a five-year term. These past five years have been the most significant in the annals of South African history, since 1652 marked the arrival of the Dutch settlers and the beginning of colonial domination.

The first democratic election on April 4, 1994, was a day most of the country had longed for, and the rest had dreaded. An atmosphere of fierce anticipation led up to this day, while in some areas basic foods disappeared from supermarket shelves as whites prepared to barricade themselves against exultant and rioting mobs. For many, the reality of the joyous and peaceful voting procedures and the euphoria that gripped the country in the following weeks was a revelation. The handing over of power had been accomplished in a relatively ordered way, and as one Nationalist Party politician was quoted as saying, the sky had not fallen. Liberation, or at least liberation in the sense that every citizen in the country now had the right to vote, was indeed here. The reconstruction of the country along equitable lines could begin.

It was this event, or series of events, which brought South Africa favorably to the attention of the rest of the world, and awakened the curiosity that brought an increasing number of experts of all kinds to our shores. But dramatic as the changes seemed, the lives of many within the country remained little altered. Even those whites most deeply opposed to change found that they were, in fact, able to continue living comfortable and insulated lives almost as they always had. There might be more black

Truth Games: the Series attempts to consider the role of the Truth and Reconciliation Commission in the healing/not healing of post-apartheid South Africa through a series of interactive pieces. Each piece pictures an accuser, a defender, and an image of the event in question. At no time are all three images visible, as text taken from the transcripts and printed on slats obscures sections. Viewer are invited to slide these slats across different parts of the images to trying to decide whether the truth is being spoken or still hidden.

In my work, I try to recontextualise issues of contemporary South African history in such a way as to engage a wider public in the profound issues sometimes masked by media hype. By mediating through art the information offered for public consumption in the mass media, I try to give dispassionate readings and offer new oportunities for engagement. Art can provide a distance and a space for such considerations.

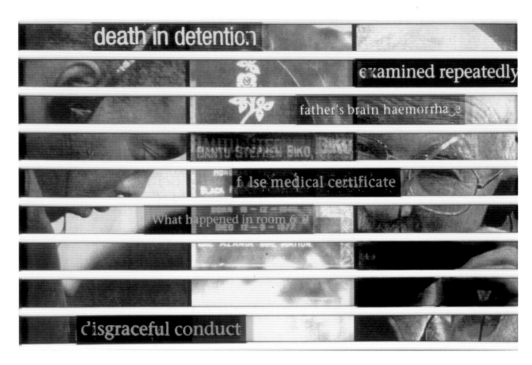

CAT. 3
Truth Game Series:
Nkosinati Biko – false medical
certificate – Dr Benjamin Tucker.
By Sue Williamson, 1998.
Color laser prints, wood, metal,
plastic, Perspex. 83.5 x 120 cm.

The surviving family members of victims, and those who had allegedly perpetrated the crime, often came face to face for the first time in the Commission chambers. In this piece, Nkosinati, son of the popular leader Steve Biko, who died of massive head injuries in jail, is seen with Dr. Benjamin Tucker, the district surgeon who had signed the death certificate stating that Biko died of natural causes.

faces presenting the news on television, but domestic workers continued to bring their tea on a tray to their bedside every morning. It is true that crime has escalated, with daily horror stories of murders, carjackings, and other violent acts coming from every section of the community, but the old white fears of "the impis coming over the hill" and the "whites being swept into the sea" did not materialize. For those at the bottom of the economic ladder in the black townships and squatter camps of South Africa, there have been significant changes for some: houses and electrification. For many, however, the deeply held hopes of employment, economic betterment, the little piece of land are as unattainable as ever.

President Mandela pointed out in a speech in November 1998, as he handed over the leadership of the African National Congress to Thabo Mbeki, that while the ANC remains wholly committed to the policy of reconciliation, the country is very, very far from achieving it. Commenting on the substance of this speech, black newspaper columnists Jon Qwelane and Thami Manzwai, in a tough-talking article entitled "Whites Who Remain Recalcitrant Should Think of the AK47s in the Townships," expressed the view that white South Africans are viewed by the black community as being the impediment to change. White-dominated media comes under particular criticism: "The sensationalism that attends the coverage of the new government and its functionaries—we are not in the least suggesting they are beyond ques-

tion or scrutiny—is far out of proportion to the vast good the democratically elected government has done in a short three-and-a-half years."[1]

Whites keep pointing fingers at the new government, citing inefficiency and corruption as factors slowing the pace of change, but, say Qwelane and Manzwai, what is commonly lamented in black forums is never the slow pace of delivery of economic reforms by the ANC government, but the reluctance of whites to accept that they must change to fit in with the new South Africa. White resistance to true change is a constant refrain. The pervasiveness of apartheid-think lingers on, setting up smoke screens between whites and blacks on almost every issue—screens that are invisible to viewers who believe that their efforts to see clearly are being rewarded. In the United States, this phenomenon has been referred to as "critical race theory": The idea that a different cultural upbringing makes it virtually impossible for blacks and whites to view any incident or event involving both races from the same point of view.

As an example of the gulf that divides the perceptions of blacks and whites, we might examine the case of Winnie Madikiza Mandela. In the early 1980s, Winnie Mandela, wife of the jailed leader and herself banished from Soweto was seen as a heroine of the struggle against apartheid and known to everyone as the "Mother of the Nation." At the end of the decade, she returned to Soweto, and

Cat. 3
Truth Game Series:
Linda Biehl - understand the
context - Mongezi Manqina.
By Sue Williamson, 1998.
Color laser prints, wood, metal,
plastic, Perspex. 83.5 x 120 cm.

Amy Biehl was a young American student working at the University of Western Cape when she was stoned and stabbed to death while dropping off fellow students in Guguletu. The attack took place during a schools boycott, while feelings were running high, and her attackers, young Pan-African Congress members, asserted they acted for ideological reasons. Amy Biehl's parents, Linda and Peter Biehl, have shown a remarkable degree of reconciliation, accepting that their daughter was in the wrong place at the wrong time.

gradually a different picture emerged. A group of youths centered around the Mandela home and known as the Mandela Football Team was implicated in the beating and death or disappearance of a number of young people, notably Stompie Seipei. A series of court appearances resulted in the jailing of her associates but Winnie went free. It was not until December 1997 that the Truth and Reconciliation Commission heard evidence against her. The week long court proceedings were televised live, attracting millions of viewers. For the most part, Winnie remained silent until the last day when she flatly denied the accusations against her. Begged by the chairman of the commission, Nobel Peace prizewinner Archbishop Desmond Tutu, to apologize to the nation for "what went horribly wrong," Winnie finally gave a brief and grudging general apology. Heavy castigations appeared in the white newspapers, which seemed to take for granted that her guilt had now been proved to the nation at large. But what quickly became evident was that this view was not shared by all South Africans. For every white columnist outraged by the fact that Tutu had had to beseech Winnie to apologize—and to whites, her few words could not have seemed more superficial—there was a black columnist who said yes, but.... it was the (apartheid) system that caused the problem with Winnie. The system had cracked her long ago. Her behavior was indeed wrong, but we must embrace her as the dark side of all of us, the side injured by apartheid.[2]

The nation is fortunate that the Truth and Reconciliation Commission was brought into existence to provide an invaluable, if imperfect, vehicle for the past to be uncovered and for such divergent views to be aired. "Trying to understand the new South Africa without the Truth and Reconciliation Commission would be futile," writer Andre Brink has said. The seventeen-member Commission came into being to try and establish as complete a picture as possible of the causes, nature and extent of the gross human-rights violations committed in the period between the 1960s and 1990s. "These can now be addressed," read the last clause in the country's new constitution, "on the basis that there is a need for understanding but not for vengeance, a need for reparation, but not for retaliation, a need for *ubuntu* [the African philosophy of humanism] but not for victimization." The clause also provided for the granting of amnesty to the perpetrators of violent acts on condition that those applicants make full disclosure of the truth and prove that their actions had been politically motivated.

The first sessions of the Commission took place in April 1996, and over the next two years, it had received 20,000 statements from victims, and almost 8,000 applications for amnesty from perpetrators. Church halls, schools, and other community buildings improvised as official spaces across the country. Commissioners listened to evidence of killers laughing and drinking beer while the bodies of their victims burned, of bodies thrown into rivers, of a child blinded by a

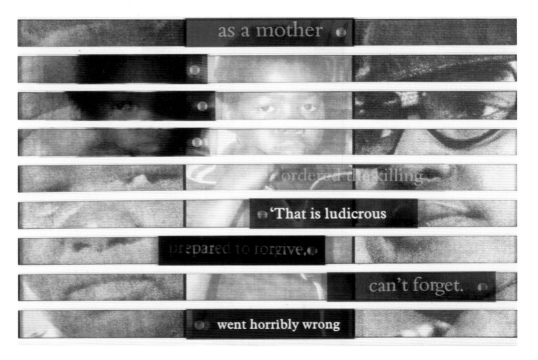

CAT. 3
Truth Game Series:
Joyce Seipei - as a mother -
Winnie Madikiza Mandela.
By Sue Williamson, 1998.
Color laser prints, wood, metal,
plastic, Perspex. 83.5 x 120 cm.

In one of its most closely
followed hearings, the Truth
and Reconciliation Commission
attempted to establish the
degree of culpability of Winnie
Madikiza Mandela in the death

of teenage activist, Stompie
Seipei, at the hands of the
Mandela Football Club.

police *knopkierie* (baton) of deaths in detention, of teenagers who "disappeared." There were revelations of extreme horror. There were also moments of extraordinary reconciliation, a depth of forgiveness which has seemed beyond human ability.

The process in its very conception is seriously flawed—so many stories that could not be heard, victims who testified to feeling that justice had not been done, amnesties awarded that seemed questionable—but there is little doubt that it has been an absolutely essential process for the country. The rotting grave has been broken open. Those whites who had before chosen to look away, not to scratch the surface, can no longer say, "we did not know."

In July 1997, Ariel Dorfman, the Chilean writer and activist, was visiting South Africa to meet the Truth and Reconciliation commissioners, and he had this to say on the issue of criticism in a new democracy:

> The central problem when you go to war is that you have to swallow your doubts and your criticism. There is a word often used in war, and that's traitor. That language of them and us, of treachery and loyalty carries on into democracy. It's essential to transgress that line too—criticism is basic to a healthy democracy. It's the only way government will be able to understand its own mistakes. I worry about hiding things too much.

It can become, and often perpetuates, the political culture of a nation. That's where the media and the arts play an important role. When established criticism gives rise to such a level of horror stories that people can't absorb them any more, the arts are able to created the distance, and conversely ensure the immediacy, of such stories.[3]

With this in mind, we might consider the role of art as mediator, as interpreter of reality, as presenter of alternative truths. During the past fifteen years, many artists in South Africa have been deeply involved in social change and with the new government in power, they have not forsaken this role. Thus we have "Faultlines," an exhibition curated by Jane Taylor at the Cape Town Castle in October 1996, which centered on the themes of the Truth and Reconciliation Commission.

Thus we have the William Kentridge video *The History of the Main Complaint*, which moved from "Faultlines" to Documenta X in Kassel in 1997. Kentridge's powerfully rendered animation continues the saga from earlier work of Soho Eckstein, Johannesburg "property developer extraordinaire" who we find lying in a hospital bed surrounded by doctors, unable to give a name to his malady. In flashbacks, we see Eckstein driving wildly through the darkened countryside, hitting a black man with his car, not stopping, and driving on. The metaphor of damage caused by willful blindness is clear.

Fig. 1
For Thirty Years Next to His Heart
By Sue Williamson, 1990.
Color laser copies, hand
covered frames, 196 x 262 cm.

At this point, perhaps one might give a certain consideration to the exact meaning of the words "liberated voices" as part of the title of the show at the Museum for African Art. The "voices" are those of the exhibiting artists. Certainly they were politically liberated by the advent of democracy in 1994—but in the days of apartheid, what sort of control was exercised over their creative output and how free were they to confront the state as artists?

Recently, I showed slides of political art from the 1970s and '80s to a group of American students, and was asked if artists who made work that was critical of the government suffered repercussions. The answer is that most of the time, they did not. The police in South Africa were far more likely to ban or place under house arrest popular leaders and activists than to worry about the effect of political art on the population. It is unlikely that this was due to any respect for cultural activity on the part of the state: probably officials considered art unimportant and peripheral and the small gallery-going public an elitist minority unlikely to cause trouble in the streets. How else can we explain Paul Stopforth's triptych of the white policemen responsible for Steve Biko's death in 1977 hanging publicly in the South African National Gallery in Cape Town, while the state was sending T-shirts impregnated with acidic substances to the children of newspaper editor Donald Woods, a friend of Biko's, and the followers and compatriots of the Black Consciousness leader were being tortured in jails?

The anomaly of gallery/outside world did not go unnoticed at the time. Writing in the *Rand Daily Mail* (9 September 1978) on an earlier exhibition of Stopforth's, critic Ann Pogrund said, "It is part of the contradiction of this country that at a time when the treatment of detainees is arousing acute anxiety, it should be possible for an artist to hold an exhibition depicting torture during interrogation. It is astonishing that such a public protest should pass without much response, positive or negative from anyone."

Stopforth commented, "I want to make and spread an image as real as possible for the time now. I want to bring the facts home to those willing to look. My figures parallel something that we can't be witness to. We can't refuse to accept that these things happen."

Once such work moved out of the "safe" or semi-hidden confines of the gallery, however, it became more threatening to the state. In 1981, Stopforth had been selected as one of six artists to participate in the Valparaiso Biennial in Chile. The government was sponsoring the exhibition costs, but after viewing Stopforth's submissions, two small graphite drawings of damaged hands and feet, *Steve Biko* and *We Do It* (both 1979), the state intervened and sent a letter that read in part: "The works chosen made political statements.… While the department did not want to interfere with the autonomy of artists, it decided, after discussion with interested parties, that it was not the way of the department to promote and finance such works overseas."

Similarly, in 1978 I made a series of five small etchings entitled *The Modderdam Postcards* depicting the state's demolition of a black squatter camp near Cape Town. The etchings were exhibited in three commercial galleries, and appeared on SABC, the state controlled television service. One of the etchings was made into a postcard as a piece of consciousness-raising media to prevent the demolition of yet another squatter community. Within a week of printing the postcard was listed in the Government Gazette as

banned for distribution. A lawyer wrote a letter on my behalf to the state censors to inquire as to the reason for the ban, to only receive an unctuous reply from an official in Pretoria stating that while it was not without artistic merit, it was a weapon in the hands of the enemies of our country.

The message seemed clear: art was considered impotent until it hit the outside world. While the work of Stopforth or Alfred Thoba's *1976 Riots*, a painting picturing the death of the first child shot by police during the unrest in Soweto, commented directly on the oppressive situation within the country, there were many artists whose message was a critique of a more complex and coded nature, not quite as open to interpretation.

Patience on a Monument—"A History Painting," 1988, is one of a number of "ironical" history paintings that Johannesburg artist Penny Siopis produced in the late '80s. In this body of work Siopis casts a cool and revisionist eye on genre painting in which the climactic moment of a notable event (usually military) receives the respectful attention of an artist. Such canvases are vast and the central figures, embodiments of such manly virtues as courage and patriotism, strike heroic poses. In *Patience*, the figure of a seated woman ("anti-heroic, an inversion of Liberty

leading the people") is engaged in the very ordinary activity of peeling a lemon. Her back is turned to a landscape made of myriads of miniature battles scenes with soldiers, warriors, horses, and flags—all overpainted photostats of illustrations from history books of battle scenes establishing white colonial dominance over the black indigenous peoples of South Africa. The objects on which the woman is seated, and which the monument is constructed, is the debris left behind by the process of colonization—a stretched canvas, a skull, models of a pregnant womb and a broken heart, a little handbag, ornamental fittings, an open book, and two views of a bust of a black man. Siopis quotes Walter Benjamin, "the angel of history. (Her) face is turned towards the past. Where we perceive a chain of events, she sees one single catastrophe which keeps piling wreckage upon wreckage...."[4]

The willful self-destruction of apartheid was also the theme of Brett Murray's work. Graduating from Michaelis in Cape Town in 1989, Murray produced a series of painted resin sculptures—a manic butcher with a slashing knife in each hand, who has contrived to amputate both his legs; a policeman with an unformed baby face but a truncheon and huge jack boots. "My intentions were fundamentally political," says Murray. "In the '80s, satirical targets

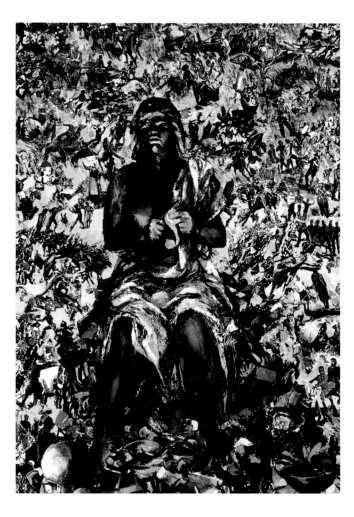

Fig. 2
Patience on A Monument -
"A History Painting" (detail).
By Penny Siopis, 1988.
Oil paint and collage,
200 x 180 cm.
William Humphries Art Gallery,
Kimberley.

presented themselves—there was a strong line between wrong and right, good and bad. I took aim at the military, at abuses of power, the system. I wanted to shift people's minds. I still do."

Murray is an artist working within the parameters of frank criticism espoused by Dorfman. "My intentions haven't changed. I want to reflect on what is happening in South Africa. There are still abuses of power—all those endemic problems that come with bad government—I'll always throw stones at that."[5]

In the mid '90s, Murray picked up a blowtorch and started making drawings in steel, combining this material with colored Perspex, or coins, or plastic to make iconic images with strange cross-cultural references which often seemed to skirt dangerously close to being politically incorrect: a Zulu warrior with a yellow smiley face; a black Richie Rich figure, clutching a bag of dollars; Colonel Sanders of Kentucky Fried Chicken fame with an Afro hairstyle—work that earned the artist a critic's epithet of the "dark prince of pop." "I'm fascinated by it—the language of communication and all the media ephemera that comes with it," said Murray. "I like it, I use it—but I invert it. I take the piss out of the popular."[6] This work appeared in an exhibition entitled "White Boy Sings the Blues" at the Rembrandt van Rijn Gallery, Market Theatre complex, Johannesburg.

"One needs a wry wit and a healthy dose of skepticism in order to mediate Murray's vision," commented critic Ashraf Jamal in 1996. "In South Africa today such traits are necessary for survival. South Africa is being parasited at every turn—dazzled by foreign investment, inundated by consumerism. Murray points to this neocolonial threat."[7]

But Murray, the arch-parodist, has in the past two years allowed himself to reflect more closely on his own corner of history. In 1997, he was one of nine artists invited to make work for the booths of the Visitors' Block on Robben Island, the site of Nelson Mandela's and other political prisoners' incarceration under the Nationalist government and situated a half-hour ferry ride from Cape Town harbor. On Robben Island, prisoners were brought to the Visitors' Block for a thirty-minute visit once a month. Prisoner and visitor would be seated on either side of a small grimy window, each trying to make his or her voice heard above the din. Referring to that traumatic experience, the artists called their show "Thirty Minutes." Robben Island is an icon of the South African struggle against apartheid and regarded by millions with veneration. For artists to create work in such an emotionally heavy space was no easy task. Typically, Murray took a risk by making a piece of art regarded by many as white self-indulgence, but by others as honest and even approaching brilliance. Visitors to Murray's booth gazed through the glass at an arrangement of photographs of his family. The piece was entitled *Guilt and Innocence, 1962-1990, the Rivonia Years*. "I was born in December 1961, a few months before the Rivonia trialists were imprisoned. . . ," reads Murray's catalogue statement. "I am a white, middle-class cultural hybrid. This was and is my comfortable and uncomfortable inheritance. The political and social forces beyond the confines of my family formed a system that protected and infringed on me, empowered and disempowered me, promoted and denied me. When I looked beyond my private experiences of loves and relationships, family and friends and of boy becoming man, the contradictions in this system, which divided my life from others, resulted in a cross-questioning of responsibility and complicity."

Fig. 3
White Boy Sings the Blues.
By Brett Murray, 1996. Wood, metal, and plastic, 57 x 44 cm.

Fig. 4
Black Like Me.
By Brett Murray, 1996. Wood, perspex, coins, 140 x 90 cm.

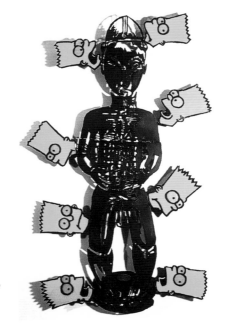

Fig. 5
Africa. By Brett Murray, 1993.
Metal and plastic,
229 x 130 x 10 cm.

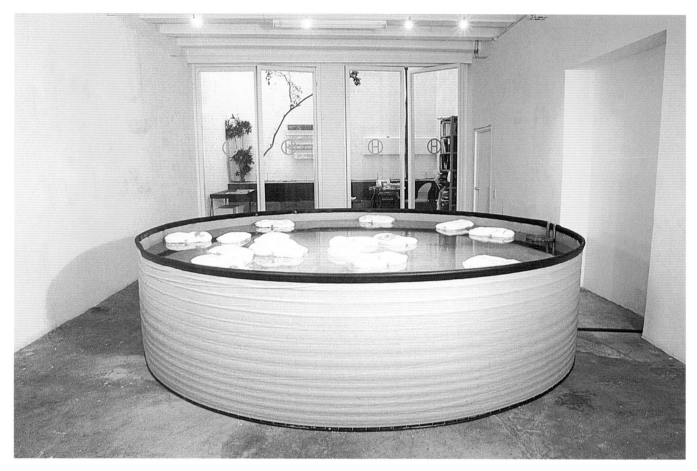

Fig. 6. *Bridget Baker - B.A.F.A.(Stell.), B.A. Hons(FA)(Stell.), M.F.A.(UCT) cand.* (Detail). By Bridget Ann Baker, 1996-7. Installation: Porta pool (2.74 diameter and 80 cm deep), 17 kickboards (35 x 15 x 3 cm each), plastic, valves, cotton, polystyrene balls. Photographed by Ulrich Wolff.

A more personal, autobiographical bias has also become apparent in the work of Siopis. The freedom to look more closely at one's own reality instead of feeling compelled by circumstance to take a broad view is the window that a more equitable situation in the country has opened. "I explore ideas of history and memory as a presentation of 'self,'" comments Siopis on the work presented in *Liberated Voices* and adding, "I am trying to understand more fully what it might mean to be an African of European descent." Looking back at her "history paintings," the emphasis has changed, but elements remain: the notion of wreckage, of detritus, of objects that once had personal significance for the owner but have either been forcibly removed or, through circumstance, abandoned, is one which persists in Siopis's work. The painted mound of objects from *Patience on a Monument* has metamorphosed into real objects that Siopis has collected over the years, and now presents as signifiers for her own cultural history: "I am interested in how lived experience is embedded in objects.... I see them as traces of bodies and lives."[8]

Both Siopis and Murray come from a generation of artists making mature work at a time when the reign of the Nationalist government seemed absolute, and the end of apartheid was not in sight. Claudette Schreuders and Bridget Baker graduated from art school after 1994—members of the generation who some have called the "post-apartheid kids." The liberty of making work that is a personal investigation into identity, which this generation takes for granted, is seen not as a liberty at all but as a given. In Schreuders's and Baker's work, the search for identity—the processing of personal problems through artmaking and performance—is a common theme even though their approaches and practice vary widely.

Schreuders's work is inspired by the carved and often painted wooden Colon figures of West Africa. In a paper prepared for a 1995 seminar, she wrote, "The Colon figure falls under the category of stranger or outsider," and she then quotes M. H. Cole, "Strangers in any society are anomalous. Sufficiently inside to be identified, to affect

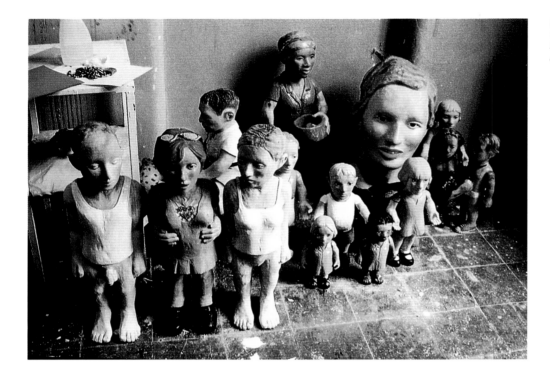

Fig. 7
Exhibition invitation of Claudette Schreuders' work showing some of her statues in her studio.

and be affected by the host culture, they are identified nevertheless as outsiders who are to some degree alien."[9]

Schreuders has said, "My own preoccupation with the Colon figures of West Africa lies less in wishing to align myself with the meaning and significance of these artistic objects than in their status as strangers or 'ambiguous aliens,'" talking of the "precarious situation" in which she has found herself as an Afrikaan-speaking, white South African. Schreuders quotes black writer Bessie Head in *An African Story* (1972), "South Africa made white people rich and comfortable, but their ownership of the land is ugly and repellent. They talk about South Africa in tourist language all the time. 'This grand and sunny land,' they say."

In practice, Schreuders bases her sculptures on specific people, then situates them within an appropriate frame of reference, working in creamy jacaranda wood cut to size and delivered by the Pretoria municipality. *Ma–Trix*, for instance, is based on Schreuders's mother, a housewife with something of a Virgin Mary hand-over-heart stance. The piece also represents the misguided innocence of the colonial idea of "bringing cleanliness and light and civilization to Africa. I make a type as well as a portrait to avoid sentimentality." Schreuders labors long over her pieces, and has produced thirteen in four years, her hand and eye growing ever more confident and authoritative. The stance of the figures, "the strangers" may imbue uneasiness, but the stockiness of the bodies with their foreshortened legs and large feet seems to suggest a rootedness and determination, a strength of which they may themselves be unaware.

Like Schreuders, Baker comes from a conservative white background and studied art at the University of Stellenbosch—an academic choice made by Baker's mother and stepfather, who would not allow her to go to the University of Cape Town, because they considered it to be "Moscow on the hill." Baker has described her cocooned childhood in the midst of this Eastern Cape, English-speaking, fundamental Christian family shielded from an awareness of the true political situation in the country as "monstrously idyllic." Christian values and Christian codes were espoused. Again, like Schreuders, Baker's work is an attempt to come to grips with her closeted upbringing.

Most of Baker's pieces incorporate extensive handwork—embroidery, or knitting. "This is not a feminist statement," says Baker. "My use of embroidery is connected to the way I think—I ponder over issues in my life while I'm busy with my hands. I like the tactile qualities of my materials and it's challenging to find new ways to use this medium."[10]

Bridget Baker—B.A.F.A. (Stell.), B.A. Hons (FA) (Stell.), M.F.A. (UCT) cand. (1996-7) is a portable swimming pool on which a number of "belly boards," inflatable swimming aids for children, are floating. On each of these, Baker has painstakingly hand-embroidered the replica of one of the certificates awarded to her over the years—for scripture camp, good behavior at school, dancing class—thus representing a skill or achievement designed to equip Baker to face life. But inflatables are all too easily punctured, a false and dangerous means of support. The metaphor is clear. Baker's piece is conceptually and formally inspired.

"The way I look at my work is always changing," says Baker, "but mostly it's to make sense of my life now. I think I wouldn't need to make work if I didn't have the past that I have. I constantly can't understand why I was brought up the way I was—a very constricted, one-dimensional way of looking at life. Regarding political matters, I feel like an irresponsible citizen, so I keep on locating myself in what I know and what I understand."

Stitch, 1999, germinated from a letter written by an ex-boyfriend asking Baker not to run from him, and exhorting her not to run away from her problems. Reflecting on the letter, Baker decided to explore ideas on running, and the subject became the theme of this two projector piece. On the left screen in slow motion is a close-up of Baker's face rising and falling gently and filmed while she runs, unaware of and looking away from the marathon of energetic but anonymous runners dashing towards her on the other screen. Our view is interrupted by reflective running belts handstitched with biblical quotes and extracts from letters to Baker which include the words "run" or "running." The smell of Mentholatum, a salve used to massage tired muscles, fills the air. Baker takes the distance she needs to deal with life.

The strength of Baker's work lies in the cool and visually poetic way that she uses what she knows and understands, and in the clarity of the gaze she turns upon herself. Her past circumstances may be specific, but we are all struggling to overcome past problems while at the same time drawing on that same past to achieve balance and wholeness in a difficult world. Baker's pieces can be read as a universal reflection of those efforts, working as she does from the personal to the general.

Artists make art because they must. It is the way they process their daily life and attempt to make sense of their experiences. Perhaps in a country like South Africa with its bitter past and challenging, uncertain present, daily life and past experiences offer more raw material for artists to work with than in more settled countries. One might add to this equation the freedom democracy has brought for honest and searching reflection, the national obsession with the idea of reconciliation, and the real gift of the possibility of reinvention and starting a fresh page. The interest and encouragement shown by the rest of the world towards South Africa has played its part, too. These, I believe, are the factors that have made art in South Africa what it is today. Whatever that may be.

1. *Sunday Independent*, 21 December 1997.

2. Sandile Dikeni, "Winnie Cracked—The Rest Is All Dialectic," *Cape Times*, 1 December 1997 (Cape Town). See also Jon Qwelane, "Lynching Winnie: It's A Rush To Judgement," *Cape Argus*, 29 November 1997.

3. *Cape Times*, 2 July 1997 (Cape Town).

4. See Helga Geyer-Ryan, "Counterfactual Artefacts: Walter Benjamin's Philosophy of History," in *Visions and Blueprints*, Edward Timms & Peter Collier, eds. (Manchester: Manchester University Press).

5. Unpublished interview with the author, January 1999.

6. Sue Williamson and Ashraf Jamal, *Art in South Africa: The Future Present* (Cape Town: David Philip Publishers, 1996).

7. Ibid.

8. Unpublished notes by Penny Siopis on *Sacrifices*, July 1998.

9. Herbert M. Cole, *Icons: Ideals and Power in the Art of Africa*. Washington, D. C. and London: Smithsonian Institution Press, 1989.

10. Unpublished interview with the writer for this essay, February 1999.

This triptych is a portrait of the three security policemen who 'interrogated' (Stopforth's quotes) his friend Steve Biko. The portraits, which hang one above the other, stare back at the viewer. The cool grayness of the piece is suitable for the subject. Stopforth says about this piece: "My purpose was to show how terribly ordinary these men looked – except perhaps the one with dark glasses (Colonel Harold Snyman). The shadow of the chair is a reference to the 'struggle' that was supposed to have taken place while Steve was in their custody. The most mundane objects can take on frightening connotations in prisons and interrogation spaces." (Williamson 1989:112).

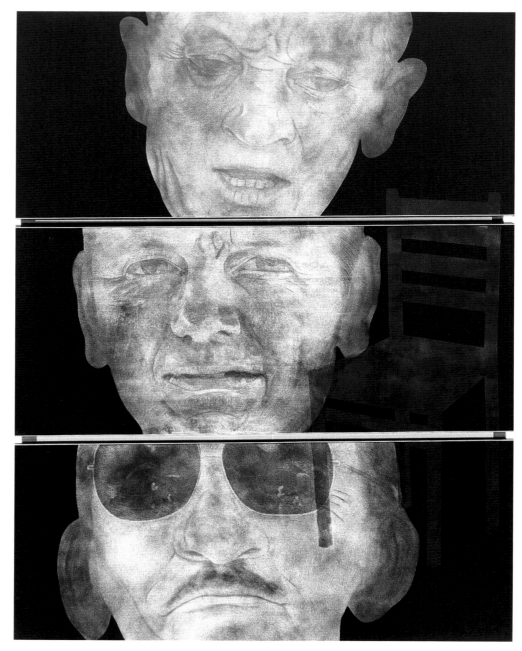

CAT. 4
The Interrogators. By Paul Stopforth, 1979. Graphite and wax on board. 180 x 99 cm. South African National Gallery, Cape Town.

Beyond the Trauma: The Transition of the Resistance Aesthetic in Contemporary South African Art

Mark D'Amato

As this is being written, South Africa has held its second national election after the end of apartheid. The question still being asked is how the country will finally move beyond apartheid, whose cruel legacy was vividly documented in the recently released report by the Truth and Reconciliation Commission. While concerns about the country's political and social transition are evident, South Africa's artistic development is also being viewed through the lens of its reaction to this terrible time. Current critical commentary highlights the new opportunities offered to South African contemporary artists, seen recently in the 1997 South African Biennale, "Trade Routes: History and Geography," which placed this art firmly within the complex of the political, social, cultural, and economic forces of this postmodern age. Such analyses are certainly worthwhile, but a review of how South African contemporary art reached the point at which it now stands is also useful.

Specifically, this essay will analyze some of the literature presented by artists, art historians, and critics who are seeking to reveal the tendencies of this art as it moves beyond the trauma of apartheid. It will identify how this critical discourse developed and changed through the concept of a "resistance aesthetic"—briefly stated, a concept involving artists who take an active role, through a critical discourse, to effect change—be it political and social or aesthetic and cultural—in the status quo.[1] The essay will begin by examining the consequences of apartheid on contemporary artistic production, the reaction to contemporary art after apartheid, and the transition of

this critical discourse as the art of South Africa becomes accepted within global contemporary-art discourses.

Trauma

Any discussion of contemporary South African art must acknowledge the importance of apartheid in the emerging cultural expressions, the most prominent of which is "resistance art." A notable early work on this subject is Sue Williamson's 1990 book *Resistance Art in South Africa*, which identified, through general headings including "Roots of the Conflict," "A Mutant Society," "Exploitation," and "Confrontation and Resistance," the content and means by which both white and black artists were fighting that repressive regime.

The events that led to this artistic reaction were the Soweto Riots of June 1976 (Williamson 1990:8). The riots began as a march led by young black schoolchildren protesting the government's imposition of the language of Afrikaans as the medium of instruction in the schools. They turned tragic with a ruthless government response to this march, shocking the country and ultimately the rest of the world. The riots led many South Africans, black and white, out of apathy and into direct political action. But during the late 1970s, government repression of political organizations effectively limited their activities. The Black Consciousness Movement, including organizations such as the South African Students' Organization (SASO) and the Black People's Convention (BPO), which had focused on the

shared heritage of black South Africans and had mobilized them into a powerful social, political, and cultural force (see Pityana et al. 1990), suffered a terrible blow with the death of BCM leader Steve Biko in prison in 1977.

Describing how artists of her generation responded to the Soweto Riots and the ensuing repression, Williamson distinguishes their work from an "elitist activity" by identifying its vital role in the cultural resistance movement. Before the emergence of resistance art in the mid-1970s, she argues, art betrayed very little evidence of the country's social and political problems. For Williamson, the resistance aesthetic means a socially conscious art with a definite political role, as opposed to an art divorced from reality—landscape, abstraction, figure studies, and "township art."[2] The growing importance of culture in the resistance movement is demonstrated by two conferences held in the late 1970s and early 1980s: "The State of Art in South Africa" (1979), in Cape Town, and "Art toward Social Development and Change in South Africa" (1982), in Botswana. These conferences encouraged artists, or "cultural workers," to be active in their communities, and concluded that cultural resistance was a tool of immense political power (Williamson 1990:9).

The broadness of Williamson's definition of resistance art is revealed by the works she discusses, ranging from John Muafangejo's historical linocut *The Battle of Rorke's Drift* (1981) to Jeremy Wafer's minimalist drawing *Air Conditioner* (1988). Further examples include the "peace parks," as well as murals, posters, T-shirts, and graffiti with a direct political message. Williamson also describes resistance art as a natural development out of traditional African art, which makes it a governing principle to support the proper functioning of the community (1990:9). It was Williamson's book that really established the discourse on resistance art.

Opening Up the Discourse
In 1988, the prominent Johannesburg Art Gallery mounted the first large-scale show of work by black artists, "The Neglected Tradition: Towards a New History of South African Art (1930–1988)." Curated by artist and teacher Steven Sack, who was also a community activist, the exhibition addressed the underrepresentation of black art in South African art institutions, and attempted to revise the canon. In this light it was a political act of resistance against the segregationist policy of the country's art institutions.

The catalogue of "The Neglected Tradition" remains a valuable resource for a "more balanced and comprehensive" South African art history (Sack 1988:7). By acknowledging the "complexity" and "cultural interchange" involved throughout black South African art history, Sack provides valuable insights into the development of the different art forms produced both in the rural areas and among the "newly

educated elites" of the cities who were exploring "Western" approaches to art. He examines the role of founding institutions such as the Polly Street Art Centre, Johannesburg, during the 1950s; the Evangelical Lutheran Church Art and Craft Center at Rorke's Drift, Natal, established in 1962; the Alexandra Art Center, Marlborough, Sandton; the FUNDA Center, Soweto; the Mofolo Art Center, Soweto; and the Johannesburg Art Foundation, among others. He also discusses a "township style" in the work of artists such as Durant Sihlali; a "neo-African style," synthesizing "Western" and African figurative traditions, produced by Sydney Kumalo and Dumile Feni; and the art influenced by the Black Consciousness Movement, which incorporated an increased awareness of the sociopolitical situation.

The important question for black artists during the 1970s was how to refashion the role of the artist in terms of social responsibility and accountability, and how to overcome alienation from their community (Sack 1988:18). A conference in Cape Town in 1979, "The State of Art in South Africa," had been significant, Sack writes, in challenging state arts policy by calling for increased educational opportunities for all artists and a boycott of all state-sponsored exhibitions (ibid.:24). This intervention had signaled the promotion of art to the political arena, and the advent of a vision of all exhibitions and educational institutions in relation to the political forces behind them (ibid.). This politicization of art coincided with changes not only in the art market but in the media and imagery of art, and in the opportunities for formal training in community art centers and university art departments (ibid.:24–25).[3] This expansion of educational opportunities included a shift in the control of resources and planning to black artists, educators, and administrators (ibid.:25). When two types of art—fine art and community art—were being produced, the issue of accountability became important in the artistic community, and along with it the question, To whom does the work belong—the individual or society? (ibid.: 25–26). In presenting all these issues, "The Neglected Tradition" reflected an important resistance effort to construct a new history of South African contemporary art based on an expanded canon. The exhibition also sparked a debate on the possibilities for a postapartheid art.

The End of Trauma?
Though resistance art was produced in support of the fight against apartheid, it sustained a challenge from the political party that symbolized that resistance—the African National Congress (ANC).[4] The resulting debate was highlighted in the exhibition "Art from South Africa," held at the Museum of Modern Art, Oxford, England, in 1990. The goal set forth by David Elliot, one of the show's curators, was to discern, from the varied art produced by South African culture, some order or pattern from which to understand South African society (1990:6). The show took place at a pivotal time—the same year in which Nelson Mandela was released from prison and the ban was lifted from the ANC.

"Art from South Africa" provides a window on the debate about South African art's postapartheid future. As Elliot points out, this is a country in which "history is literally being made," and in which the past must be reconfigured for the needs of the present and the future (1990:6). A key element in the debate has been the language and structure of the ANC, which was originally formed as a revolutionary organization to fight apartheid, and adhered to a "straightforward Leninist prescription of art as a weapon of struggle" (ibid.:7). This prescription of a "proletarian culture," however, became an "instrument of oppression, rather than liberation," because ANC sponsorship of cultural events, both inside and outside the country, made for a "people's culture" that was as onerous as the state-sponsored apartheid culture (ibid.). Albie Sachs's 1989 paper "Preparing Ourselves for Freedom," in the catalogue for the Oxford exhibition, explored the limitations of interpreting art as strictly a political weapon, and thereby provided the catalyst for a more open and inclusive discussion of the future direction of South African art (1990:10–15).

Sachs, an ANC constitutional advisor and member of the National Council, originally prepared his paper for an in-house seminar on culture in 1989. In February 1990, however, it was excerpted in the Johannesburg *Weekly Mail*, and drew a variety of responses, some of which also appear as essays in the Oxford catalogue. Just as the ANC was preparing new constitutional guidelines for postapartheid South Africa, Sachs argues, it also had to create a new artistic and cultural vision (1990:10). The conception of culture as only a weapon of the struggle was too narrow, and impoverished South African art by limiting its themes and leaving out any "ambiguity and contradiction" (ibid.). The power of art resided in its ability to "express humanity in all its forms, including our sense of fun and capacity for love and tenderness and our appreciation of the beauty of the world" (ibid.:11). If South African art remained focused solely on the oppression and trauma of apartheid, it would impoverish the struggle itself (ibid.). By going beyond apartheid and establishing their own contents and forms, artists would express the "new consciousness" developing in the country (ibid.). This would lead to the creation of a "culture of liberation" representing all of the nation's communities (ibid.).[5]

Sachs's proposal to expand artistic content was addressed by two members of cultural organizations. Frank Meintjies, an executive member of the Congress of South African Writers, proposed to enlarge the definition of the "culture of resistance" beyond just the ability to "rouse and embolden the oppressed" by forming a "new language" to promote life and celebrate democracy-building based on the creative energy at the grassroots level (1990:17). Phil Molefe, the interim cultural desk chief for the United Democratic Front (UDF), argued that although it was essential for culture to be a weapon of the struggle, that culture could be "alternative, truly non-racial," and could express the "whole

range of human emotions and experience" (1990:21). The establishment of such a broad-based culture was one of the best ways a cultural worker could fight apartheid (ibid.). The challenge for cultural workers, in fact, was to contribute to a discussion and theory of culture that would "help us understand what a nonracial culture could be, and how to address the imbalances to cultural expression brought about [by] apartheid" (ibid.). Maintaining the notion of the resistance aesthetic in its strict revolutionary sense, Molefe did continue to insist on the importance of the conclusions of the 1987 conference "Culture for Another South Africa"—that the struggle came before one's role as a cultural worker (ibid.). Yet both respondents allowed for more varied aesthetic expressions, with Meintjies even calling for a new language to discuss this new art.

The same catalogue contains essays by two South African artists addressing this new aesthetic expression. Kendell Geers suggests that the method of resistance should expand to include not only a political posture but an aesthetic one, which he calls "motivated criticism" (1990:23). This "avant-garde" resistance art would take on apartheid and art itself, critically reexamining itself and continually readjusting its strategies in a way both revolutionary and subversive (ibid.:24). Ultimately, all art was political if it "challenge[d] the ideological and cultural prejudices of both the viewer and the artist," including the ideologies of "social structures like race, sex, culture, class, etc." (ibid.). By following this course, South African contemporary artists could reexamine both First and Third World art traditions to create a "uniquely African avant-garde" (ibid.). Building on this argument, Gavin Younge questioned whether the notion that there was only one national art form could assure the future role of South African art in the international arena (Younge 1990:25). For him, South African artists had to create an art inclusive of international contemporary issues yet characteristic of South African experience and tradition, both of which had an affirmative role as a "catalyst of revolution" (ibid.: 25–26).

Also in the same catalogue, artist and art historian Colin Richards investigated the "artistic language about the development of South African contemporary art" (1990:35). This language, he argued, involved a notion of "transitional art" that initially referred to a shift between traditional and modern art forms but soon came to encompass factors related to shifting socioeconomic and patronage relations (1990:36). In the 1970s, South Africans had attempted to form a "national cultural identity" in response to the oppression of apartheid. This attempt had led white artists to a search for an "authentic African image"; black artists, meanwhile, were "effectively absent" from the scene (ibid.:36–37). This absence, though exhibitions such as "The Neglected Tradition" had begun to address it, was exacerbated by critics who referred to the work produced by the Polly Street artists as an "inauthentic Africanesque

art," and who saw township art as trivial (ibid.). The "establishment," which had dictated the terms of the critical discourse about "black art," had created the concept of "transitional art" to encompass the shifting contemporary and African influences in South African art (ibid.:37–38).[6] The question was whether the term had been constructed to limit the discourse about and the canon of South African contemporary art (ibid.:38).

To be useful, transitional art had to acknowledge the roles of "acculturation" and "cultural pluralism" (ibid.). One had to recognize that cultural contacts were not new, and that they had usually involved force (ibid.:39).[7] Second, pluralism could not rely solely on the idea of "unity in diversity" without acknowledging the "forces of domination," or the "vocabulary of state power," in South Africa's "nonplural present" (ibid.). Richards concluded that the discourse on transitional art was emblematic of discussions of contemporary African art, in which a "minority visual art world" had acquired a false "diversity and pluralism" without achieving any real "structural or ideological adjustments" or confronting the cultural conditions of urban and rural black communities (ibid.:40).

The Transition Beyond

A number of writers have addressed this discourse about the future of South African contemporary art, providing some ideas for how artistic production can move beyond political concerns as it incorporates the postapartheid experience.

Richards begins his 1991 essay "About Face: Aspects of Art, History, and Identity in South African Visual Culture" by linking what he calls the "apartheid gaze" with "western ocularcentrism," both notions being concerned with the regulation of meaning through "classism, sexism and ethnic prejudice" (1991:101). By equating apartheid and "Western" critical discourses generally, Richards shifts the focus of the "culture of resistance" from the local to the global context. No longer limited to local "strategies of boycott and confrontation," it now involves a "critical engagement" leading to the conditions for creativity (ibid.:103). Supporting Sachs's call for "more cultural openness and critical introspection," Richards asserts the importance of nationalism in creating "identity," which he defines as an effort to construct or reconstruct the self, and sees reflected in South African "nation-building" efforts (ibid.). This kind of nationalism also reclaims the individual's history. The present site of the struggle, then, is the person who can construct, or reconstruct, the South African cultural identity (ibid.:104).

Many "voices" are involved in this struggle. For Richards, images are not only important expressions in themselves, but serve as a resource for historiography.[8] South African artists must therefore play a role in reconstructing history after apartheid. Richards points to the 1987 conference

"Culture for Another South Africa," which he believes marked the "people's return to history," although he acknowledges that the struggle continues over who will define this history and identity (ibid.:108). He also asks what sort of "evaluative framework" will be needed to understand art produced by South Africans: should the work be judged as a "document," for its connotations of evidence and fact, or should it be approached for the purpose of "aesthetic contemplation" (ibid.:111)

In the 1980s, conferences were held both inside and outside South Africa in an attempt to support the liberation struggle by revising the relationship between history and visual culture. Here the notion of resistance to the forces of apartheid shifted to include a cultural struggle for the control over representations of South African history and identity. Many national cultural activities and events, Richards writes, were "motivated by the need to achieve something 'truly' South African" (ibid.:119). If the "apartheid gaze" placed the notion of identity "beyond context and history" for South Africans, the challenge for South African artists and cultural workers then becomes to "uncover history and recover traditions" (ibid.:130). The major challenges facing South African artists and cultural workers, Richards concludes, are "resisting co-option, risking legitimizing exclusive cultural events parading as inclusive, while challenging and reappropriating existing cultural forums and resources to advance democratic, free culture" (ibid.:124).

Whereas Richards explores the importance of reestablishing control over South African history and identity, Pitika Ntuli, in his response to Sachs, deals with the power of culture and the artist's role in this new struggle. Addressing the new postapartheid opportunities, Ntuli calls for a "new language," like Frank Meintjies, and a "self-criticality," like Kendell Geers. Seeing Sachs's definition of culture as inadequate, he offers another that would include "all material and immaterial works of art and science, knowledge of manners, modes of behavior and thought accumulated by a people both 'through and by virtue of their struggle for freedom from the hold and domination of nature'" (1993:71). Within such a definition, culture "is and always will be a weapon of struggle," for it expresses the "dialectical relation of domination and power" (ibid.). The struggle is a "process of adjusting, rearranging and engaging the forces that militate against a natural flow of life" (ibid.). Ntuli contends that artists, as part of this environment, are "constantly involved in the challenging and refinement of methodological attitudes towards culture, society and towards their own art" (ibid.).

In that art serves social needs, it resembles politics, and so must challenge its own "conceptual tools" (ibid.:72). Agreeing with Richards about the importance of constructing history and identity, Ntuli warns that the postapartheid generation must wage a continuing struggle against the remnants of the "apartheid gaze." For Ntuli, this is possible only if action is guided by a new, "revolutionary" theory of

culture. Since art is inherently political, the artist can use cultural expressions to deal with issues of tradition and modernity. Aesthetic issues are related to individual or social concerns (ibid.:73–74). The artist is both a propagandist and an aesthete. In the context of liberation, the South African artist must act as "mobiliser, educator, recorder, and as 'ideology,'" since he or she has been conditioned "socially and historically … [the artist's] ideological position plays a crucial role" (ibid.:76).

The International Arena

In 1995, a year after Nelson Mandela became South Africa's president, the country's first biennial was held, titled "Africus: Johannesburg Biennale." This multinational exhibition concentrated on the search for identity through the "process of reconstruction and development through artistic interchange and exploration" (Till 1995:7). Using the themes of "volatile alliances" and "decolonizing our minds," "Africus" addressed concerns about the debut of South African contemporary art on the world stage, and its confrontation with the "debates, arguments and examples which characterize the nature of contemporary art" (ibid.). For Lorna Ferguson, one of the show's directors, the oppressive regime of apartheid, along with the resulting cultural boycott, had plunged the country's art into a "stifling seclusion" (1995:9). This isolation, however, in causing a "forced and necessary period of introspection of our own multiculturalism," ultimately acted as a "stimulus" for South African art (ibid.); and the Biennale was a "barometer" to measure these effects. The stated theme of "volatile alliances" focused on a "dialogue around cultural difference and identity," while that of "decolonizing our minds" showed "Africa as a focus," along with the "global repercussions of colonialism" (ibid.:10). This framework of placing South African contemporary art in "seclusion" from the world, it was thought, would now allow the exhibition's participants to determine the history and merit of South African art, and its importance for the world art community. This was evident in the Biennale's catalogue essays, including Rasheed Araeen's "What Is Post-Apartheid South Africa and Its Place in the World?," Bongi Dhlomo's "Emerging from the Margins," and Jean-Hubert Martin's "Art in a Multi-Ethnic Society."

In reaction to *Africus*, Gordon Metz, who presented a paper at an affiliated conference, sought to reinforce how South African contemporary art could take advantage of the "new climate of democracy." Metz called for South Africans to be "more honest and open, more critical, and more confident in our exchanges if we are to disengage from the past and embrace a new future" (1996:57). This came down to what he called "three essential components of representation": 1) how the political transformation of South Africa had affected "issues of representation and identity" concerning the artist's "creativity and aesthetics"; 2) the "role, responsibilities, and response to transformation, representation, and

identity" by cultural institutions; and 3) how "transformation, representation, and identity are reflected in the Biennale itself" (ibid.). Now that the country was past apartheid, what would the new cultural expression be, and what the new subject matter that artists would represent? Since the same cultural institutions had remained intact through the fall of apartheid, they would now have to grow sensitive to the complexities of new cultural representations and identities. They would have to do what was necessary to "reclaim what has been written out of history" (ibid.:58). Had the first Biennale addressed such "historical imbalances"? Though international exposure for South African art was important, and the international community's interest in South African art was obvious, the Biennale was "flawed" for not adequately representing South African art to the world (ibid.:58–59). Metz noted that South African art had not been absent from the world stage, being known throughout the "liberation struggle and the experience of exile." He suggested that the country's art was now being "diluted" by an "almost sycophantic engagement with the international community" (ibid.). For Metz, the guiding principle for South African artists was to take up the "national moral challenge" by "enabling people to take a collective responsibility for the future of our country" and create an art that promotes this "new morality" (ibid.:59).

"Don't Mess with Mister In-Between," an exhibition held in Lisbon in 1996, examined the resistance aesthetic from the point of view of asking how the protagonist and victim of apartheid should remember and repair the damage, and how the resulting conflict might fit within postmodern critical discourse. Ruth Rosengarten, the show's curator, stated in the catalogue that she was not interested in another "survey show" of South African art. Concerned lest "multiculturalism" become for the 1990s what "primitivism" had been to earlier decades, she had sought to put together an "issue-based" show of work by artists underlining the "notion of individuality within the context of certain overlapping experiences" (1996:5).

Rosengarten's critical discourse focused on what she called an "interstitial space" brought into being by the shift from apartheid to a postapartheid era. Instead of classifying the art in the exhibition into two distinct eras, she argued that the questions that were important to examine were those of how the new community, the new art, the new traditions, and the ensuing progress would be constituted. By eluding both an "apartheid" and a "postapartheid" framework, she tried to focus on the "organic relationship between social and political realities and visual culture" (ibid.:17). Rosengarten's analysis emphasized the "organic" nature of constructing the "present," the "most dynamic and prevalent sense that contemporary South African art engenders" (ibid.). She also argued for the relevance of postmodernist discourse, with its interest in the "multiplicity of ethnicities, cultures, identities, and narratives," to the discussion of South African art. While agreeing with Richards

that such concepts as "transitional," "acculturation," "unity in diversity," and "pluralism" were problematic, Rosengarten suggested that the notion of "multiplicity" was basic to any discussion of South African art. Through the lens of a "Western" discourse, she examined the "complexity and diversity" of the works in the exhibition, and the "affinities and dissonances between them" (ibid.:7).[9] She also noted that the previously "entrenched and categorical" positions on the relationship between aesthetics and politics, and the "separatism" imposed by apartheid, were reflected in contemporary discourses as the dialectics of "the indigenous and the global, or the traditional and the contemporary" (ibid.). This new discourse on South African art conceptualized it as existing only within notions of "ethnicity" or "identity." Was this the only site of critical discourse for South African visual expression?

Rosengarten also discussed the Truth and Reconciliation Commission, and its role in the "need to mourn and memorialize" (ibid.:17). Through acts of *anamnesis*, or "recalling to memory of things past," South Africans would be able to "invent" their future (ibid.). Rosengarten noted the similarity of this process to that of postwar German culture as it moved beyond Nazism. By engaging postmodern discourses, she suggested, the multiple "voices" found in South African contemporary art speak to their "readiness to confront the ambivalence and anxiety that signal the work of mourning and repair" (ibid.:21).

Conclusions

This paper ends where it began, by briefly discussing the second South African Biennale—"Trade Routes: History and Geography," held in 1997. This exhibition signaled the placement of South African contemporary art within the global discourse, and also revealed how the discourse of the resistance aesthetic had become part of its current critical acceptance.

Okwui Enwezor, the Biennale's director, used his catalogue introduction to make some observations on "living, working, and traveling in a restless world" (1997a:7). Observing that topics such as "death of the author," "the end of history," "postmodernism," and "postcolonialism" are "incomplete," Enwezor suggested that they nevertheless provided metaphors with which his Biennale would try to grapple. Globalization, he wrote, a "circulatory system of exchange and site of translation," was crucial to the current "evolving culture of the image," a culture in the process of reinvention. The contemporary artist had to be able to "map" this new world, to "pose durable questions" that would confront culture in the new globalized world. Contemporary artists, he believed, were performing the "highest levels" of investigation into the "philosophical, political, phenomenological and social processes of our time" (ibid.). "Trade Routes," then, would show how artists were addressing, "both explicitly and conceptually, new readings and renderings

of citizenship and nationality, nations and nationalism, exile, immigration, technology, the city, indeterminacy, hybridity, while exploring the tensions between the local and global" (ibid.:9). This conceptual framework could easily be equated with the resistance aesthetic of South African artists, who were dealing conceptually with the same issues as other contemporary artists. Enwezor stressed his point by noting that "Africa" does not exist as a "single nation"; it is actually a "complex space" with "transcultural" and "transnational" aspects that reflect the essence of globalization (ibid.:11).

As the preceding pages show, the discourse of the resistance aesthetic is an adaptable one. It began with a focus on politically oriented art, which Williamson discussed as a direct confrontation against the repression of apartheid. At the beginning of the 1990s, as the end of apartheid approached, scholars began to ask what visual culture would now become. Sachs, an ANC member, proposed the emergence of a visual culture reflecting a "new" South Africa. This led other artists and scholars to ask what to do with the "culture of the struggle"; and their answer, in a sense, was to make it a "struggle" for a new culture. Artists like Geers saw the "self-criticality" in art as both a political and an aesthetic struggle, while those like Meintjies called for a "new language" to discuss this new art.

This emphasis on language led scholars such as Richards to point out how some terms, including "transitional art," are unsuitable, and that true "pluralism" must acknowledge how cultures truly interact with each other. Richards argued that South Africans had to reclaim their "history" and "identity," and that art had an important role to play here. The process by which history and identity are constructed, or reconstructed, was the new site of the struggle. This debate also revealed how the discourse of the resistance aesthetic was shifting in the postapartheid era to focus on cultural concerns. For Ntuli, the construction of culture was a "revolutionary" process. So the artist, once a "cultural worker" in the struggle for freedom, was now recognized as a revolutionary shaping the political and aesthetic agenda for postapartheid visual culture.

The vibrancy of this discourse is increasingly revealed as South African contemporary art is becoming accepted onto the international stage in this postmodern era. As the South African artist sorts through the opportunities of postmodern discourses, with their focus on shifting identities, histories, and nations, the resistance aesthetic remains relevant in that it creates a place for these artists in the global art community while preserving their ability to effect change in their local visual culture.

1. The "resistance aesthetic" concept is not the only way to examine South African contemporary art, but it provides a useful framework that seems adaptable to discourses that give artists an active role in their environment. Other discourses on contemporary South African art include such notions as "space" and "landscape" as the site of critical engagement. See Koloane 1997:32–35.

2. Frances Verstraete's essay "Township Art: Context, Form and Meaning" (1989:152–71), however, not only demonstrates the acceptance of the term "township art" as a viable art-historical label, but makes the case that these representations of township life are subtle yet powerful social commentaries, not just picturesque depictions of life in an expressionist style.

3. While the rise of workshops and university training programs has broadened the educational base of black artists, some of these programs have been criticized for their "Western-style" approach to painting, and their lack of focus on figurative or politically committed art (Sack 1988:25). David Koloane calls this criticism a "discriminatory censure" based on the assumption that "artists from other race groups are [not] capable of transcending realistic expression" (1990:84).

4. Kenneth Grundy has discussed the extent to which the ANC and affiliated organizations, as well as other organizations not directly connected to it, effected the establishment of a cultural program both during and after apartheid (1996:1–24).

5. To achieve this change, Sachs proposed "guidelines for culture" that would build "national unity" and encourage a "common patriotism" while recognizing the "linguistic and cultural diversity of the country." He also proposed a "Bill of Rights" guaranteeing freedom of expression and political pluralism. His guidelines would similarly guarantee the right of the individual to make use of adult education and literacy programs, and of the media to access "all the cultural riches of our country and the world" (Sachs 1990:15).

6. Any analysis of contemporary African art must recognize it as a "product of a multicultural society rather than merely being experimentation with international models," and its exhibition of a "continued dialogue between tribal ritual and space age technology, between the 'primitive' and 'civilized'" (Richards 1990:39).

7. Richards deals more specifically with the issue of force in cultural contact in his essay for the 1997 South African Biennale (1997a:234–37).

8. Quoting Luli Callinicos's essay for the 1991 exhibition "Art and the Media," Richards makes the important point that in the "West" the emphasis on historiography is derived from the emphasis on the written word, other types of record being held unreliable. In the "non-West," on the other hand, history is based on oral or visual expression (Richards 1991:106).

9. Attempting to link South African and "Western" art histories, Rosengarten proposed a resemblance between the South African art of the 1970s and '80s and the New Objectivity style produced in the Weimar Germany of the 1920s, which focused its criticism through "subject matter, caricature, satire, or some form of realism rather than through a formal or conceptual reorganization within the work" (1996:13). She seemed to identify resistance art as a realist style, postapartheid art as more conceptual or abstract in nature. Regrettably, she did not pursue the consequences of this view.

CLAUDETTE SCHREUDERS

SANDILE ZULU

PAUL STOPFORTH

WILLIE BESTER

DAVID KOLOANE

CLAUDETTE SCHREUDERS

BRIDGET BAKER

MBONGENI RICHMAN BUTHELEZI

THABISO PHOKOMPE

ZWELETHU MTHETHWA

BRETT MURRAY

SAMSON MNISI

ISININI NOSON

PENELOPE SIOPIS

SUE WILLIAMSON

NOSWMAILLIM SON

SIPOIS

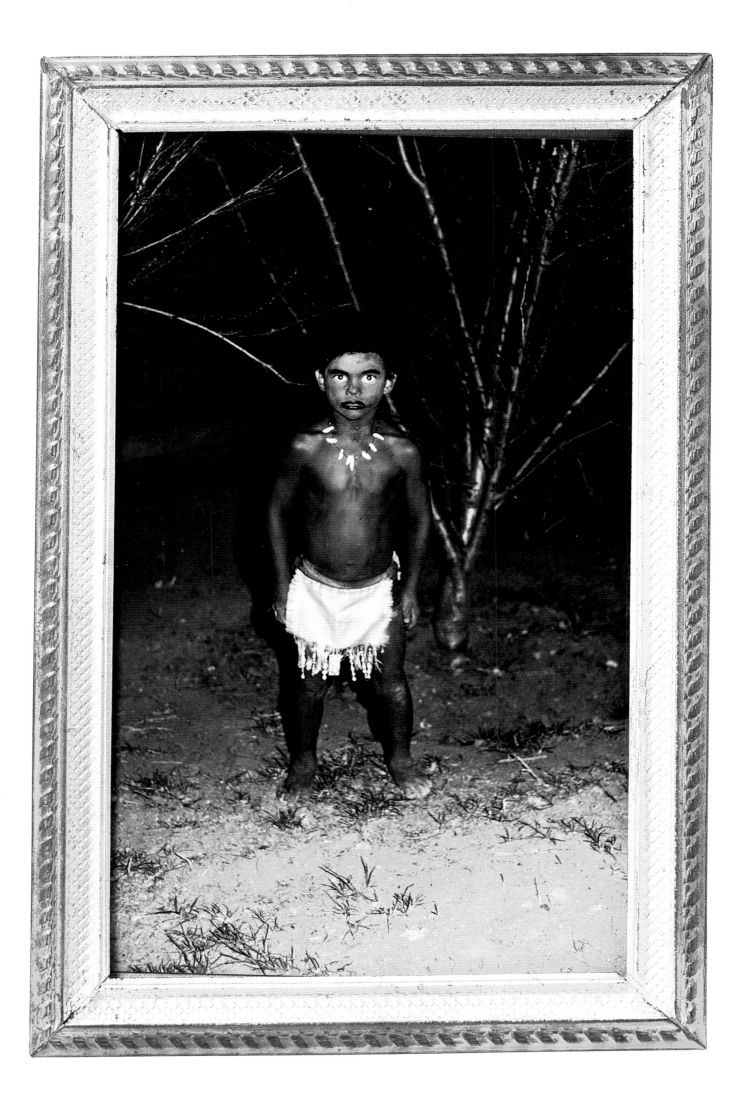

Brett Murray's Reconciliations

Ivor Powell

"I was born in December 1961, a few months before the Rivonia trialists were imprisoned. Being born in Pretoria, into a half-Afrikaans, half-English family, where my father's heritage extended back to include both Paul Kruger and Louis Botha (Boer presidents), disguised by my grandmother re-marrying a Scottish Murray, and my mother's history reaching back to the French Huguenots, I am a white, middle-class cultural hybrid. This was and is my comfortable and uncomfortable inheritance. The political and social forces beyond the confines of my family formed a system which protected and infringed on me, empowered and disempowered me, promoted and denied me. When I looked beyond my private experiences of loves and relationships, family and friends and of boy becoming man, the contradictions in this system, which divided my life from others, resulted in a cross-questioning of responsibility and complicity. This uncertainty challenged the understanding of what became ambiguous life experiences. The photographs document moments of my life within this context and date from 1962 to 1990, when most of the political prisoners were released from Robben Island."

(Brett Murray in the catalogue to the exhibition *Thirty Minutes,* Robben Island Museum 1997.)

In the 1980s, coming out of art school, Brett Murray made a series of sculptures that mapped out in part the aesthetic problematic that he has explored ever since. The works are stylistically based in caricature, and their subject matter reads in terms of an especially biting sense of the absurd.

One image has a manic butcher, brandishing knives, above the bloody stumps of his own legs, which he has just amputated. A soldier in another has sticks of dynamite protruding from his ears. In a third, a policeman, rendered as a child, wields a truncheon in an appropriately threatening way; yet he is standing inside boots that are far too large for him. Each of these works contains a kind of metonymy that operates on a self-debunking level. The part that stands for the whole is turned in on itself, used in such a way as to make a nonsense of the figure's function or identity. Thus the butcher butchers himself; the soldier threatens his own life and limb, not that of the enemy; the figure of authority that is the policeman is rendered in such a way as to negate and parody his own sense of that authority as something on loan from somebody else. Note here the roots of the word "authority," as in "author," suggesting something that is peculiar to the one who possesses it.

As for the figures themselves, Murray emphasizes their rotundity and oddly childlike quality. Something in them—maybe the bland inexpressiveness of the line—is reminiscent of a bygone era of cartooning. The Little King cartoons and the drawings in the Babar the Elephant books are examples that spring to mind; but Murray's images are the Little King or Babar from hell. They have a far harder and more uncompromising kind of edge. The figures share a manic, sometimes almost demonic quality. Their expressions are blank and wildly fixated at the same time; the way they have been represented makes them less than human. Yet of course at the same time this fixated quality is used to comment on a human condition.

CAT. 5
Guilt and Innocence 1960-90 (detail). By Brett Murray, 1998. Installation of 130 framed photographs. 76 x 914 cm. overall length.

Brett Murray

Fig. 8
Butcher.
By Brett Murray, 1988.
Cast resin and wood.
40 x 40 x 65 cm.

In all this—the preposterousness of the figures, and the exaggerated quality by which the work effects communication—these images stand in the Western traditions of caricature and satire. Familiarly, something that resonates in lived experience is taken beyond the limits of the way it would be experienced in real life, in order to highlight its absurdity. But at the same time, it should be noted, this is not the kind of satire that seizes upon the individual, the quirky, and the deformed, exaggerating those qualities in the service of the absurd or the grotesque. Instead, Murray appears to be hooking into older traditions of commentary in which the subject or message is expressed less through observation than through ideation. Such images render the human form as the vehicle for a kind of *idée fixe*.

Murray, however, does not embed the passion, the folly, or the vice in the figure or its expressions. He is not concerned to find the individual traceries or signification of madness, possession, passion, or whatever inside the vicissitudes of the human figure. His figures are more or less interchangeable; all are conceived according to a sustained and consistent formula. By implication, they do not carry in their expressions or their form any traceries of time or of experience. The mode in which Murray is working is not of such an order as to explore the ways in which experience and idiosyncracy etches itself into the human clay.

One might take this a step farther: the conception of the human subject in this series is not of a specifically humanist order. Murray has little interest here in exploring the feelings, emotions, or experience of the figures as the subjects of that experience. Instead they are being used as tokens to communicate the play of other, and superhuman, forces. The figures, one might say, are being used in a way that has more to do with medieval conceptions of the position of the human in the cosmic scheme of things than it does with the Cartesian universe.

This thought should not be taken too far. Certainly the work does rest on a sense of the world in which forces play themselves out through human action, and in which there is an underlying moral order (to be measured through disturbances of that order in the madnesses that possess Murray's figures), but to note this is not to invoke a sense of any theologically absolute kind of universe, as medieval art forms do. Instead, the superhuman dimension that is being explored in the series is of a historical order.

Another image in the series has a pair of Voortrekkers (the founding fathers of the Afrikaner people) clothed in somber and muted nineteenth-century dress, the man in a top hat and tails, the woman buttoned to the throat and ankle, her modesty further guaranteed by the bonnet that covers her head. The couple are the very archetypes of the stern, glum, and god-fearing puritanism that was passed down to the youth of white South Africa, in part as role model, in part as a justification of white supremacy. Only these two are frolicking. The man—and the "doggy-style" sexual metaphor is difficult to miss, though not overtly explored—is caught leapfrogging over the woman, his puritanical reserve lost in a moment of utter abandon, his patriarchal authority shattered in childish behavior. Likewise the moral mother is reduced in submission (she is the "frog" over which the patriarch leaps) and discomposure. Though fully and excessively clothed, they are caught *in flagrante*, so to speak, with their pants down. And so is the mythmaking process that they represent.

Fig. 9
Policeman.
By Brett Murray, 1988.
Cast resin. 40 x 40 x 70 cm.

In a number of the other works in the series, it is a more contemporary kind of history that is being explored. The cops and soldiers that Murray parodies were an insistent part of life in the police state that was South Africa in the troubled 1970s and '80s, when there was virtual war in the townships and a crushing campaign of attrition against the forces of democracy— with which Murray was unambiguously aligned. As stereotypes, then, the personnel of the apartheid security forces were highly charged with fear and loathing—probably with the emphasis on the fear. Perhaps more than anything else in the symbolism of South African

CAT. 5
Guilt and Innocence 1960-90 (detail).
By Brett Murray, 1998.

CAT. 5
Guilt and Innocence 1960-90 (detail).
By Brett Murray, 1998.

society at the time, the security forces were the symbols of apartheid authority. So by debunking and parodying those symbols, both in their the historical and their contemporary forms, Murray was making a highly political kind of intervention in the semantics of the society—at a time when those symbols were in jeopardy and at stake. He was engaging in a struggle, which was particularly intense at the time in South African society, for ownership of the guiding discourse.

This particular body of work is of course highly partisan, passionately moralistic, and, as befitted the struggle aesthetics of the time, unashamedly didactic. Murray's later work shifts gear, growing more meditative, more interrogatory of its concerns. But even at this point the worm of doubt or self-analysis is there to be found in the images. The irony is introduced in a curious and startling way, one that Murray has sustained and revisited in various ways in later work. The figures in the series are based on South African stereotypes to be sure. But at the same time, the source caricature—the physical type that serves as the medium for his explorations of subject—is of the artist himself.

Inserting himself into his subject matter and the dynamics of the discourse that he is exploring, Murray makes himself, so to speak, the site of his interplay of images and stereotypes. To put this in a different way, his interrogation of the image and its levels of reference is at the same time rendered as a questioning of identity. It is especially significant in this regard that the images with which Murray works in the series—and, in fact, more or less through his artmaking to date—are received images drawn from the public rather than the private domain. Although they are transformed in the artmaking process to draw on other levels of reference, the original source and the original context of meaning are seldom far from the viewer's response to the work. What this adds up to in very significant ways is that in Murray's work (at least this body of it) the self is seen as the place where the images collide, and that self is created precisely through those collisions of images and elements of discourse.

It is a wise and postmodernist kind of take on the semantic realm. But at the same time it is probably worth noting that, particularly in the divided and fragmented context of South African politics and society, it also structures a way of seeking understanding—rather than merely judgment—through the project of making art. The bulk of politically committed South African art in the 1980s was in retrospect essentially propagandist. It sought to drive wedges and enforce distinctions between "them" and "us" (that is to say, the forces of apartheid and the forces aligned with the liberation). Murray's work, on the other hand, implicitly acknowledges that all of those dynamics of history are reproduced and rehearsed in the self, and that if art is about reproducing the self through the medium, then those polarities have to be brought into the nexus of identity.

On one level this is a very abstract point to make. On another it is very concrete, something deeply lived by critical white South Africans, especially those, like Murray, who could have been eligible to be conscripted into the army and sent into the townships on the side of the repression. There was always a sense that the soldier one saw in the street could have been oneself. There was also the conundrum of the fact that as a white, however much one rejected the system, one could not escape the knowledge that one was a beneficiary of apartheid. By the same token, however much one identified with the cause of liberation, one could never be as integrally or as organically part of the struggle as those who had personally suffered the injustices and iniquities of apartheid history.

It is one instance of a broader truth: that identity for white South Africans is a concept more fraught and less given than lived identity in more stable historical circumstances.

Brett Murray

Murray's later work explores the divisions and schisms in the experience of South Africans in usually more direct—though also more complex—ways. In a 1994 piece entitled *The Oros Man*, Murray seizes on an icon of old-time advertising for his contribution to a show organized in Cape Town to mark the coming of democratic elections in South Africa. Stylistically a not-too-distant cousin of the Michelin Man, the Oros Man endorses a brand of orange squash. He is a figure specific to a white suburban childhood in South Africa, part of the weekly groceries package.

Stylistically considered, the figure of the Oros Man is vaguely archaic, and as is the case with many outdated images, part of its charm lies in the representational frisson that arises from the recognition of that archaic quality. At the same time, in the form and the way it is drawn, in its rotundity and its fixated cheerfulness, it is strongly reminiscent (at least in the context of Murray's oeuvre) of the sculptural figures discussed above. In doing this, as I have argued above, it invokes—at an initially playful level—the identity of the artist as a site of meaning. And in the context of an exhibition at one of the most significant moments in South African history, the image of the Oros Man multiplies ironies.

These are only emphasized by the introduction of a fringing of coins on the outlines of the figureand a Ndebele-style patterning on the interior of the form. Murray is in the first instance drawing attention to the disjunctions of experience and identity in the context of South Africa: the Oros Man is presented as not far from the symbol of a commercially motivated imperialism. By adopting, in irony, the persona of the Oros Man, Murray highlights a hegemony of western discourse in an African situation—and puts that into question by placing it in an exhibition that was designed to respond to the condition of national liberation. At the same time, however, all this is undercut, and the identity of the Oros Man image further jeopardized, by the the introduction of the Ndebele motif.

This confrontation between the representations of a western, colonialist discourse and the representations of an African reality is something that Murray returns to again and again in his oeuvre. Another 1994 work, *Bloody Marriage*, takes as its starting point two primary icons of Afrikaner nationalism, the figure of a Boer Commando from a Pretoria monument and the figure group from the Vroue Monument (Women's Monument) in Bloemfontein. With these he juxtaposes two generic tourist-type images of of Basotho people, one male and

Fig. 10
Bloody Marriage.
By Brett Murray, 1995.
Metal, wood, and plastic.
180 x 107 cm and 166 x 154 cm.

Fig. 11
Oros Goes N'debele.
By Brett Murray, 1994.
Plastic, wood, and coins.
130 x 170 cm.

Fig. 14
Truth: Quiet Lesson.
By Brett Murray. Wood, plastic,
and glass jars. 106 x 90 cm.

Fig. 12
*Collected Tears and Promised
Land.* By Brett Murray, 1996.
Wood, plastic, glass jars,
water, and earth.
118 x 98 and 113 x 78 cm.

Fig. 13
Own: Territory.
By Brett Murray, 1997.
Metal, chrome, glass jar, earth,
and photograph. 65 x 200 cm.

the other female, both wrapped in what the brochures sell as their picturesque ethnic blankets. This juxtaposition alone is enough to deconstruct the discourse of Afrikaner nationalism; there is a very real sense in which the projection of Afrikaner destiny that is contained in the Boer monuments cannot coexist with the images of Africans. But Murray takes the disjunction a step farther, introducing red dots on a superimposed perspex plane. These he describes as "bullet holes," and the theme of violence is further developed through the addition of twists of polony, a processed meat traditionally wrapped in a shiny red plastic wrapping, which, as it were, decorate the Boer figures with their primary attribute of blood.

In related works, Murray directly addresses the degradation of the image of Africans in this country in and through the ways in which they have been represented by whites. *Collected Tears and Promised Land* (1996) is a particularly moving instance of this concern. The source images here are drawn from the oeuvre of Anton van Wouw, one of the most effective of the Afrikaner artists who sought, especially in the heyday of apartheid in the 1940s, '50s and '60s, to image the ideologies of white supremacy in the representation of Africans. Taking two of Van Wouw's best-known sentimental sculptures, one offensively titled *Sleeping Kaffir* and the other (equally tellingly) *The Accused*, Murray superimposes on them jars filled with evocatively real materials—mineral water for the "collected tears" image, earth and metal (recalling the land from which "the accused" has been driven) for the "promised land."

Similar themes are explored in a more pointed context in a series of works around South Africa's Truth and Reconciliation Commission. A generic African profile, reminiscent of the Van Wouw image discussed above, is a constant throughout the series—it is, so to speak, the representation of African experience against which Murray superimposes elements that question the integrity of that representation. In *Truth: Quiet Lesson* (1996), for example, jars filled with blackboard chalk are affixed to a kind of shadow version of the profile. The associations of the chalk, together with the muteness and blandness of the image, create a chilling evocation of the silence of history that the Truth Commission sought to make vocal. This sense of a silence that is pregnant with the untold, a silence that has historically been sustained by the owners of the dominant discourse, is given in various ways in the series—books are tied up with wire, an emptiness appears in the middle of the profile, rows of lights suggest unspoken ideas. And the viewer is left in a meditative space, left to fill up for him- or herself the emptiness that has been structured.

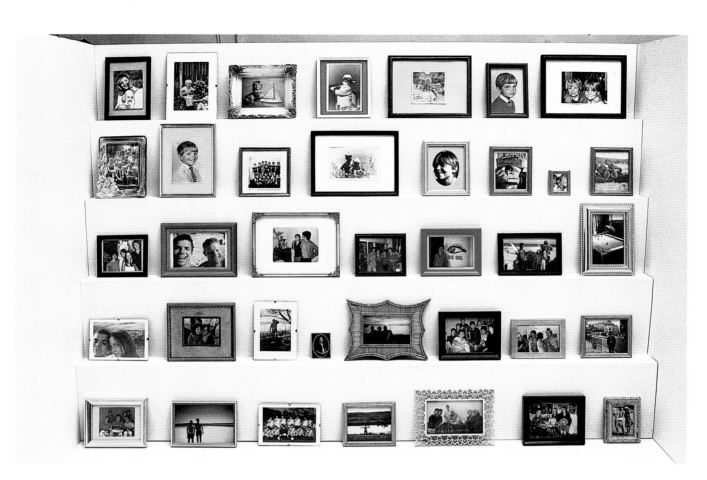

Cat. 5
Guilt and Innocence 1960-90 (detail).
By Brett Murray, 1998.

Brett Murray

What Murray is uncovering in this series is a profoundly fragile and transitional moment in the discourse of postcolonial South African society. It is a moment when the terms of the discourse are shifting, but the new "truths" have yet to be decisively defined. Murray's vision is quiet and thoughtful in the "Truth" series, allowing the works to breathe and the viewer to enter into an interaction with them.

A more cynical and in-your-face take on a similar theme is given in a linear installation piece titled *Continuity and Change* (1997). Here the sentence "Victory Is Always Written by the Winner" is written in small-denomination coins. A series of works from 1997 in a similar register is entitled "Own," a word with two meanings, as noun and as adjective; this play is very much to the point, as Murray reproduces in metal the lines of eighteenth-century watercolor representations of South African landscape. One work in the series, derived from a painting by the Dutch explorer Robert Jacob Gordon, is titled *Territory*, and bears its title on a copperplate plaque affixed to the metal from which the work has been made. *Territory* is a particularly immediate realization of a crucial insight: the act of representation is at the same time an act of appropriation. This notion has added layers of reference in the context of colonialism and of the twisted history of the African continent. Adding two further elements—a photograph of the landscape thus pictured and repictured, and a jar filled with earth—only serves to layer the ironies and the shifting multiciplicity of versions in and through which the land is experienced.

Guilt and Innocence (1997) is an installation of 130 snapshots of the artist together with his family and friends. Mapping out Murray's life from early infancy to adulthood, the photographs are the usual (if at the same time absolutely specific) snapshots of the half-lives of the generally sheltered white suburban kid: as an infant with his mother, as a child at the beach, as a member of various sporting teams, as a graduate, with girlfriends, playing pool, traveling overseas, adopting bohemian poses as a young artist, and so on. But at the same time, the gallery of snapshots is presented in such a way that it becomes a parallel record of something that shadows the work but is never shown: Murray has assembled the photographs as a record of his own life during the period 1962 to 1990, the years when democratic South Africa's first president, Nelson Mandela, and his fellows in the Rivonia treason trials were incarcerated on the notorious offshore prison of Robben Island. In this regard it is significant that *Guilt and Innocence*—in an earlier and less developed version—was first exhibited as a site-specific piece on Robben Island itself, after the political prisoners had been released and liberation finally attained.

The collection of snapshots poses an overwhelming question. As the artist himself writes in a note on the work,

> I am a white middle-class cultural hybrid. This was and is my comfortable and uncomfortable inheritance. The political and social forces beyond the confines of my family formed a system which protected and infringed on me, empowered and disempowered me, promoted and denied me. When I looked beyond my private experience of loves and relationships, family and friends and boy becoming man, the contradictions in this system, which divided my life from others, resulted in a cross-questioning of responsibility and complicity. This uncertainty challenged the understanding of what became ambiguous life experiences. (Catalogue to the exhibition *Thirty Minutes*, Robben Island Museum, 1997.)

Exactly! The point that Murray is making here is one that closes the circle on the artworks discussed in the earlier part of this essay: here he holds up moments in his own experience to his own scrutiny and to the scrutiny of others. He notes that in the awareness of the partiality of his own life experience, the condition of being cut off from the experience of

Fig. 15
Continuity and Change. (detail)
By Brett Murray, 1997.
Coins. 500 x 65 cm.

others, he begins to doubt the quality and integrity of his life as it has been lived. And in the way that he has structured the work, bracketing it with the more public history of the prison on Robben Island, he creates a situation in which the viewer too must look on the physiognomy that recurs in the series as a physiognomy both of presence and of absence.

On one level there is the admission of guilt: this is what Brett Murray was doing while South Africa's most famous and most distinguished son was doing painful time. On another level there is the assertion of innocence, the assertion that this is no more than the ordinary life lived with love and pride and achievement and pleasure—no more, to be sure, than the birthright of any human being. But the ordinary life, as given in this installation, is at best a half-life. You can't help noticing, as you look through the series, the absence of black faces, the complete and utter schism that is indicated through the absence of any representation of the other side of life in South Africa.

Looked at from another angle—the angle of the virtual—the title of the piece opens into a different though equally relevant kind of ambiguity. The "guilt" of the Robben Islanders was established in a court of apartheid law, and they were duly sentenced to lifelong imprisonment. But that putative guilt was only sustained as such under a system of law that was itself indicted by the world at large—and the innocence of the "guilty" continued to be proclaimed, until it was made real in the release of the prisoners. Thus layered, *Guilt and Innocence* is an instance of a kind of raw nerve ending of the discourse of power in the South African context. It finds a relation between what is shown and what is not shown. It structures the ambiguities and the ironies that emerge at the point where the stitching of ideology comes apart. It also finds a moment in history where things mean things other than the things they have always meant in the past. It is also the point at which the artist resolves—in a signal ambiguity—the two strains in his oeuvre thus far: the private exploration given in the appropriation within his own image frame of the public representation, on the one hand, and the public life of the representation, on the other.

That he leaves the viewer with a set of questions rather than with answers is perhaps the final point. Art can pose options, explore alternatives, present and interrogate versions of the real. History and time can bring the polarities together.

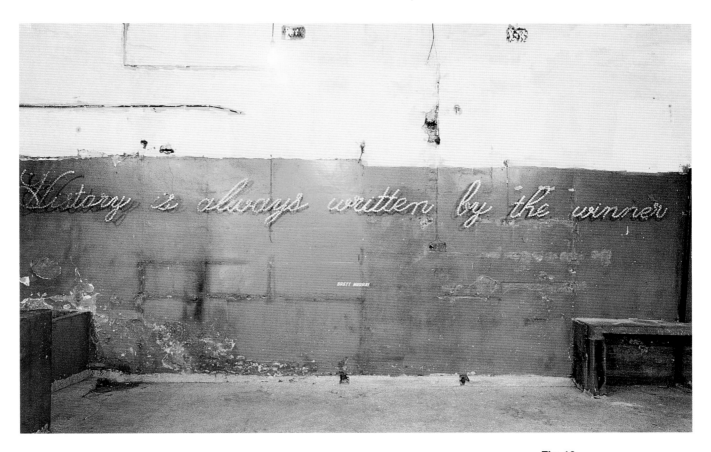

Fig. 16
Continuity and Change.
By Brett Murray, 1997.
Coins. 500 x 65 cm.

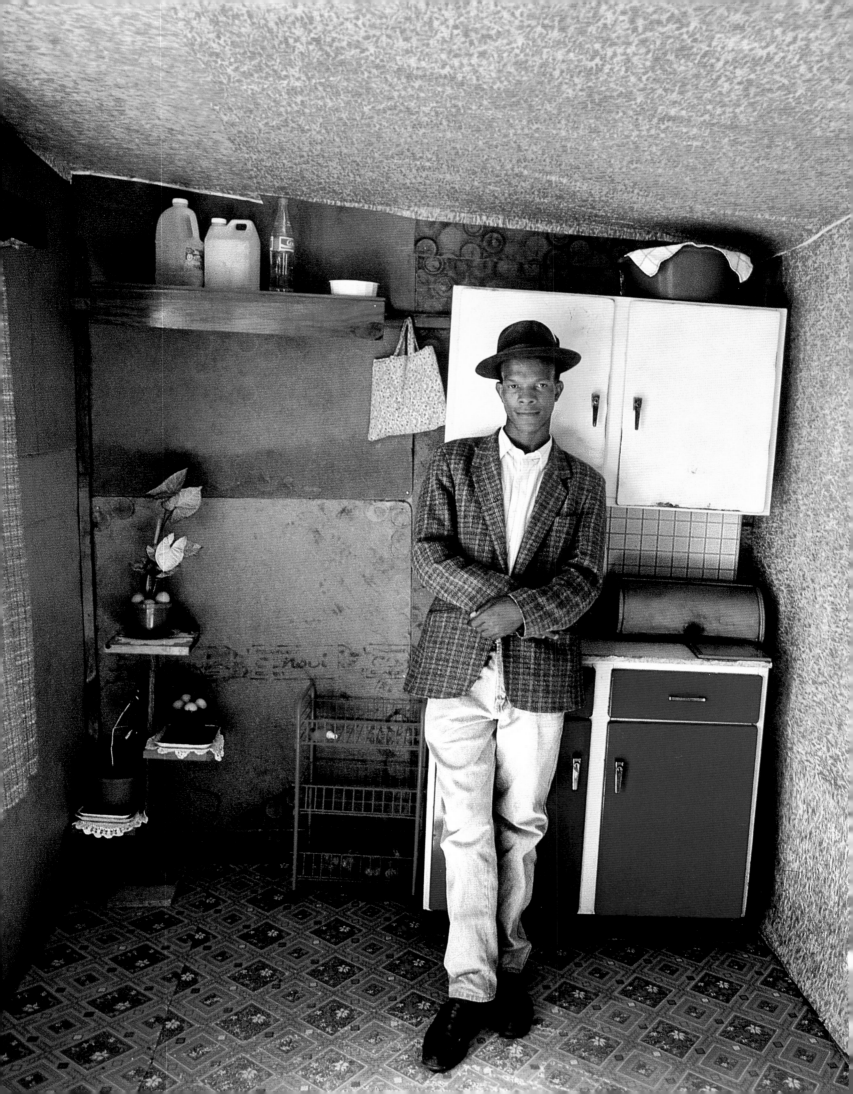

Zwelethu Mthethwa Talks About His Photographs

Bongi Dhlomo

Bongi Dhlomo: After your final year at high school you enrolled at the University of Zululand to study for a bachelor of science degree with the aim of pursuing a medical profession. This was in the 1980s, and now in the late 1990s you're both an artist and art educator. You've said that you find both professions to be engaged in a healing process. What do you see as the link between stethoscope and camera as healing tools? What is the link between scrutinizing people's health and people's way of life?

Zwelethu Mthethwa: Education for a black student was geared at making him/her educated well enough to understand simple instructions in order to be useful in the labor market. Fortunately, by the time I attended school, mathematics and science had been introduced in the black schools. During my high school studies it became clear that I was good in mathematics and science. The Bantu education system in general did not give us as black students opportunities to make career choices at an early level. My interest in mathematics and science, therefore, meant that I would follow one of the careers in the medicine field; careers that were known, popular and tailor-made for students who excelled in the sciences. If a student excelled in those subjects they were automatically elevated to a status of an "A" student.

When it became clear that I was a "gifted" student, I and other students from Durban were selected for the "Gifted Child Programme." This program set us above other students, and obviously our parents were happy and my family, in particular, pressured me to pursue a medical career. Black students had few choices at the time, so I enrolled at the University of Zululand with the goal of entering the medical profession.

Doctors use a stethoscope to diagnose their patients, but they do not use the same tool to heal. While both stethoscope and camera diagnose conditions, I find that the end product

CAT. 6
Untitled.
By Zwelethu Mthethwa, 1999.
Color photograph. 102 x 76 cm.

of the camera, the photograph, offers a different aspect to healing. Doctors depend on the dispensary and pharmacist to heal patients, whereas the camera diagnoses the condition with a photograph and immediately begins the healing process.

Both instruments and careers are predominantly diagnostic, but I feel that the tools for art go beyond diagnosis because the camera offers photographic images. While X rays are photographic images, people do not carry these images around in lockets, wallets, and albums. The X-ray images are usually used by doctors in an effort to dig further into a patient's condition—diagnosing in order to use medication to heal. Photographs make emotional connections. People carry photographs of their loved ones, living or departed. When the time demands, whether through sentiment, longing, remembrance, or otherwise, these photographs are retrieved, viewed, and emotions pour out. The healing process comes, therefore, from the camera's end product, which comes from the artist's/photographer's decision to engage in the project or process of photographing in order to create a "bank of emotions." If the photograph is of a happy scene, such as a sporting event or wedding, the emotion that the image evokes would be that of happiness. In a sense, the viewer's emotions are stored, as in a "bank," at the time of seeing the images for the first time. Each time the photograph is viewed, the bank is opened and the relevant emotion is utilized.

With technological advances in recording media new trends in creating these banks of emotions are evolving. The tendency has always been to record happy memories, but nowadays, people have begun recording sad memories, like funerals, on video. Some people believe that the process of watching this sad recording of a loved one is healing.

BD: When you decided to chose an art career against your family's wishes, you did not go to Rorkes Drift Art and Craft Centre or any other community art center, you enrolled at the Michaelis School of Fine Arts, University of Cape Town. Why or how did you come to that decision?

ZM: I was accepted at the University of Zululand (Ongoye), which as I mentioned would have been followed up by a degree in medicine. It became very clear to me that I was not cut-out for this kind of study and after six months at the University I decided to drop out. Fortunately, this was during the half-year holiday, and during that month I received a letter from SACHED (South African Committee for Higher Education) and was called for an interview. I had no idea why I was called and how I had been chosen. When I arrived at the SACHED offices, I realized that there were a number of other students who had come for an interview. I had a long wait for my turn. Fortunately, I'd had the presence of mind to bring papers and pens for the interview. While I waited for my interview, I started sketching and soon became engrossed with the drawing. Mr. Ian McClain was my interviewer. He asked me what studies I was interested in pursuing. Having been indoctrinated into the world of science, I simply told him that I needed to do something, anything in the science field. He noticed the paper I was holding and asked to see what I was doing. I showed him my drawing. He studied it at length. He suggested that I shift my interests from the sciences to art. I looked at him and laughed. I was laughing at his suggestion and because art did not feature into my understanding of careers that could be followed after finishing high school with excellent scores in math and science. I could not, at that time, think of any prominent artist who had made it big in South Africa, black or white. I had had no exposure to art in my years of study. This was my main reason for laughing at the suggestion.

Mr. McClain, however, insisted that I take his suggestion seriously. I was eventually persuaded though I was still doubtful. When I asked if SACHED offered art classes, he told me that these classes were only available through the South African Institute of Race Relations' Abangani Open School.

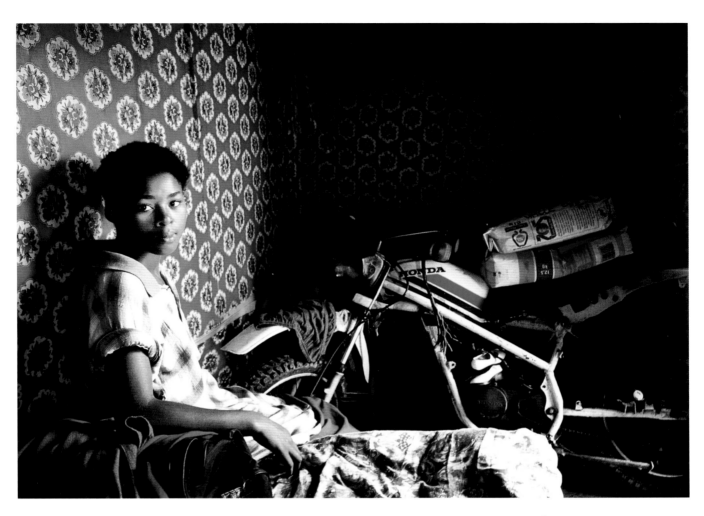

CAT. 7
Untitled.
By Zwelethu Mthethwa, 1999.
Color photograph. 76 x 102 cm.

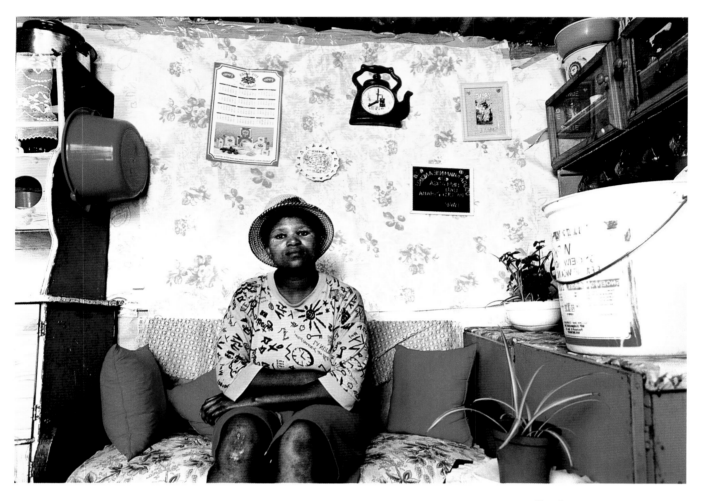

CAT. 8
Untitled.
By Zwelethu Mthethwa, 1999.
Color photograph. 76 x 102 cm.

Zwelethu Mthethwa

My first introduction to art was at this informal art school. My tutors were Charles Sokhaya Nkosi and Joe Ndlovu, who were both graduates of Rorkes Drift. I enrolled from 1979 to 1980. During that period, I built a good portfolio and began to understand what career opportunities were available in this field.

BD: You dropped out of University and followed something as unknown in the black community as art. What was your family's reaction?

ZM: I expected them to object, but to my surprise, my parents were just happy that I was at school doing something. They did not care what I was doing—I was off the streets and that was good enough.

BD: You had to study photography as a condition to be accepted at the whites-only university. Why photography? What was your reaction to this condition at the time?

ZM: As you know, there were faculties that were offered only at white universities. While visual arts or the bachelor of fine arts degree was offered at the University of Fort Hare, the standard was not equal to that of a B.F.A. offered in white universities. My tutors, Mr. Nkosi and Mr. Ndlovu, suggested that I apply to Michaelis School of Fine Art at the University of Cape Town (UCT) in order to get the best art education.

During those days it was very difficult to gain entrance into white institutions especially if the intended studies were available in black universities, as was Fort Hare in my case. We had to be creative in applying to Michaelis at UCT. Photography was not offered at Fort Hare University but it was at Michaelis. It became important for my application to highlight my wish to study photography.

Another important reason for applying to Michaelis was that my tutors had direct contact with the printmaking lecturer, Mr. Jules van der Vyfer. Mr. van der Vyfer had been the principal at the Rorkes Drift while Nkosi and Ndlovu were students at the center. He and his wife Ada were my lecturers in printmaking, and at this point, there was a growing dissatisfaction among students who wished to study art at a level higher than a community art center. There was a feeling that white institutions needed to open their doors to black students.

BD: Would I be correct in saying that, like most local black artists who are now becoming international household names, you literally stumbled across your career through a series of dramatic and unbelievable events?

ZM: You could certainly say that. If I had not dropped out of university, I would not have met Ian McClain at SACHED. I would not have met Charles Nkosi and Joe Ndlovu, who helped me engineer my acceptance into Michaelis through the Jules and Ada van der Vyfer connection.

BD: It sounds very familiar. I assume you did not walk into a white tertiary institution just like that, what were your initial experiences?

ZM: Of course not, I could not just walk into a "whites-only" university. I was accepted into Michaelis by my portfolio from the Abangani Open School. Despite my portfolio and acceptance, I still had to receive ministerial consent to study at a white university. This consent could be given or refused without any explanation. During the first two months at Michaelis, I did not know whether I would be granted or refused permission to study there.

Those two months were the most traumatic. First, there was the ministerial consent situation and the uncertain waiting. Second, I was suffering from an inferiority complex that was compounded by my poor command of the English language. Third, I had never attended class with whites before, I was one of two black students at UCT, and I was new in Cape Town.

Zwelethu Mthethwa

BD: New in Cape Town—obviously no accommodation in the white residence or did you get the Minister of Education to grant you permission to stay in the residence, too? An uphill battle—how did you get around this?

ZM: The minister's consent, when granted, would only cover the campus and not residence. Meanwhile, I had to find lodging in Cape Town. During the first month I stayed with Jules and Ada van der Vyfer. In the months that followed, I discovered that other black students, who had no homes or relatives in Cape Town, were suffering from the same predicament. Black students could not stay at a residence that was in a white area and reserved for white students only. We were accommodated at the City Hospital. One section of the hospital was demarcated for use by black students, while the rest of the buildings continued to function as hospital. The hospital was situated in Green Point, also a white area. I guess authorities turned a blind eye and "took pity" on us and our situation.

There were thirty-eight "homeless" students: twenty women and eighteen men. We lived in wards that were crudely partitioned for privacy. The women lived on the upper floor, and the men lived on the ground level. We could not cook in this makeshift residence, and our breakfast and dinner were provided by the hospital. There was a special menu for the students that differed from that of the patients, but it was all prepared in the hospital kitchen.

Transport for white students was provided from the residence to the university grounds, but none was provided for black students from the hospital. We had to find our own way to the campuses.

All in all it was not a pleasant experience, and looking back, I feel it was not necessary. The university, especially the fine arts department, had differing views on our situation. Some, like Jules and Ada, who were not South Africans, were baffled but they understood. Some of the South African staff's views varied from noncommittal to understanding. Luthando (the other black student in my class) and I discussed our situation at length during the first two months. We concluded that if we were granted permission to study at the university, we would have only one goal: to do our best, and where possible, to exceed it.

When I finally received the ministerial consent I was happy and my confidence was restored. From that point on, I started to concentrate on my work. After the first two projects I had established my ground and felt that I had earned respect from both fellow students and the faculty staff.

BD: About the work you are doing now: your earlier work resembles photographs or reflects your understanding of the photographic medium, even though you use pastels and play with unnatural colors in your subject matter, especially in your human figures. Would you attribute this freedom to your exposure to photography while your were a student, or is there another outside influence?

ZM: The primary influence in my work is my mother. The narrative approach that I use stems from her story-telling tradition. Photography definitely added a great deal to my narrative, and in a sense, being forced into photography was a blessing in disguise.

BD: Do you find that you have a somewhat different outlook to your artmaking than your counterparts who did not study photography? Do you have objectives in your creation?

ZM: I believe my work is distinct because of the colors, not only in my pastels but also in my printmaking and photography. With photography I am drawn to color, as opposed to the much-used black and white in the visual art sector. My objective is to present clear messages to both the initiated and the uninitiated in society. Color and composition help me reach those

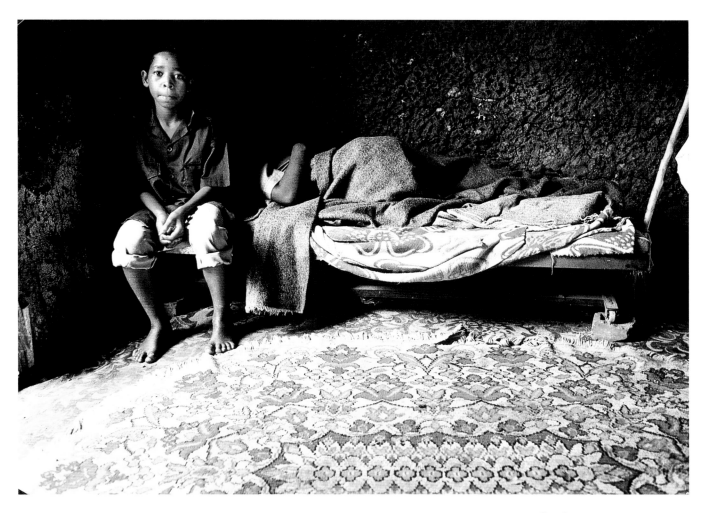

Cat. 9
Untitled.
By Zwelethu Mthethwa,1999.
Color photograph. 76 x 102 cm.

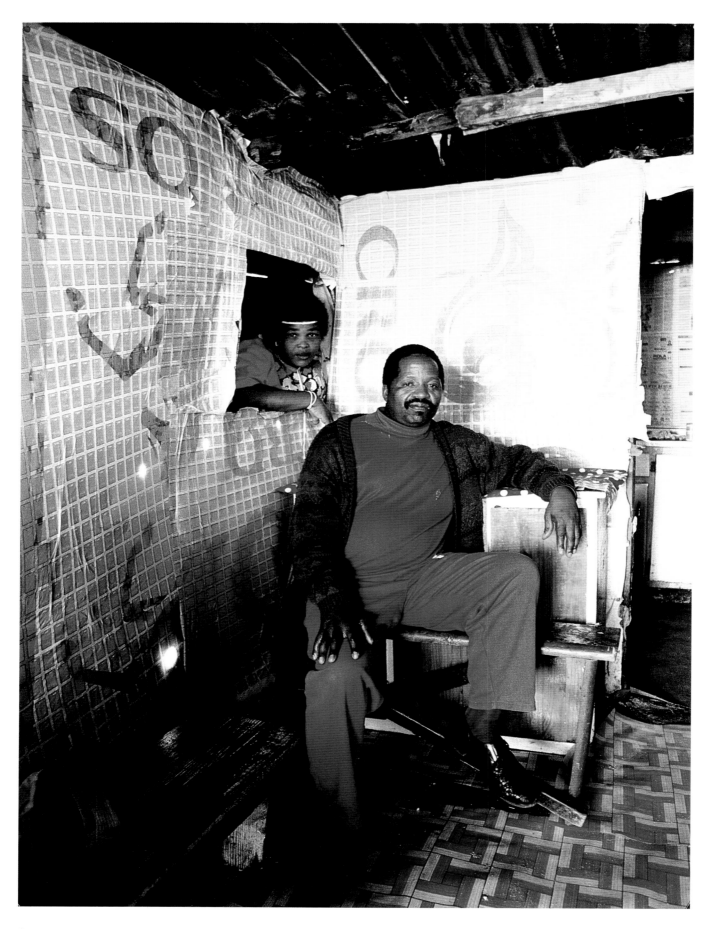

Cᴀᴛ. 10 *Untitled.* By Zwelethu Mthethwa, 1999. Color photograph. 102 x 76 cm.

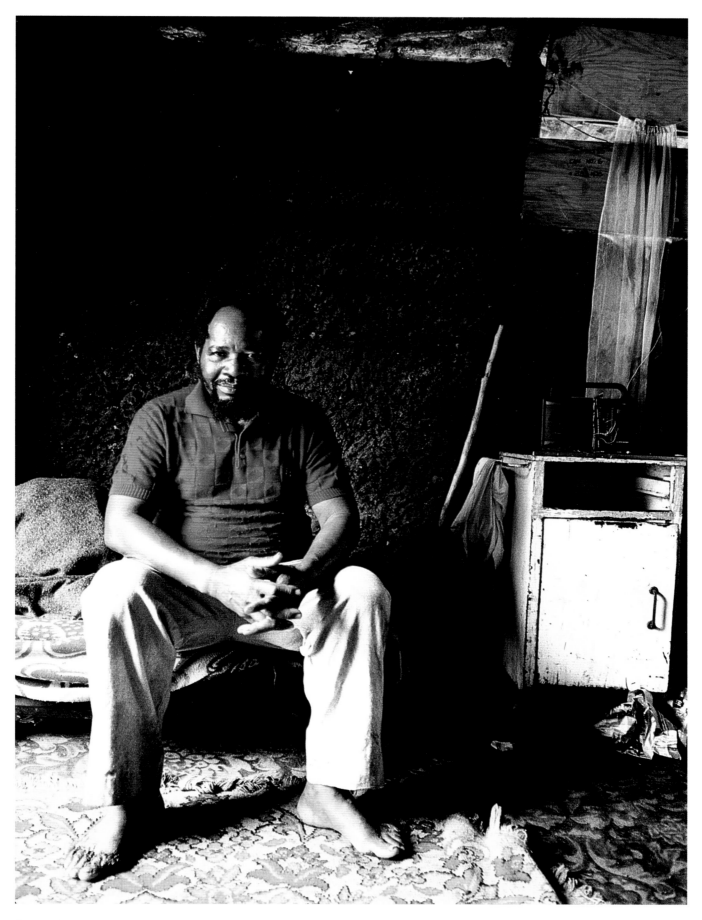

CAT. 11 *Untitled*. By Zwelethu Mthethwa, 1999. Color photograph. 102 x 76 cm.

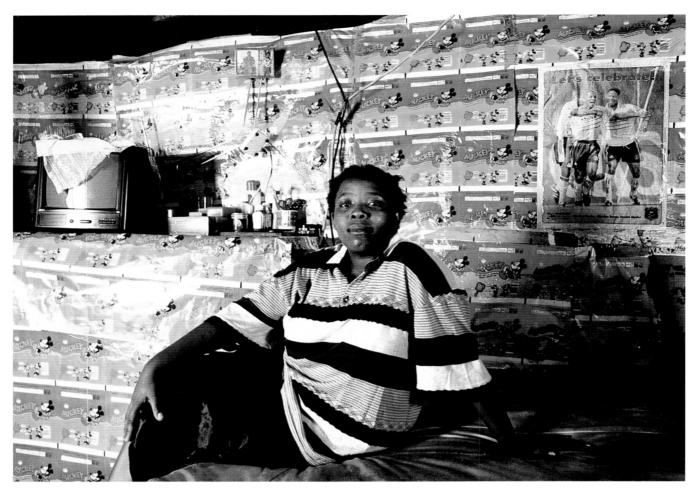

Cat. 12
Untitled.
By Zwelethu Mthethwa, 1999.
Color photograph. 76 x 102 cm.

objectives. My aim is to be heard, seen, and understood by the person I photograph in Paarl, Cape Town, as well as the viewer in Madrid, Spain.

BD: Taking portraits of people in their private spaces and in informal settlements in Paarl, Cape Town—this is your current project. How and when did you start this project, and why this subject?

ZM: As a photographer, I have seen most of the photographs that come out of South Africa, whether from photojournalists or from artists. I have found that the common objective is to sensationalize and to draw attention in a distasteful manner. When I view some of these photographs I cannot help but think of these people who have been photographed as victims of abuse. The choice of photographing in black and white by most photographers gives an acute political angle of desertion and emptiness.

I do not believe that poverty is equal to degradation. For me, color restores people's dignity. I ask myself why we, as photographers, should deny these people color while it plays such an important part in their lives. I cannot start to imagine how drab the photographs I am currently taking would look in black and white; and how desolate their state would be to the viewer's eye. I think these photographs preserve and show a humanness of the occupants in their private spaces. They restore their pride and affirm their ownership.

BD: Do you at any point engage in discussions with the people you photograph? If you do, what do you discuss, in general?

ZM: I do engage in discussions with the people I photograph. Basically I explain to them what I am doing. I clarify the historical and social context of the project before taking the picture. For them to believe in the project I always promise to bring them the photographs, and I do. This enhances my work relationship with them, and I feel that once this relationship is established, they stop being "subjects" and become collaborators on the project.

BD: Have you ever found yourself drawn deeper into conversation with any of the people you photograph, and if so, how does this affect your work as an artist?

ZM: I do have long discussions with them. I guess I feel as though I have become a part of the Paarl community, because I am taking photographs. During one of my photographic visits, thirty families were being evicted from their homes. For a photojournalist, these scenes would have produced award-winning photographs. I could not take a single photograph, but I only listened as they related the difficulties of not having water or toilets after the evictions.

BD: Most people in your photographs stare into the lens with very serious faces. One gets the feeling that they take the photo shoot very seriously indeed. Normally, and due to the nature of their setup, most informal settlements are happy, noisy, and carefree, but somehow one does not get this from your photographs. Do you think that this aspect of life in the informal settlement is replaced by such serious faces because of the camera and what you ask the people to do, or by your reason behind taking these pictures? In other words, I am asking if the image that one finds in most of your photographs is really what you are aiming for?

ZM: In a sense, this is what I aim for. After the explanation of the project they know that we are not doing the "cheese" or "mask" image. They are free to be happy, to smile, and to joke, but we try to avoid acting parts or portraying someone other than what the person really is. It was difficult at first. I have learned to be patient and to understand where everyone is coming from.

I believe that by discussing with the people before the session, I get them to relax and to become focused on the session as a project and not "happy-snapping." All the photographs I have taken have been posed and there is complete acknowledgement by the person

photographed. The images are never "stolen shots" that capture "the moment." We capture all the moments in a calculated and deliberate manner.

I believe I have earned the residents' trust because I have recently started photographing "home churches." I am now able to interrupt the pastor and congregation and request to take photographs without a problem.

Less than one percent of the people I asked have refused to be photographed, but often, when they see other people with their photographs they consent. I always go back if invited.

BD: As you look through the lens and find your picture have you ever noticed that people's sense of aesthetics and design, which comes from their need to survive, is also potentially dangerous for their survival? The elements that make up the interiors of their dwellings are all fire hazards: paper and cardboard, plastic, PVC, naked electric wiring/cables, wood, kerosene, candlewax, and matches.

ZM: I do notice these elements. I also realize that most people believe their informal settlement situation is temporary and, as you know, temporary can be a relative term when it comes to housing in South Africa. Most people use temporary materials because they believe that new houses are being built, and they will be moving soon.

BD: Are the people you photograph aware of why you photograph them? Do they ask questions about your projects? Do they ever ask to be compensated?

ZM: I discuss with each person who I photograph the main objectives of my visit, and where possible, I even give details of the project that I am working on. Some people become curious and in our discussion they may ask more questions. Somehow, I have found that through my discussions with them I understand my projects better. I also begin to understand their social situation and in the process, get to know myself as well.

Surprisingly very few people I have photographed have asked to be compensated. I always pay if they request but, as I say, it is very rare.

BD: What do you think of the black people as subjects in commercial postcards? Would you consider turning this series of photographs into commercial postcards? If yes, how or why? If no, why not?

ZM: I view most of the photographs for commercial cards as superficial. Sometimes I get the overwhelming feeling that the subjects are exploited and have no one to defend them. While these photographs are said to be fulfilling a role of informing people outside of South Africa about the flora, fauna, and cultures of our country, I cannot help but raise an objection about the motive of these photographers. I refer to the people being photographed as subjects in a guarded manner. Most of the time the photographers are not informed about the people they photograph. They photograph them out of context and in more ways than the location or backdrop. They become victims of photographers' greed. They are also victims of their own ignorance. In many of these photographs black people are used as objects in the same manner as trees, flowers, and wild animals. To be honest, I have never thought of using the photographs I am taking for commercial postcards.

BD: How far do you intend on taking this project?

ZM: Looking at the material that I have accumulated since I started this project and talking to a number of advisors, I would like for this to culminate in a book. The book would have the photographic material, interviews with some of the people photographed, and maybe essays by invited writers.

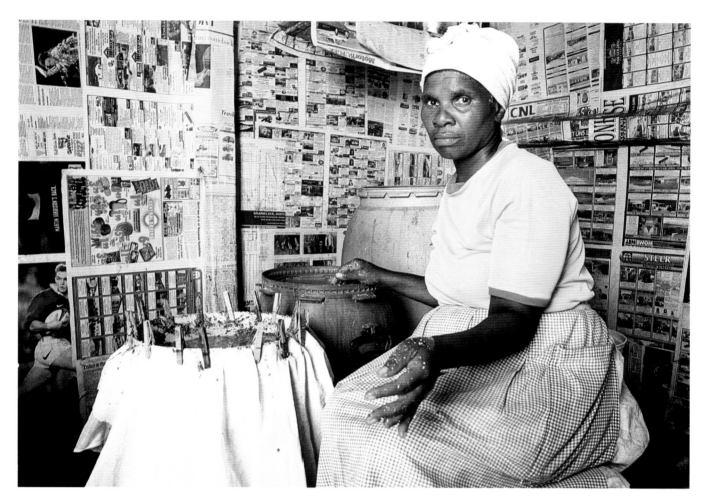

Cat. 13
Untitled.
By Zwelethu Mthethwa, 1999.
Color photograph. 76 x 102 cm.

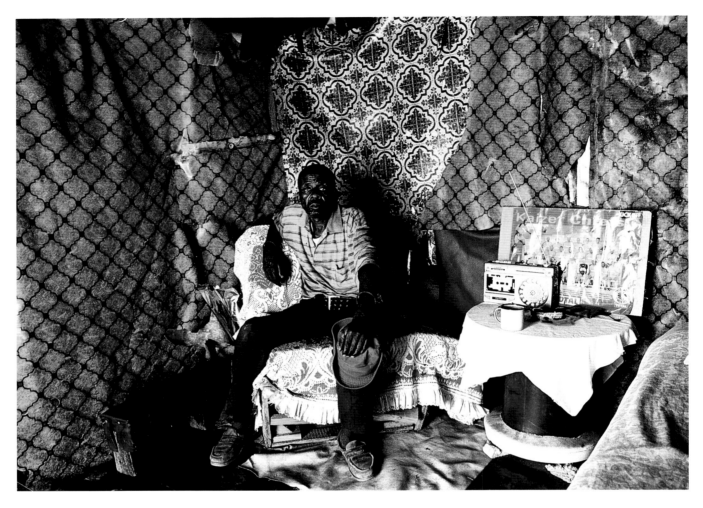

CAT. 14
Untitled.
By Zwelethu Mthethwa, 1999.
Color photograph. 76 x 102 cm.

Zwelethu Mthethwa

BD: What do you see as your gains since you started this project?

ZM: In a strange way this project has been the most empowering of all in my artmaking career. Interaction with people is not the same as closing yourself in a studio and painting or drawing. I feel I have contributed positively to other people's lives. I have been able to restore some of their dignity by acknowledging the spaces in which they live as homes worth recording. Through understanding the people with whom I have interacted I have found it possible to understand myself and the work I am doing. By empowering other people with photographs, I am empowered as a photographer. We have long limited ourselves in our abilities to change our situation through art. We have been brought up to censor ourselves and to not say what we really want but to say what we are expected to say. This project has taught me to believe in what I do, the same way as the people I photograph believe in their integral role in society despite their situation. I feel affirmed by the project, and for me, with my history in the art field, it is a real gain.

BD: Any regrets?

ZM: I cannot say I have any regrets. I was very lucky to have people in my life who recognized my potential and encouraged me. I have been able to achieve two of my childhood goals: to study overseas and to publish a book. My first goal was realized when I walked into the United States Information Services (USIS) library in 1985 and looked in their directory for fine art courses. In 1987, I received a scholarship to study in the United States. I am closer to my second goal of publishing a book on a subject that I have developed a passion for over the few years I have been working on it. Regrets, definitely none. I know I would have regretted following a career in the medical field. I would have been rich but maybe I would not have had time to travel the way I have traveled as an artist. I have learned a lot from visiting different countries where my work has been exhibited. I have widened my horizons, and in the art field that is very important.

BD: Starting off as a student living in a hospital ward to becoming the first black lecturer at Michaelis School of Fine Arts at the University of Cape Town, what are your thoughts?

ZM: When I first started to teach I realized that many of the white students would be very curious to know how I came to be teaching them. I did not volunteer information until they asked. The questions would come in a casual way, which told me they really wanted to know where I had studied. I would inform them that I started exactly where they were as first-year students. On further probing, it would come out that I had studied in the United States. After this revelation they would relax. I was different. I was acceptable. It has been a long, arduous, but yet enjoyable journey.

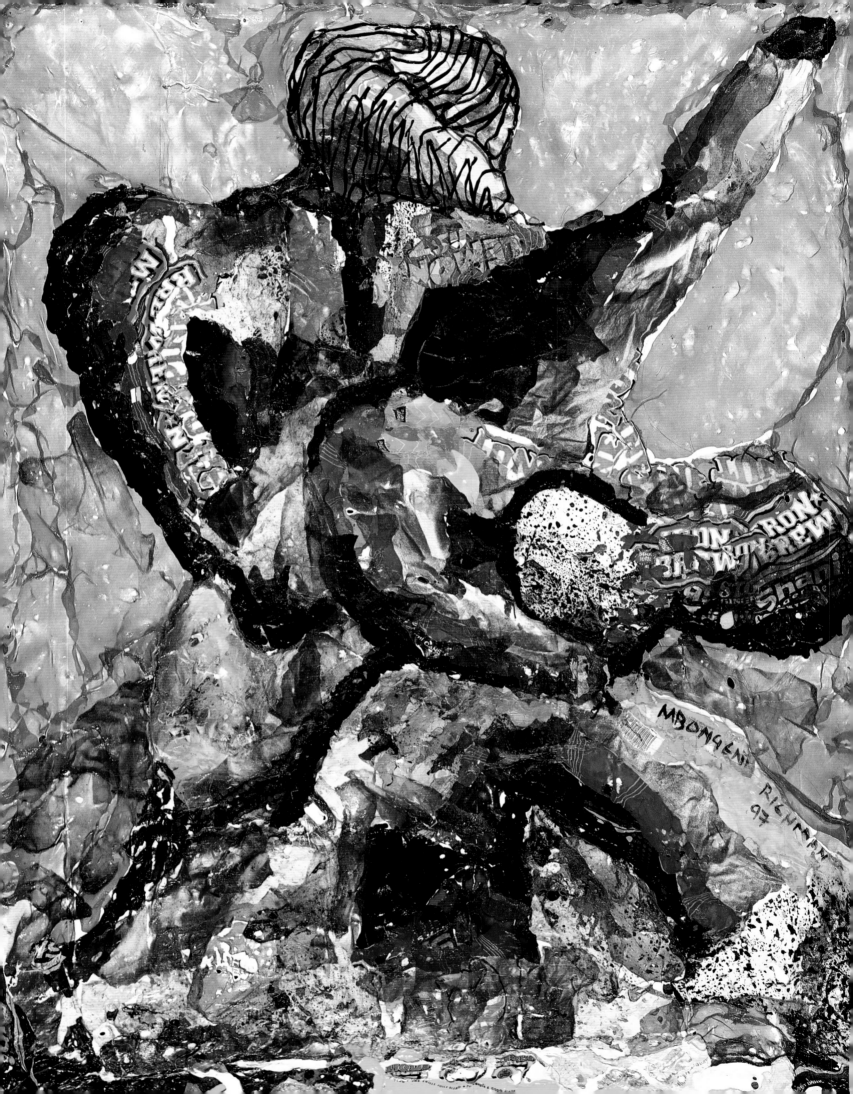

Mbongeni Richman Buthelezi

Interviewed by Kristine Roome

Locally, President-elect Thabo Mbeki, the new leader of the new South Africa, espouses notions of an African Renaissance replete with art and creativity, and also of preserving our natural environment for the sake of our children. Globally, Zygmunt Bauman writes, "One may say that if the catchword of modern times was creation, the catchword of our times is recycling. Or again, if the favorite building material of modernity was steel and concrete, today it is rather biodegradable plastic" (1995:267). Although Bauman may not have meant his statement to be taken as literally as it is being applied here, the coupling of the two visions is manifest in the work of artist Richman Buthelezi, whose recycling of plastics into artworks is a symbol of hope in this new age.

The isiZulu phrase "*Siyafundisana*" can be literally translated "We teach each other." This simple sentence offers an apt approach to the complexities of Buthelezi's life and work. A lecturer in fine art at Funda Community College in the Diepkloof section of Soweto since 1990, he was recently presented with the *Weekly Mail and Guardian's* Green Trust Award for his commitment and contributions to the environment. This "inspiring man," as the journal described him, was honored by the judges for his "social conscience, creativity and sheer hard work" (Macleod 1998). His personal drive is coupled with a sense of shared humanity that allows him to draw continuously on his surroundings and return with renewed vigor for a "better tomorrow."

Before coming to Funda Community College (in 1986, when it was known as Funda Centre), Buthelezi lived in his hometown of Springs, studying art privately with artist Lucky Moema. There weren't many opportunities for young people to study art in the townships, especially those in the East Rand, but Buthelezi received lessons in perspective and drawing from Moema in exchange for bread and tea. Eventually he made his way to Johannesburg, where he began studying at Funda Centre. Commuting between Johannesburg and Springs in those days was always an adventure for the young artist—the country was in a state of

CAT. 15
Untitled.
By Mbongeni Richman Buthelezi, 1997. Melted plastic on wooden board. 123 x 97 cm.

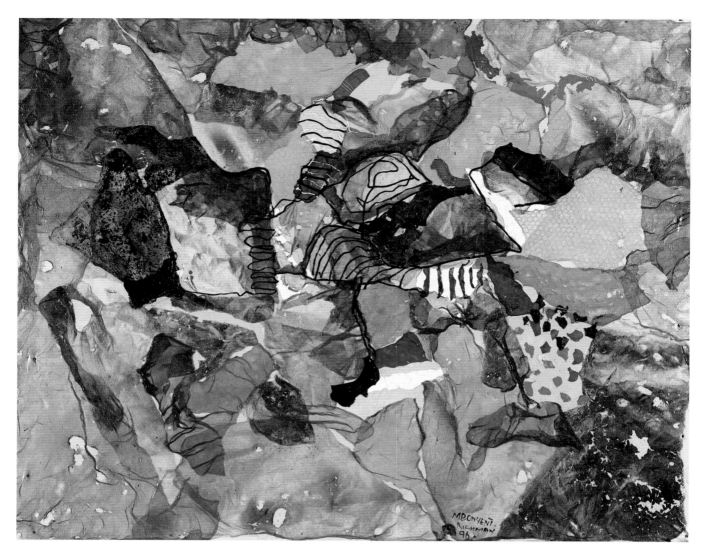

CAT. 16
Untitled.
By Mbongeni Richman Buthelezi,
1999. Melted plastic on wooden
board. 109 x 133 cm.

emergency. The trains, too, were flooded with *impis*, migrant laborers living at Jeppe Hostel, Germiston, and working in the mines around Johannesburg.

> *I was fortunate to come to Funda. It was the best institution; it was a black institution. I didn't see myself going to Wits or Wits Tech, I felt those were white institutions. The very best artists are coming from Funda. I want to be a role model to young up-and-coming artists, and I wanted older artists to see what I was doing.... The fact that it was in the township was important.*

Buthelezi originally came to Funda as a part-time student who wanted to be a sculptor. At the center, however, he met Charles Nkosi—BraCharles (slang for Brother Charles), as he is often called—who convinced him to try out other media, including drawing and painting. Buthelezi was financially hard pressed. For the three years he attended the center part-time, he worked during the week at his father's shop in Springs and went to school on Saturdays. His mother tried to contribute to his fees, drawing on the money she earned cleaning offices. Then, in 1989, Buthelezi won his first prize, the top honor in a drawing and design competition hosted by South African Breweries. Determined to be an artist, he enrolled at Funda full-time.

Moving to Soweto, Buthelezi lived in one small room. Even here he adapted creatively to his environment. He had left home with a blanket and a small bag of clothes. By folding the blanket in half, he found he could use the lower part as a sheet while keeping the top as a blanket; folded up during the day, the blanket could be used as a chair. The bag of clothes doubled as a pillow. Borrowing a small filament from an electric burner, Buthelezi could both keep warm in winter and cook food in a borrowed pot.

Things got easier in 1990, when Buthelezi was hired as a part-time lecturer at Funda. With his earnings of 150 rand a month, he could pay the 80-rand monthly rent for this one room, as well as the 20 rand a month he needed for transport, and still have 50 rand left for food. Of his work at that time he remarks,

> *I believe artists really played a major role in trying to address the issues in terms of the political situation in this country. When I first arrived at Funda, the statement that one read in the artworks was protest, all the way. Drawing a person in chains, you could just read the images. If you look at some of the images that were created in the '80s, you can really get an idea of what was happening in this country. I was hooked up into that myself, I mean, there was no way I could paint flowers, because there was so much for us to address. My images were of chains and broken crosses. We were trying to say, Here we are, and we have been crying and having these problems for a very long time. Some people were protesting for Mandela to be released, I mean, most of the political leaders were still in prison. And through art, we really needed to convey our messages.*

In 1992 Buthelezi completed his courses. He continued teaching part-time and ultimately became a member of the full-time teaching staff, as he currently remains. Since then he has also received commissions and several prizes—in addition to the South African Breweries prize mentioned above, he has won awards from Development Bank of Southern Africa, Martel V.O., and Momentum Life.

Funda Community College was an initiative to empower the disempowered majority community. From its inception in 1984, as the African Institute of Art, it fostered appreciation and opportunities for advancement for people in the visual arts. The African Institute of Art was one of three independently run projects at Funda Centre. The other two projects were the Madimba Institute of African Music and the Soyinkwa Institute of African Theatre. Like most community art centers in South Africa, Funda is still often stricken by financial crisis.

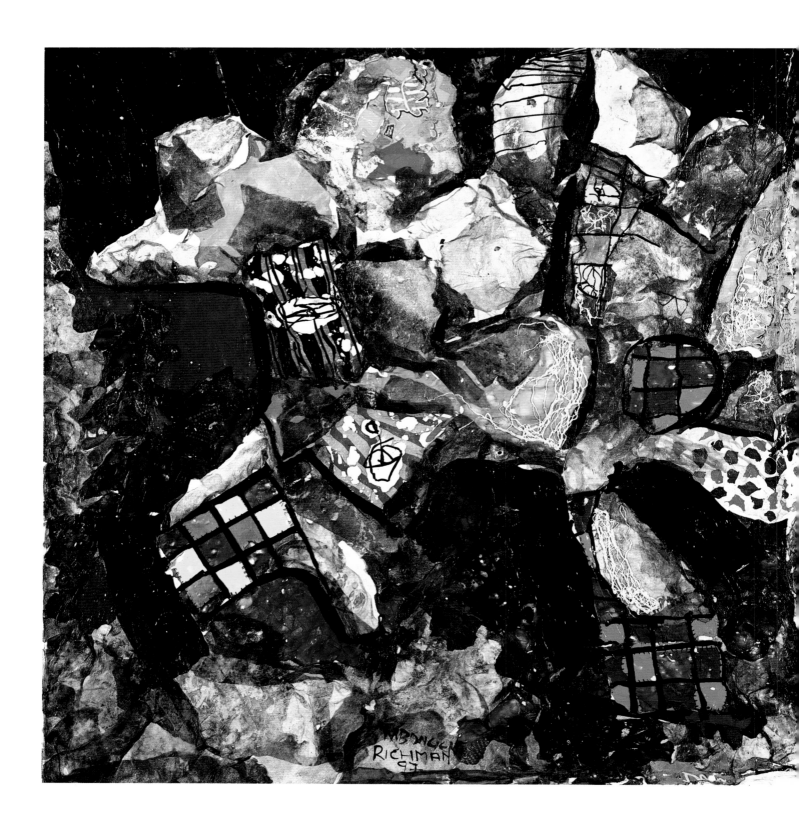

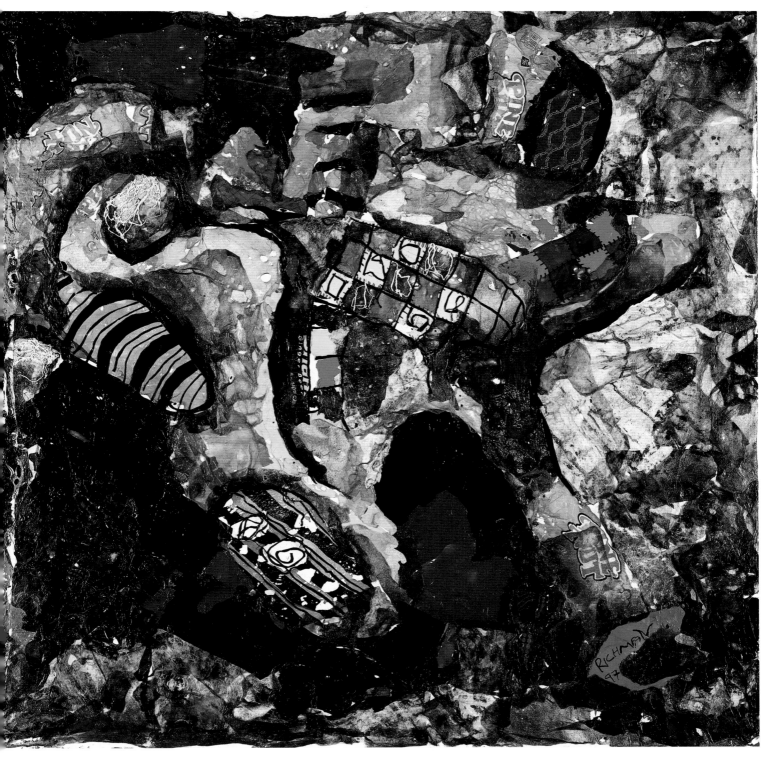

CAT. 19
Untitled.
By Mbongeni Richman Buthelezi,
1999. Melted plastic on wooden
board. Diptych: 123 x 244 cm.

Mbongeni Richman Buthelezi

Although a recent grant from the corporate giant Eskom and the Department of Education has kept it from closing, the future remains unsure. Unlike the universities that host well-stocked studios for their students, Funda Centre has had to use "survival strategies" to cope, as Charles Nkosi, head of the fine arts program, explains: "The problems that we have sometimes had in 'proper' materials acquisition prompted us to settle for unthinkable materials like PVA, rags, and plastic" (Nkosi 1994:27).

Given the punctuation of contemporary aesthetic discourse by such declarations as the "end of art," and lost as we are in an era of armchair digitalization of the domain of creativity, perhaps we should look toward so-called "developing" societies to initiate or reinvigorate productivity. Perhaps the apparent disadvantage of lacking access to materials actually forces articulation of the creative spirit in new and previously unperceived formulations. This is not to suggest for a moment that such disadvantages are fair, or to try to find the silver lining—in fact it is worse than unfortunate that most black South Africans still live in a society that is quite outside their control, and, further, within the constraints of a white-dominated social structure. In the arts, for example, Johannesburg has only two significant commercial galleries, both of them owned and operated by whites, and it is whites who control the market, as both buyers and sellers. Yet now that South Africa is without an overt ideology, such as apartheid, to combat forcefully, the new, nonracial, abstruse policies of the current government allow only more subtle forms of resistance. As Herbert Marcuse suggests, "The autonomy of art contains the categorical imperative: 'things must change.' If the liberation of human beings and nature is to be possible at all, then the social nexus of destruction and submission must be broken" (1978:13).

But where to start? For Buthelezi, it begins with the environment.

> I needed to convey this message to people: art is not about the kind of materials that one can purchase, art is about how one puts things together to get something out of it. The use of so-called recycled waste materials is something people need to know about. Because our environment is just horrible.... At the end of the day, I believe one needs to contribute, to do something for other people. It's good if people look at my work as a way of contributing to the environment. I want people to look further and appreciate the effort and hard work that one is doing behind everything. Sometimes I use up to 4,000 to 5,000 plastics just to complete one work.

President Thabo Mbeki concurs, "The process of globalization emphasizes the fact that no person is an island, sufficient to himself or herself. Rather all humanity is an interdependent whole in which none can be truly free unless all are free, in which none can be truly prosperous unless none elsewhere in the world goes hungry, and in which none of us can be guaranteed a good quality of life unless we act together to protect our environment" (1998).

South Africa has signed at least twenty-four major international agreements on environmental preservation. In 1989, it signed the Environmental Conservation Act (no. 73), which called for a system of "Integrated Environmental Management"—which, however, gave precedence to development. Many business and community leaders place development of the infrastructure far ahead of environmental issues. But the legislation does set out to "preserve species and ecosystems, to maintain ecological processes, and to protect against land degradation and environmental deterioration resulting from human activities" (Clarke 1997:238).

One of the primary causes of environmental degradation in South Africa is the industry on which the country has built its fortunes. Mining, especially along the Witwatersrand, puts industrial wastes and pollutants into the environment. The separation of gold from ore produces solid wastes that lie in dumps along the road to Soweto. Liquid wastes that are

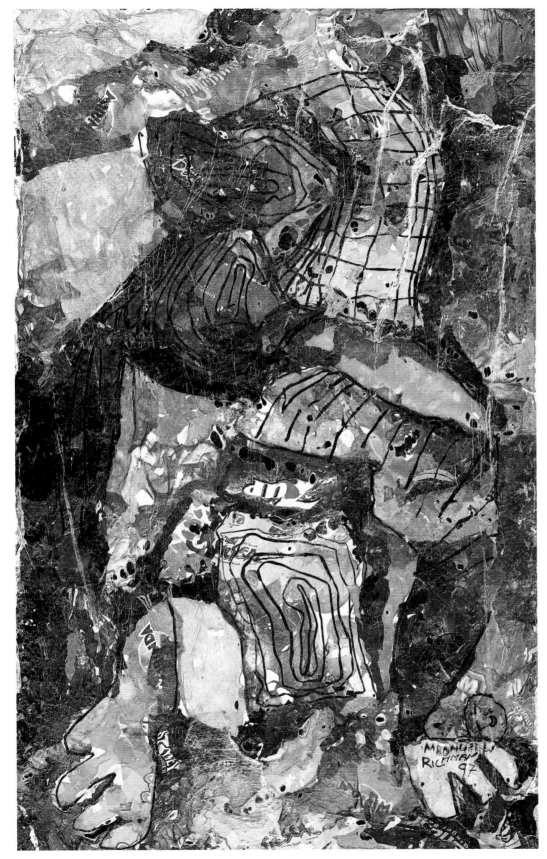

CAT. 17
Untitled.
By Mbongeni Richman
Buthelezi, 1997. Melted
plastic on wooden board.
142 x 85 cm.

Mbongeni Richman Buthelezi

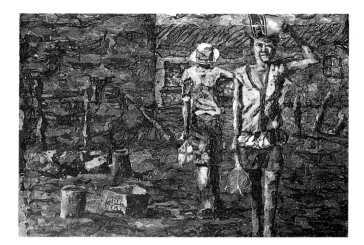

Fig. 17
Soweto Midday Blues.
By Mbongeni Richman Buthelezi,
1995. Melted plastic on
wooden board. 120 x 80 cm.
Artist's Collection.

collected in pits contain radioactive uranium. Acids and chemicals contribute contaminants to the water supply. Streams around Johannesburg townships such as Soweto have been found to contain uranium, sulfates, cyanide, and arsenic (Thornton and Byrnes 1997:102).

A further contributor to environmental worries is rapid population growth. The population of South Africa is expected to double by 2025, and by that year one half of the population may be living in "grinding poverty" (ibid. :239). In the most densely populated area in the country, Gauteng province, the average density may exceed 300 people per square kilometer, according to a study done in 1994. More than 7 million people—nearly 17 percent of the population—live in Gauteng, which constitutes less than 2 percent of the land area of South Africa. Further, Gauteng provides almost 38 percent of the country's total economic output (ibid.:108).

After the 1994 elections, the new government formed a Department of Environmental Affairs, and charged it with coordinating environmental policy. These issues have also been incorporated into the Reconstruction and Development Programme. Yet the government has been criticized for lack of results: the priority of "economic development and improved living standards among the poor appeared likely to outweigh long-range environmental concerns for at least the remainder of the 1990s" (ibid.:103).

A vital issue for Buthelezi, then, is to convince the members of his community on the local level to appreciate their environment. In 1992, he attended a workshop at an exhibition organized by the Swedish artist Luca Genser and the late Matsemela Manaka at the Nasrec Showgrounds in Johannesburg, where Genser demonstrated ways of using alternative materials for artmaking. Buthelezi was struck by Genser's use of a heat gun to melt plastics onto a backing of canvas or board. Although Genser used only one color, which he would often couple with acrylic paint, Buthelezi imagined ways of negotiating plastics that would allow an intermixing and layering of their colors and textures.

As early as 1964, Thelma Newman wrote, "Plastics have created a silent revolution in our time" (1964:1). She had already recognized that "their unusually plastic, formable quality ... makes them a natural material for the artists' studios as much as marble, bronze, clay or iron" (ibid.:2–3). And she continued, "The new plastics' strange potential is bound to change traditional art forms because of the new technical demands and innovations that the substance requires.... These new materials reach frontiers heretofore unknown to creative users of traditional media because they are capable of going beyond the capacity of other substances" (ibid.:3). Indeed they do, and Buthelezi's use of them has further advanced their possibilities—especially when one realizes that the dramatic effects he achieves are the results of a transformation of waste products, products that had served their purpose and

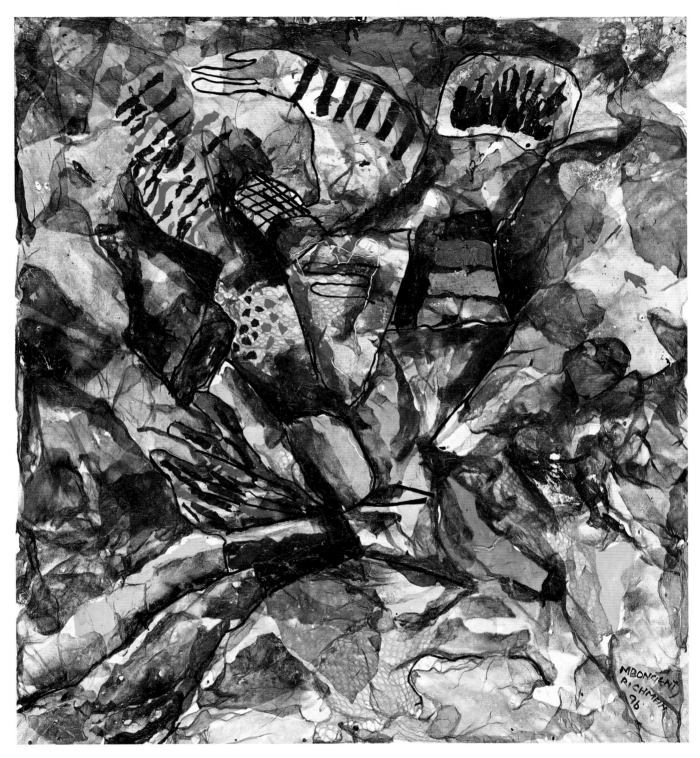

CAT. 18
Untitled.
By Mbongeni Richman Buthelezi,
1996. Melted plastic on wooden
board. 123 x 108 cm.

were in any case never meant to be art. So engaging are Buthelezi's works that one is tempted to reach out and touch them—just to be sure that this really is recycled plastic. For otherwise one would not know, except in the occasional cases where a hint of a label or image in the material reveals its prior life.

This tactile temptation helps to bridge the gap between artist and viewer. It is a link, an entrée into dialogue, between the Soweto township and the work's spectator. In postapartheid South Africa, the dividing lines are no longer neatly drawn—not that they ever were to begin with, yet spatial relations have changed, and the location of the line in the negotiation of self and other is now more ambiguous than before. At the same time, the country still resonates with economic and social dispossession. Although black South Africans can vote, and a meager few have made financial advances, the majority of the majority still live in squalor. Sensitive to these issues, Buthelezi presents the viewer with a continuation of the struggle narrative that many in the world might think had ended in 1994. His presentations, as beautiful as they are, are his way of transforming and transcending his environment—in a sense, of taking control.

Buthelezi's earlier works were much more figurative, depicting township life in a relatively realistic style. When asked why he has moved away from the figure, the artist explains that although he feels his work has undergone a stylistic reevaluation, it still contains figurative elements and forms:

> When I started, I wanted to understand and play around with technique. If I can work on images that are easily recognizable, it will allow me then to do whatever I want to do with this technique. And I believe that making figures was the best way to handle this. But yes, there is this shift and the basic reason for that is sometimes I feel slightly restricted working with figures. I need to explode to say all I want to say. I think this approach, this abstract, semiabstract approach, it allows me to say it all, without restrictions.
>
> The kinds of forms and organic shapes that I am now working with, to me, it is easy for people to relate to that. They are the kind of shapes, images, that people are familiar with. For example, there is a work entitled Soweto; in the shape of that work I was trying to capture the aerial view of Soweto. I didn't plan its shapes, because I don't think Soweto was planned either; people were just dumped here as cheap labor. And I just said to myself, this is my Soweto. It's a shape that develops and changes all the time.

Maurice Merleau-Ponty says of Cézanne that the artist would look deeply into the landscape, then weld a series of partial views to "recapture the structure of the landscape as an emerging organism" (1977:98). Buthelezi's images, similarly, are replete with a dynamic movement in which images and counterimages engage one another in rhythmic patterns of line and color. Figures appear and disappear as one tries to locate the image's center.

An untitled diptych shown in 1997, for example, proceeds across its two panels to envelop a continuous form. Nebulae and tentacles embrace each other in a continuous sea of images, the space encoding tensions and altered states. At first glance, the medium in which these forms are created seems to embody properties of watercolor painting, with bold strokes over-lying soft washes. The richly modulating figures are encompassed in dark lines, their fineness reflecting Buthelezi's mastery of the material—which, of course, is actually discarded plastic. Are the figures dancing with joy? Withering in pain? Or are such emotive patterns coupled here, and indistinguishable from one another? In a sense, the painting may be describing the perseverance and adaptive abilities of the people sentenced to live in the township, a place where sorrow persists but humor prevails. As Bauman writes, "Under the circumstances, the opposition between conservatism and creation, preservation and critique, collapses. The

imposition of the opposition is aptly grasped by the idea of recycling—which blends preservation with renewal, rejection with affirmation" (1995:77).

Fig. 18
Animal Cage.
By Mbongeni Richman Buthelezi, 1992. Melted plastic on wooden board. 120 x 80 cm. Artist's Collection.

> *In Soweto, people tend to ignore their environment, they don't care. I even used some newspapers on the canvas with the aim of trying to capture the actual color of the township, because the browns, they resemble, they capture, the actual roughness of the township, the dirtiness, the dullness, because there is no spark of life at all. In winter it is just dull. In Soweto, they chop down trees to build shacks, they build scrap yards—there are few trees. And in winter, they burn anything. At any given time one can smell the burning of Soweto.*

Other items peer through the melted plastic, including discarded newspapers and chicken wire. Direct borrowings from Buthelezi's surroundings, these items add not only texture but meaning. The choice of newspaper clippings is not accidental; those selected often preserve one of the stories of victimization and horror with which the "imagined community" of Soweto township engages every day (Anderson 1983). According to *The Star* ("Reality Check Supplement" 1999), at least one in three people in Guateng has been the victim of a crime. One newspaper columnist recently quipped, "We have all, at one time or another, been victims of crime. Anyone who hasn't must be extremely lucky or spend half the year elsewhere in the world" (Malala 1999:24). Living in inhuman conditions makes people do inhuman things; the levels of child abuse, rape, and murder in South Africa are among the highest in the world. Buthelezi's simple chicken wire, like the barbed wire fencing it represents, casts horror on the forced removals and disrupted lives contaminated by apartheid and colonization, and perhaps recollects a time when the land could be harvested and livestock reared in relative freedom. As Thoreau contended after his reflections at Walden Pond in 1847, "I am convinced, that if all men were to live as simply as I did then, thieving and robbery would be unknown. These take place only in communities where some have got more than is sufficient while others have not enough" (Thoreau 1993:30).

When asked what he hoped this exhibition's non-South African viewers would see in it, Buthelezi replied,

> *I think really people will understand that the works are from Soweto. And they should fully understand the kind of environment that one is exposed to. Really, our everyday life, my everyday life, in this area, is very harsh. I'm sure people out there in America will definitely understand this is the type of environment these people are exposed to. If I didn't buy anything in creating these artworks, it will really make people think, Where did you get this plastic all over the place?*

Despite the hardships and struggles of everyday life in Soweto, Buthelezi's unyielding optimism is the most striking feature of his personality. As he explains,

> *I'm the kind of person who never gives up. I tend to give anything a chance—I'll try and fail and try and fail.... Because I always believe that tomorrow will be better than today, always, as long as I keep on working as hard as I can, all the time. I don't just give up easy. I push all the time, I struggle. Because through working hard, nothing is impossible, everything is possible.*

Silent movies in those days.

They were told by their sailor men that Africa was a savage place.

"In Africa!" they exclaimed.

Charmed lives!

Nothing to fear.

What do you know of the real world?

Penny Siopis: The Storyteller

Jennifer A. Law

i.

A fetish is a story masquerading as an object.[1]

ii.

"Talk," she commands.

This is idiotic, if not a deranged thing to say to a bowl, even to a bowl like me, thin-walled, sporting the scorpion look of Samarra-ware that was the rage of Mesopotamia six and a half thousand years before Rosa was born. Pottery, after all, isn't renown for its chatty nature, so why futilely address a vessel thus, even me, the bowl with soul? But Rosa is far from being unhinged.…

Rosa goes for the phone, "Yes, it's genuine, but … I don't know how to put this, I'm not sure what sort of genuine it is. I'd like to hang on to it for a bit longer." Silence. "It's difficult to explain." Silence. Listening. "Well, you'll think me crazy, but I have the feeling the bowl is lying." This will be hard work.[2]

iii.

The Physiognomist

Long have I been intrigued with the idea of an object as narrator. As the saying goes, "If these walls (chairs, lamps, cutlery, bowls . . .) could talk, what tales they would tell. . . ." Any true collector, I think, can identify with this somewhat whimsical desire. Walter Benjamin, for example, in his well-known essay on book collecting, claims that for the antiquarian, "the book itself must speak."[3] Indeed, if we are to believe Benjamin that "owner-ship is the most intimate relationship one can have to objects,"[4] then it follows that one might like to hear what they have to say. The "most profound enchantment" for the collector, as Benjamin explains, "is the locking of individual items within a magic circle in which they are fixed as the final thrill, the thrill of acquisition passes over them." In that captivating moment, the object comes alive in a flood of memories and imaginings—"the period, the region, the craftsmanship, the former ownership"—in which the "whole background of an item adds up to a magic encyclopedia whose quintessence is the fate of his object."[5] Thus does the collector become a great physiognomist in the world of the material—an "interpreter of fate."

South African artist Penny Siopis is such an interpreter: "A silence-taker. A diviner. A vase tickler. An intruder."[6] She is an enchantress, able to wondrously transform the ordinary into the extraordinary; able to animate the inanimate. She is Benjamin's physiognomist, holding the collected object as a small world toward a future etched out of history and memory. She is a collector, collecting a life still living; a soothsayer, procuring blood from a stone, seeking truth in simulacra. Each object drawn to the artist embodies an extended moment urged forward toward its destiny. Curios seem to accumulate indefinitely around her—in her home, her work, her life. The collector gathers the world to her breast. Yet a closer glance witnesses the collector gathered to the breast of the world.

CAT. 20
My Lovely Day.
(video projections)
By Penny Siopis, 1997.

Penny Siopis

Like Benjamin, Siopis recognizes the emancipatory potential in the act of collecting. In being gathered the object is freed, released from the bondage that keeps it tethered to its origins. Through the collection, the object is able to become, to add another narrative to a biography-in-process. While some may witness the object die on the shelves and glass cases of the antiquary, the true object-diviner collects to renew, to rescue the thing from its anonymity, to offer temporary reprieve from the commodity realm. For the artist-collector recognizes the manifold stories inhumed in the object awaiting a voice for which the diviner herself acts as a medium. With this in mind, Siopis's recent practice has increasingly turned toward strategies of autobiography and documentation via the genealogy of the object as a means of engaging and critiquing private and public histories, while simultaneously staking out and challenging originary claims of legitimacy and "belonging" as a white South African. As Igor Kopytoff maintains, "[b]iographies of things can make salient what might otherwise remain obscure."[7] It is her life which the artist collects and the life of a nation in the tentative years of democratic emergence. Thus, amidst the rhetoric of nation-building, Penny embarks on an ongoing and indefinite project of nation-collecting.[8]

By examining the work of the artist in overview (however abbreviated), it is possible to map the ways in which specific objects and kinds of objects emerge as significant markers of personal and collective history, sometimes multiply resurfacing in different works and contexts spanning two decades. These key objects, fetishes if you will, take on new meaning with each resurrection. In this, they are not markers of fixity, so much as symbols of transformation. They come to represent, in some small way, the potential for emancipation. The objects that make this possible are not things of aura, but rather those material traces which appear ready-to-hand. The contemporary artist, as object-*monteur*, does not "shy away from cutting up the fragments ripped off the world," but rather uses them to create "an optics oriented to action."[9] She takes on various guises in the profile of the (re)collector—physiognomist, inquisitor, fetishist, surrealist, illusionist, exorcist—and in so doing creates herself anew with each addition to her collection. Indeed, as regards the nation: "These collector[-selves] with their scavenger sensibilities promote a profoundly democratic attitude to the world of the material that can function only as a critique of what is."[10]

The Inquisitor

There is a childish impulse in the act of collecting which, via the power of the imaginary, seeks out a new and fantastical world from amongst the mundane objects at hand. Every object found harbors within it the revolutionary potential to metamorphose into something other than what it is: "prickly chestnuts that are spiky clubs, tinfoil that is hoarded silver, bricks that are coffins, cacti that are totem poles and copper pennies that are shields."[11] The child collector is a tireless inquisitor, whose ceaseless questions of the world seek answers in material experience. Scarcely has she entered life, than this puerile diviner "hunts the spirits whose trace [s]he scents in things."[12] Each carefully conscripted item gleaned from the rich trove of the domestic realm is hoarded into her personal archive, where she purifies it, secures it, casts out its spell. Through the most ordinary of objects, the child takes possession of an inaccessible world, and discovers through the imaginative act of material transformation, the endless interpretations and potentialities of an ill-experienced history set against a future not-yet-formed.

It is this romantic, inquisitive relationship to ordinary, yet nonetheless enchanted, objects upon which Siopis bases her practice of collecting. Indeed she tells us that "childhood memory, or the memory of childhood, is the substance of autobiography."[13] Through autobiographical

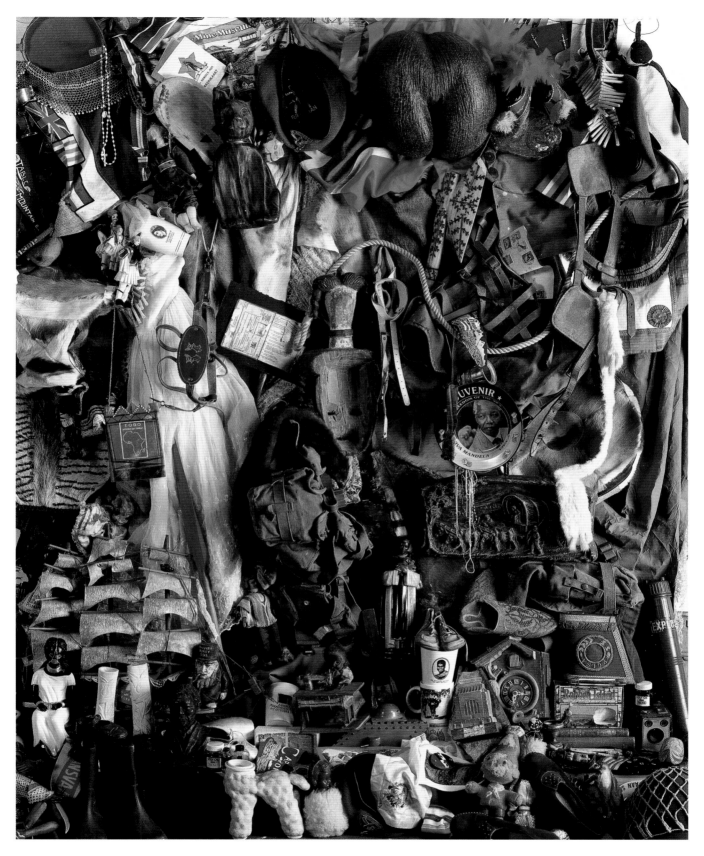

memory, imaginative play assumes a transformative, mimetic, magical capacity that awakens "an originary impulse to revolution that exists in the child."[14] After all, it is, as Benjamin reminds us, the play that makes the toy, not the toy that determines the play.[15] Such magic is not to be found exclusively in the work of art, but in the vernacular objects that perpetually circulate around us and bind us to the world. The promise of emancipation reveals itself in the copy, the print, the mass-produced kitsch wrought from an age of mechanical reproduction, as it did for Benjamin over half a century earlier. The work of art remains intangibly aloof in its singular transcendence. Only the facsimile can disentangle its image from the thick fabric of tradition that tethers it to history, and thus liberates the thing from "its parasitical dependence on ritual."[16] Once the criterion of authenticity ceases to bind the object to its origins, the production of the artwork "begins to be based on another practice—politics."[17]

Penny recognized the revolutionary potential of simulacra long before the appellation of truth was pressed to the lips of a nation in the throes of confession. Over the past two decades, a striking body of work has grown out of domestic debris. The artist covets those vernacular treasures so often abandoned in our insistence on relinquishing the profane in favor of the sacred. Modern capitalism has hardened the serious collector of art against the crass availability of the promiscuous copy, for surely it stands to reason that truth may only be found in a demure original, which affects a certain constraint? Where the objet d'art coyly hides behind its aura, demanding pilgrimage, kitsch appears off-the-rack, cheekily advancing upon the consumer in all its plastic affectation. It seems candid in its intention, for kitsch does not hide its meaning behind a patinaed veil of scholarly conjecture, but rather prefers to flash its naked signification for all the world to see.

As it is linked to the copy, however, kitsch remains indelibly marked by duplicity, mimicking the a priori, pretending to be something it is not. It conceals, even as it reveals. We mistrust its ability to belong to more than one, for it offends our individuality. Nevertheless, kitsch succeeds in awakening within us a sentimental humanity, deriving from the basic images people have engraved in their memories turned maudlin in retrospect. Born out of the romanticism of the mid-nineteenth century, kitsch has come to exclude "everything from its purview which is essentially unacceptable in human existence."[18] The political fuels itself on such economical utopianism, appealing to mass affectation. As Milan Kundera writes, "Kitsch is the aesthetic ideal of all political parties and all politicians."[19] It draws us in through raw sentiment. Siopis explains: "Affect lies in the play of artifice. Encounters with 'things' can produce in human beings extreme identification, so much so as to bring on tears."[20]

In a democratic society, such mundane moments of collective transcendence are punctuated by healthy doses of individual inspiration. Kitsch must constantly redefine itself, competing as it does for attention alongside various other forms of propaganda. The consumer can well afford to select from a range of potential influences. In contrast, the totalitarian regime seeks out a singular image, a representation which is representative, thus endeavoring to efface the gap between the signifier and the signified, to collapse the divide between civil society and the state, so that the one speaks for and through the other. In this, the portrait of the body politic appears coherent and totalizing, drawn out of what Kundera refers to as the realm of "totalitarian kitsch":

> Those of us who live in a society where various political tendencies exist side-by-side and competing influences cancel or limit one another can manage more or less to escape the kitsch inquisition: the individual can preserve his individuality; the artist can create unusual works. But whenever a single political movement corners power, we find ourselves in the realm of totalitarian kitsch.

Penny Siopis

Fig. 19
Piling Wreckage Upon Wreckage....
By Penny Siopis, 1989.
Oil on canvas,
200 cm x 181 cm
Collection: South African
National Gallery, Cape Town
Photo: Bob Cnoops, repro-
duced courtesy of the artist

When I say "totalitarian," what I mean is that everything that infringes on kitsch must be banished for life: every display of individualism (because a deviation from the collective is a spit in the eye of the smiling brotherhood); every doubt (because anyone who starts doubting details will end by doubting life itself); all irony (because in the realm of kitsch everything must be taken quite seriously). . . .

In the realm of totalitarian kitsch, all answers are given in advance and preclude any questions. It follows, then, that the true opponent of totalitarian kitsch is the person who asks questions. A question is like a knife that slices through the stage backdrop and gives us a look at what lies behind it.[21]

During the height of civil unrest in the mid to late '80s, Siopis set out to reveal the thickened artifice behind the facade of a faltering regime. The spoils of Empire, objects of myth and monument, are thickly painted into increasingly claustrophobic spaces—tables threatening to cave under the burden of luxury, mountains of affluence blotting out the horizon. The protagonist of these works emerges as the personification of psychic disorder. This image of a nation terrorized from within parallels a subject that envisions itself diseased. It is a self that longs to be whole and yet remains irreconcilably incomplete, and in so being seeks to fill its sense of lack with gross accumulation: a desperate act of acquisition mimicking the scramble to collect and possess a continent.

The works produced during this period—*Melancholia* (1986), *Patience On a Monument—A History Painting* (1988), *Exhibit: Ex Africa* (1990)—are built, both literally and figuratively, upon the debris of history. The objects amassed here fight for room, suffocate in frivolity, clamber to escape from their constrictive backdrops. The still life is anything but still. In *Piling Wreckage Upon Wreckage* (1989), a distant figure, perhaps Benjamin's *Angelus Novus*, pulls back a white veil from the thick detritus of Empire, priceless heirlooms scattered alongside domestic commodities, objets d'art relinquished to kitsch. Andreas Huyssen writes that "objects that have lasted through the ages are by that very virtue

located outside of the destructive circulation of commodities destined for the garbage heap."[22] But not even their aura can prevent these treasures from succumbing to obsolescence. Gilded frames, sterling candelabra, marble cornices, fragments of classical statuary piled up like so much refuse—the monumental exposed as ephemeral.

The angel of history cannot tear his gaze from the past, but stares helplessly backwards as the mountain of futile objects expands forever beyond the boundaries of the frame. Perhaps he struggles not to uncover history, but rather to conceal it beneath a cloth that is hopelessly inadequate. He cannot see beyond, nor can he close his wings to the violent force that propels him blindly toward an unknown destiny. Benjamin writes:

> This is how one pictures the angel of history. His face turned toward the past. Where we perceive a chain of events, he sees one single catastrophe which keeps piling wreckage upon wreckage and hurls it in front of his feet. The angel would like to stay, awaken the dead, and make whole what has been smashed. But a storm is blowing from Paradise; it has got caught in his wings with such violence that the angel can no longer close them. This storm irresistibly propels him into the future to which his back is turned, while the pile of debris grows skyward. This storm is what we call progress.[23]

Despite the angel's inability to resist the forces of time, there is a glimmer of hope in the eye of the storm—that center of calm caught in the midst of irrevocable catastrophe. Benjamin envisioned the role of collector-historian as involving the recovery of that "hope in the past"; of intercepting the instant preceding betrayal, through the recovery of desire deposited in the historical fetish. The pile of debris represents that which longs to be whole and seeks to be renewed. But the artist retrieves these things not with the intention to recover them intact, but rather to exploit their partiality, to interrogate them as fragments, to transform them in the present, and thus exorcise the trauma that keeps them obligated to history. The resurrection of these things represents a political awakening. Benjamin writes: "Every smallest act of political reflection marks a new epoch in the antique trade. We are constructing here an alarm clock that calls the kitsch of the previous century 'to collect en masse.'"[24]

The Surrealist

Benjamin's alarm clock, of course, was Surrealism,[25] but we can see that Siopis employs similar strategies to awaken the world to the horrors of apartheid. Likewise concerned with psycho-analysis and the conditions of the unconscious mind, Siopis challenges the viewer's grasp of reality by presenting the most banal of objects in dreamlike contexts. Her installations are elaborate stagings, at once spontaneous and yet meticulously deliberate, reliant upon the fortuitous mechanisms of juxtaposition to produce affect, to change the meaning of the thing as it is coerced into contact with objects outside of its customary circuit. Through accumulation, the artist-inquisitor seeks to unmask these relics as mere props to social life—to reveal the representative as mere representation. Kitsch, in all its garish sentimentality, cannot help but expose itself. In so doing it solicits "an inquest into social desire," which Benjamin deems revolutionary.

Salvador Dalí famously spoke of the paranoiac-critical strategy of Surrealism as "essentially a method for the creative misreading of the visual world."[26] Siopis bases her fantastical accumulations on a similar model: a model that serves as form of interrogation, seeking truth in delusion, and clarifying vision through oversight. Based upon the investigations of Freud and Lacan into the nature of psychosis, the paranoiac-critical method allows the artist to "reorder the world according to . . . interior obsessions," to create "a space where

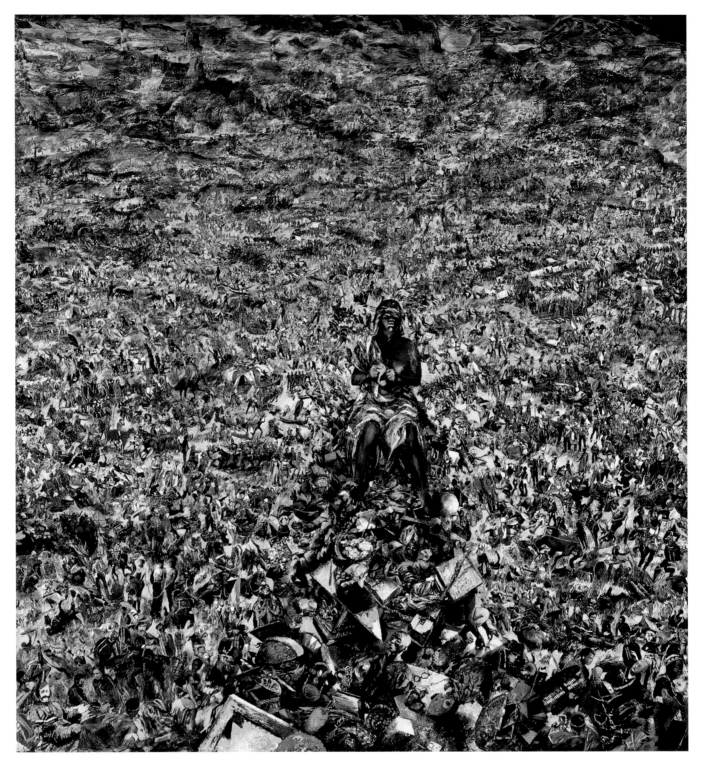

Fig. 20
Patience on A Monument -
"A History Painting" (detail).
By Penny Siopis, 1988.
Oil paint and collage,
200 x 180 cm.
William Humphries Art Gallery,
Kimberley.

Penny Siopis

Fig. 21
Sacrifices
(detail of white window panel).
By Penny Siopis, 1998.
Mixed media installation,
Holdings: Refiguring the
Archive, Wits Graduate
School, Johannesburg
Photo: Natasha Christopher,
reproduced courtesy of the artist

everything you see is potentially something else."[27] Such an illusion is accomplished through the use of simulacra, doubled objects, which root themselves in ambiguity and thus exploit the potential to represent more than one thing, meaning or experience simultaneously. The familiar is thus made foreign, the boundary between the real and the imaginary blurred, and the viewer induced to paranoia.

Increasingly the two-dimensional painted surface of the artist's work, burdened by the weight of accumulation, succumbs to tactility. Coagulated objects slowly turn plastic and emerge from the photocopied pages of history, school texts are reproduced as wallpapered background to the surreal (re)staging of inherited memory. It is as if the painted surface of the earlier works could no longer restrain the urgency of the real. Objects leak from the surface, gradually oozing over into installation. The sensuality of simulacra demands contiguity. Our curiosity is fueled by a childlike instinct to touch, to hold the object to us, particularly where such tabooed transgressions are forbidden or unrealizable. The thrill of a stolen caress quickens our breath and heightens perception. Seeing, as the artist tactfully reminds us, is conditioned by proximity, which promises to bring us closer to possession, that most intimate of relations. Siopis links this need for tactile possession to the desire to fill an absence that cannot be realized through mere immaterial signification:

> That we demand of the phenomena world that it be a bearer of meaning for us, to "act" as witness is undisputed. So we search the surfaces of things, penetrate them, open them up. We treat them as if they were human. To kiss a photograph or hold it close to one's heart is not an uncommon act. This fascination with looking as if something will be revealed before our eyes, is usually associated with personal memory, intimacy, and often happens in the domestic sphere. But with collective memory other places are needed for us to share and feel intimate within a broader community, a nation. This is apparently most true in times of political and social conflict. Museums and other sites become heavily invested and contested as they signify the place of holding our collective imaginary.

But in these contexts our seeing is conditioned by our not touching. We do not kiss the exhibits, but may only cry if we dare, at arms length. We see too in ways which are

concealing—only one side of the object, the side displayed, only in a certain fixed light, only this way, only that way. Our looking is fixed in glass cases.[28]

The museum, as public repository of the nation's valuables, disciplines our looking. It creates and maintains the aura of the object as collective heirloom, and in so doing creates a fetish of history. The historical fetish is that object which is both empowered by its association with an originary moment of trauma, and simultaneously shackled to that history as representative of some fundamental truth. For the collector, it serves as a point to anchor the gaze and project that which threatens to consume. Like the surreal object, the fetish allows the individual to touch, possess, and manipulate the psyche's innermost desires and phobias, to put a finger on an absence. Such an object thus embodies the ability to transform the detritus of history, the abject, into a thing of power. It teases; fruitlessly promising to complete that which remains irrevocably fragmented.

The Fetishist

The reading of fetishism in Siopis's work is multifaceted and well worth investigation. Her engagement with such objects of power and compensation intersects with that of ethnography, feminist discourse, psychoanalysis, and Marxist consumption theory. Siopis is well aware of Modernism's Primitivist interest in the fetish, which sought to harness the exotic and the cabalistic power of otherness, particularly as associated with Africa, veiling it—once possessed—in a shroud of mysticism, eroticism, and paternalistic desire. Such voyeuristic curiosity sought an object simultaneously sacred and profane, enveloped by myth, and hiding within it something that the collector, despite self-proclaimed enlightenment, somehow lacked—a truth deemed closer to nature, perhaps. Significantly, the fetish that obsessed the Primitivist collector was not pure in its conception, but was rather born of contact, though its appropriation generally sought to hide or ignore all evidence of this. Nonetheless, the fetish persists in integrating the ancestral with the avant-garde, the folkloric with the technological. As John Mack writes, the fetish "is firmly anchored in the space between cultures, one of the most potent zones of mutual misunderstanding."[29] To the nineteenth century collector, the fetish came to represent all that was primitive and irrational about the Other. Yet, Siopis recognizes that the production of such an object is anything but. Carefully meditated and mediated, the creation of a fetish is neither an act of accommodation nor submission, but rather one of seizing and exerting control over one's destiny. As it is conceived by the diviner, the fetish is never intended to be considered in isolation, but is rather instituted as a processual object, a prop to performance and fulfillment.

It is no coincidence that the term was appropriated by Marx in all its nineteenth century mysticism. For Marx, who satirically associated the fetish with "irrational valuation,"[30] the value of an object was determined by the social relations of its production, which under a system of capitalist exchange, could only be negative. In requiring a subordinate producer to manufacture goods for the consumption of the ruling classes, the mode of production is made remote and the producer alienated from the product of his labor, which in turn becomes fetishized. As a result, the individual fails to recognize herself in the world she creates: "[S]elf-realization is no longer an end in itself, but becomes purely instrumental to the self-development of others."[31] The fetish-like power of the commodity—"which drives a wedge between the two dimensions of the self, individual and communal"[32]—is thus unrelated to the "true" worth of the object. It casts a spell over the ego, which may only be broken when the producer begins to create objects in the fashion of the artist—for the fulfillment of the self.

Penny Siopis

It is little wonder that the fetish finds its way onto the analyst's couch. Entangled by Freud in the Oedipal/castration complex—that traumatic realization (by the male child) that the mother lacks a penis—the fetish comes to assume its role as prosthetic, lured into the processual triangulation of disavowal, transference, and compensation. Where Freud left off (some would say, left out altogether) the female relation to the fetish ("the factor of sexual overvaluation… [in women] is still veiled in an impenetrable obscurity"),[33] feminist theory picks up, examining feminine sexuality in terms of displacement and difference, pathology and surrogation.

Siopis does not collapse these various forms of fetishism in her work, but rather allows them to play off of one another. The female fetish made its first appearance in her "cake" paintings of the early 1980s—delicate pastries sculpted out of paint, candidly (even humorously) reminiscent of breasts and female genitalia. Yet the fetish is most at home, as Roger Malbert notes, in "the realm of objects and their photographic representations, rather than [in] painting; [for] the latter can depict but not embody the absolute fixity of association that the fetish demands, it can never become the thing itself."[34] With this in mind, these early painted fetishes are gradually replaced by more tactile prostheses of the female body, perhaps most interestingly realized through the artist's recurrent use of the mannequin, that corporeal "prototype of the uncanny, an article of furniture in human form."[35] Likewise a choice prop of the Surrealists, the mannequin frequently appears, as prophesied above, in both the artist's recent installations and related photographic work—eerily faithful to the corporeal, and yet unmistakably artificial. Never one to be content with mere face value, however, Siopis encourages these prosaic doppelgangers to mingle with more "authentic" traces of the body, dioramic figures on temporary leave from their sacred prosceniums. Such obsession with authenticity is itself a form of fetishism.

For Siopis, there is a natural progression from installation, as *tableau vivant*, into film. Where the painting "invites the spectator to contemplation," the film incites in the viewer a rapid series of sensory shocks with each successive flash of the image-frame: "No sooner has his eye grasped a scene than it has already changed. It cannot be arrested."[36] The film disrupts the mundane, moving the masses to distraction, meeting the mode of reception halfway

Fig. 22
Mostly Women and Children
(detail). By Penny Siopis, 1996.
Mixed media installation,
Fault Lines exhibition, Castle of
Good Hope, Cape Town
Photo: Jennifer Law, reproduced
courtesy of the artist

Fig. 23
Reconnaissance: 1900-1997
(detail of film reels used
for *My Lovely Day*).
By Penny Siopis, 1997.
Mixed media installation,
Lift Off exhibition, Goodman
Gallery, Johannesburg
Photo: Hannelie Coetzee,
reproduced courtesy
of the artist

and thus transforming the viewer into participant-observer. It is more than the representation of performance, film is a prop to social life, taking its place within Siopis's ever-growing collection. It makes material that which is immaterial. In tearing through the vernacular, the film promises release, if not quite fulfillment. Indeed, itself a prosthetic of the real, the film nurtures an interesting relationship to more overtly corporeal fetishes, like dioramic casts, stage dummies, and stunt doubles. The artist writes:

> I consider the film a prop in some way. This is not without some discomfort, as I have a complex relation to props, and the idea of a prop is central to much of my work. The prop may be thought of as allegorical, embodying as it does notions of theatre, playacting, making scenes, illusion, being craft and imaginative in an all too real world…
>
> When I was young, my mother—always a good liberal—was a member of the African School Feeding Scheme. In exchange for the money she regularly gave to the scheme, she was invited to theatrical performances produced by [Athol] Fugard and his group "The Serpent Players." As most people know, Fugard has since become famous and some of his plays have become films. One such is "Boesman and Lena." My mother was asked to make the prop of the character Outa, the black man who gets kicked around in the play. This prop was to be used in those violent scenes in the film where an actor could not be used. The prop was thus a proxy for the staging of violence against an actual person. It was a strange experience having Outa in our house, all the while my mother working on him, being careful to get everything just so, so that he might look real in a film in which he effectively gets damaged and even destroyed. The connection between history and play was both present and absent, and between these lay the seeds of some sort of uncomfortable liberation.[37]

The liberation to which Siopis alludes is partly found in the realization that there is catharsis in performative ritual. But there is also, in this anecdote, the retracing of a moment of political awakening in the artist-child. In that moment, the child suddenly becomes aware of the power harbored within the effigy, the corporeal fetish, and is thus converted to animism. Such a conversion for the artist, however, is only emancipatory when it is (paradoxically) doubled with an acceptance of the representation, however convincing its corporeal guise, as just that—a representation. It is as if, to be a believer, one must first denounce one's faith. This is, perhaps not such a leap for faith, as truth is reliant upon doubt and is perhaps most meaningful when considered in relation to the fraudulent. Where meaning becomes ambiguous, simulacra may come to be more real (if not more truthful) than the original—and this, in the hands of the artist, is a powerful tool indeed.

Penny Siopis

The Illusionist

The trick—and it is a trick—of the theatrical illusion is to first create a convincing stage. Once again, the artist looks back into her childhood for a model and stumbles into the museum:

> As a child one of my most vivid memories was of the museum. I loved the kind of extreme looking sanctioned there. The aura, the artificial light and the dead stillness of scenes and things, staring outward at me, me staring in, staring past, the staging. Dead things shamming life. For all this, I projected onto objects and scenes all kinds of things, conditioned no doubt by the modes of display, labels, etc. Memory was dramatised here. It felt a bit like the cinema, being an experience of going into, and coming out of, a temporal and spatial bracketing off from everyday life, as if some kind of moratorium from life was possible. But, again, one did not touch or kiss the screen. One sees and hears in extremes of dark and light, and imagines.[38]

It is but a short journey of desire from the museum into the cinema, especially for the (re)collector. Both are enchanted spaces that offer temporary escape—into the past, perhaps, or even the future; another time, another space unfolded. With this in mind, Siopis built a replica cinema, reminiscent of one her grandfather had owned in Umtata, for the first screening of her autobiographical film, *My Lovely Day* (1997). The darkened incardine interior of this theater, with its velvet curtains, deco lights, and soft folding seats was redolent of another distant era of (silent) filmmaking. To enter was to step into the intimate past of another's mind remembering. This charmed, Lilliputian space almost seemed a size too small, like a theater lifted from the memory of a child.

The film itself is a domestic documentary of the lives of three women—three lives overlapping, three generations immersed in a dialogue at once foreign and familiar. *My Lovely Day* is, in a sense, an attempt by the artist to extend a conversation long past, to respond to that which was, "at the time," perhaps misunderstood or left unsaid, but which persists in its longing to be told in retrospect. It is composed of an impossible dialogue of fragments—lifted from letters, old postcards, half-remembered stories, a child's imagination—which are grafted together in the present to appear flawless, complete. Remnants from an oral history narrated by the artist's grandmother as entertainment to a younger generation in the evenings, are

CAT. 21
My Lovely Day
(overview of theatre). By Penny
Siopis, 1997. Video installation.
Johannesburg Biennale
Photo: Hannelie Coetzee,
reproduced courtesy of the artist

superimposed as haunting subtitles over home-movie footage, taken by her mother during the 1950s and '60s. The film is an heirloom, the material trace of inherited memory—both private and public. It is a narrative born of the magic which only the film can conjure—words set to music against images of nostalgia, of celebration, of painful, yet strangely humorous, irony.

The most intimate of scenes—children playing in masquerade on the lawn of their home, a family *braai* on a summer afternoon, the artist as a child learning to swim—effortlessly melt into the most public—scenes from the 1961 Republic Festival, a memorial holiday celebration of colonial settlement, a civil parade winding down the main street of Umtata. We are suddenly made aware of the ways in which the political contaminates the personal; how easily they blend into one another, becoming indistinguishable. Burdened by hindsight—or perhaps, given the tense, by foresight—the viewing of these narrated images makes us uncomfortable. Their intimacy, the kitschness of their candid sentimentality, implicates us by affect. A single moving frame, an isolated phrase, projects upon multiple others, connecting in our mind's eye to a thousand other reference points. Indeed, memory eliminates any possibility of innocence or singularity. Like Barthes's famous photograph of his mother as a child, foreboding her death in recollection,[39] we cannot but cringe at the inevitable. Desperate as we may be to uncover Benjamin's "hope in the past," we cannot escape that which is "already-lived." But we can re-member it, re-interpret it, see it anew, if not ever again for the first time.

Thus, when the artist's grandmother says of South Africa, "This is a dangerous place, a place of ruin. I know it in my bones," she seems to foreshadow the turbulent decades of struggle to come. Not quite incidentally, these words of premonition are spoken over the image of the great crater of a diamond mine in Kimberly—a site of ruin, a scar, a reminder in itself of the gross imperial exploitation of the land and its people. The film is thick with troubled premonition, ensnaring the present in the past, twisting—at times pulling—its leg. Siopis's grandmother pointedly asks the artist's childhood self: "What do you know of massacre, catastrophe, disaster?" It is more incredulous accusation than question. It haunts, demanding redress. It hints, if only for a fleeting second, of the bliss in childhood ignorance. It recovers a moment of innocence, if only to remind us of what has been irrevocably lost, what has been sacrificed to history—collective and otherwise.

Siopis explains how she tried to "capture" the spirit of her grandmother "in her laconic tone of speaking," noting "how her words reflected her place and times":

> Like many people of her generation, she witnessed the formation of the new century
> with trepidation. Her stories reflected this trepidation, and were laced with fear of

CAT. 21
My Lovely Day
("But you play as if nothing is happening around you").
By Penny Siopis, 1997.
Video installation
Photo: Penny Siopis

My Lovely Day
("What do you know of massacre, disaster, catastrophe?").
By Penny Siopis, 1997.
Video installation
Photo: Penny Siopis

impending doom, a fear embalmed in millennial rhetoric and large doses of not always resigned cynicism. She made ordinary events—like swimming—seem as catastrophic as quicksand or a tidal wave. Life was unpredictably cataclysmic and we, as her grandchildren, "knew nothing of this world." This much she told us often.[40]

Sounds familiar indeed, as we fast approach another century. Yet, it also remains somehow foreign. Another time, another place, another set of circumstances. The narrator speaks of the World War II civil unrest in Greece, the difficulties of migration and settlement, and yet the words we hear seem unmistakably to speak about South African apartheid, racial conflict, and the ongoing struggle to belong to a newly emerging nation. Projection creates the most startlingly intimate illusions. Things are never what they seem. Some images are "straightforwardly referential," while others are more tenuous, acting as triggers to memory—the illusionist's greatest assistant in calling up the phantoms of the psyche. The eye, gazing through the lens of anamnesis, cannot be trusted. What is on screen, not always is in actuality: apparent scenes of Smyrna are *actually* of Cape Town; the dancing "Turks behaving like animals" are *actually* a group of Europeans celebrating the crossing of the equator by the Union Castle ocean liner in 1959; even the Metro theater (the cinema owned by Siopis's grandfather in Umtata) is *actually* the house of the missionary John Moffet in Kuruman.[41]

My Lovely Day is a "true" story not because it claims to disclose the "factual" secrets of history, but because, as the artist explains, it reveals the "truth of experience": "It wants to be 'true' not only in the way memory functions (as partisan fragment), but also in the fact that the film is an ineluctable physical trace, a concrete index of events which we take to have actually happened, of people (in this case mostly now dead) caught in a moment of life."[42] The materiality of the film, its "thing-ness," roots it physically to the event, transforms it into an artifact, acts as testimony to that which otherwise remains unrecoverable. In the end, all we are left with are such details. They are passed down to us from generations that have come before us, as historical fetishes, heirlooms, gifts. They serve to remind us of who we are and where we have come from.

The Exorcist

In his monograph on the gift, Marcel Mauss speaks of the spirit, or *hau*, of the thing that roots the object to its owner, its soil, its forest, and its homeland, and is what guarantees its life through circulation and exchange. The *hau* "pursues him who holds it"; it "wants to return to the place of its birth, to the sanctuary of forest and clan and to its owner."[43] In this way, the gift is itself "a kind of individual."[44] Indeed, it is this spirit that binds the artist to the objects in her collection, gives them life in biography, allows them to speak "the ghostly utterances which make a mockery of time as sequence, and of the kind of chronology on which we rely so heavily when telling 'true' stories."[45]

Importantly, I maintain that one may be a believer in animism without necessarily subscribing to the notion that the spirit or *hau* of the thing (if I may borrow Mauss' terminology) is the same as a primordial, authentic essence—though admittedly this is the implication in Mauss' writing, as well as in much recent cultural studies literature, and scholarship on contemporary art in South Africa.[46] The distinction is indeed a fine one, but nonetheless significant—particularly as it concerns our understanding of the ways in which Siopis aims to gather such fetishes to her biographical project.

When an object is produced and enters the world, it is always created with (and against) a set of associated meanings. As such meaning(s) may be argued to have been conceived

simultaneously with the object, which is always manufactured with a particular intention or purpose in mind (concurrent with that meaning), it is therefore difficult (if not, for some, impossible) to separate the (original) signified from the signifier, the thing from its nascent meaning. Thus the "original" knowledge (and by this, I mean the knowledge alongside which the thing was conceived) of the object, its *hau*, comes to be confused with what is deemed to be its "primordial essence"—i.e., a preexisting, immutable truth. The *hau* of the thing is not anterior to its production. It is not a soul that transcends the object, surviving its destruction. Rather, the spirit of the object is (re)produced through its manufacture and subsequent (and continuous) circulation, and is subject to reinterpretation as the object moves through a complex network of exchange.

Such confusion between spirit and essence should not surprise us, for symbolic meaning (primordial or not) is always ambiguous. Furthermore, the more readily an object is related to a specific and inceptive moment of trauma, the more difficult it becomes to dissociate that moment (and its surrounding history) from the material trace. The thing is consequently reified, and indeed, this is one of the ways in which the object may come to assume the role of fetish. The fetish, after all, is an object of power. It paradoxically and simultaneously speaks of both deficiency and excess, and is regulated by strict taboos that serve to preserve and sanctify it. It is the ambiguity of the fetish (i.e., the concurrent belief in the truth and falsity of the object), which ultimately denies its destruction. But it is likewise this ambiguity through which the "original" signification of the object may be challenged.

Like the artist, I am intrigued by the ways in which we encourage certain objects to evolve complex biographies, and thus "free" them of their origins, while we terminally "fix" others to a specific (and immobile) history. In fixation, the object's lineage is severed. Kopytoff has written of object genealogies at length, explaining that things, like people, are enmeshed in a moral economy. Invariably they transform over time, moving in and out of various roles and stages. He writes: "A culturally informed . . . biography of an object would look at it as a culturally constructed entity, endowed with culturally specific meanings, and classified and reclassified into culturally constituted categories."[47] Like any biography, we come to it with "some prior conception of what is to be its focus," and likewise we accept that "[b]iographies of things cannot but be… partial."[48] But when an object is associated with a formative moment, particularly one of trauma, it becomes that much more difficult to challenge its sacred fixity. The history of the thing is thus made anterior, sovereign. In setting the object as representative of its history, this process of sanctification may simultaneously collapse a complex set of historical circumstances surrounding the image-event into that single moment of trauma.

Michael D. Harris argues in regards to the collection of the historical fetish (especially those derogatory images of otherness which have become fixed into stereotypes) that: "[C]ollection is not an act of exorcism, it is an act of commodification. There is a line crossed when one traverses from 'knowing' to collecting, a movement from awareness to the active maintenance (or reification) of the edifice that one states is being pulled down."[49] The fetish-like power of the historically sanctified object is thus deemed impossible to destroy, and any attempt to invert or neutralize that power by reclaiming it, risks strengthening it anew by reminding the viewer of its origins. Yet, in recasting these objects of trauma in multiple stage settings, allowing them to circulate through two decades of performances, Siopis manages to momentarily loosen their historical fetters, allowing them to be something other than what they may have started as. Thus does the artist attempt to reconsider these forms—however "true" they are to an original history—as material traces. In doing so, these fetish objects manage to challenge, rather than perpetuate or forward, the representation as

representative. Thus are we able to distinguish the object from its stereotype—not through hiding or burying the painful fetish-reminder, but by confronting it, disabling it, and allowing it to become. The representation here is finally revealed as just that: a representation.

In South Africa at present, during this critical moment of democratic nation-building, historical revisionism and truth-seeking, the emerging nation has inevitably witnessed the production of images which are characterized by their fixation on the past. This much, perhaps, is inevitable. By pausing to consider the complex collection practices of an artist like Siopis, however, we may come to appreciate that the exorcism of the ghosts which persist in haunting our present, require some form of temporary return on the part of the diviner, if only to move forward. And, in the process, perhaps we are also offered a glimpse, however fleeting, of a future unfolding.

Penny Siopis

1. Robert Stoller, "Observing the Erotic Imagination," (New Haven: Yale University Press, 1985), quoted in Roger Malbert, "Fetish and Form in Contemporary Art," in Anthony Shelton, ed., *Fetishism: Visualizing Power and Desire* (London: The South Bank Centre in association with Lund Humphries Publishers, 1995), p. 94.

2. Tibor Fischer, *The Collector Collector* (London: Secker & Warburg, 1997), pp. 5, 18.

3. Walter Benjamin, "Unpacking My Library: A Talk About Book Collecting," in *Illuminations* (London: Pimlico, 1955; reprinted 1999), p. 65.

4. Ibid., p. 69.

5. Ibid., p. 62.

6. Fischer, op cit., p. 7.

7. Igor Kopytoff, "The Cultural Biography of Things: Commoditization As Process," in Arjun Appadurai, ed., *The Social Life of Things: Commodities in Cultural Perspective* (New York: Cambridge University Press, 1986), pp. 66-67.

8. I have discussed similar issues regarding Siopis's autobiographical practice in "Genealogy and the Artist's Archive: Strategies of Autobiography and Documentation in the Work of a South African Artist," in Mario I. Aguilar, ed., *Rethinking Age in Africa: Colonial, Post-Colonial and Contemporary Interpretations of Cultural Representations* (Lawrenceville: Africa World Press, forthcoming).

9. Esther Leslie, "Telescoping the Microscopic Object: Benjamin the Collector," in Alex Coles, ed., *The Optic of Walter Benjamin, Volume 3 de-, dis-, ex-.* (London: Black Dog Publishing, 1999), p. 88.

10. Ibid., p. 89.

11. Walter Benjamin, "Untidy Child," in *One Way Street* (London: Verso, 1979; reprinted 1998), p. 74.

12. Ibid., p. 73.

13. Penny Siopis, "Home Movies: A Document of a South Africa Life," in John Picton and Jennifer A. Law, eds., *Divisions and Diversions: The Visual Arts in Post-Apartheid South Africa* (London: Eastern Art Publishing, forthcoming).

14. Leslie, op cit., p. 67.

15. Ibid., p. 66.

16. Walter Benjamin, "The Work of Art in the Age of Mechanical Reproduction," in Francis Frascina and Jonathan Harris, eds., *Art in Modern Culture: An Anthology of Critical Texts* (London: Phaidon, 1992; reprinted 1995), p. 301.

17. Ibid.

18. Milan Kundera, *The Unbearable Lightness of Being* (London and Boston: Faber & Faber, 1984), p. 242.

19. Ibid., p. 245.

20. Penny Siopis, "Shadow Casts—Mostly Women and Children" (unpublished conference paper, *Fault Lines: Inquiries into Truth and Reconciliation*, 1996).

21. Kundera, op cit., pp. 245, 247.

22. Andreas Huyssen, *Twilight Memories: Marking Time in a Culture of Amnesia* (New York and London: Routledge, 1995), p. 33.

23. Walter Benjamin, "Theses on the Philosophy of History," in *Illuminations*, op cit., p. 249.

24. Walter Benjamin, *Gesammelte Scriften*, V. I., p. 271, as cited in: Leslie, op cit., p. 71.

25. Leslie, op cit., p. 71.

26. Fiona Bradley, *Surrealism: Movements in Modern Art* (London: Tate Gallery Publishing, 1997), p. 39.

27. Ibid., p. 41.

28. Siopis, op cit. (unpublished 1996).

29. John Mack, "Fetish? Magic Figures in Central Africa," in Shelton, op cit., p. 54.

30. Dawn Ades, "Surrealism: Fetishism's Job," in Shelton, op cit., p. 67.

31. Terry Eagleton, *Marx and Freedom* (London: Phoenix, 1997), p. 28.

32. Ibid., p. 27.

33. Sigmund Freud, *On Sexuality* (London: Penguin, 1991), p. 351.

34. Malbert, op cit., p. 91.

35. Ibid., p. 94.

36. Benjamin, op cit., (1992, reprinted 1995), p. 304.

37. Siopis, op cit. (forthcoming).

38. Siopis, op cit. (unpublished 1996).

39. Refer here to Siopis, op cit. (forthcoming).

40. Ibid.

41. Ibid.

42. Ibid.

43. Marcel Mauss, *The Gift: Forms and Functions of Exchange in Archaic Societies* (New York and London: W. W. Norton & Co., 1967), p. 9. Refer also to Law, op. cit. (forthcoming).

44. Ibid.

45. Siopis, op cit. (forthcoming).

46. Refer here to Okwui Enwezor, "Reframing the Black Subject: Ideology and Fantasy in Contemporary South African Representations," in *Third Text* 40, Autumn 1997. Also see Brenda Atkinson and Candice Breitz, eds., *Grey Areas: Representation, Identity and Politics in Contemporary South African Art* (Johannesburg: Chalkham Hill Press, 1999).

47. Kopytoff, op cit., p. 68.

48. Ibid.

49. Michael D. Harris, "Memories and Memorabilia, Art and Identity: Is Aunt Jemima Really a Black Woman?," in *Third Text* 44, Autumn, p. 26-27.

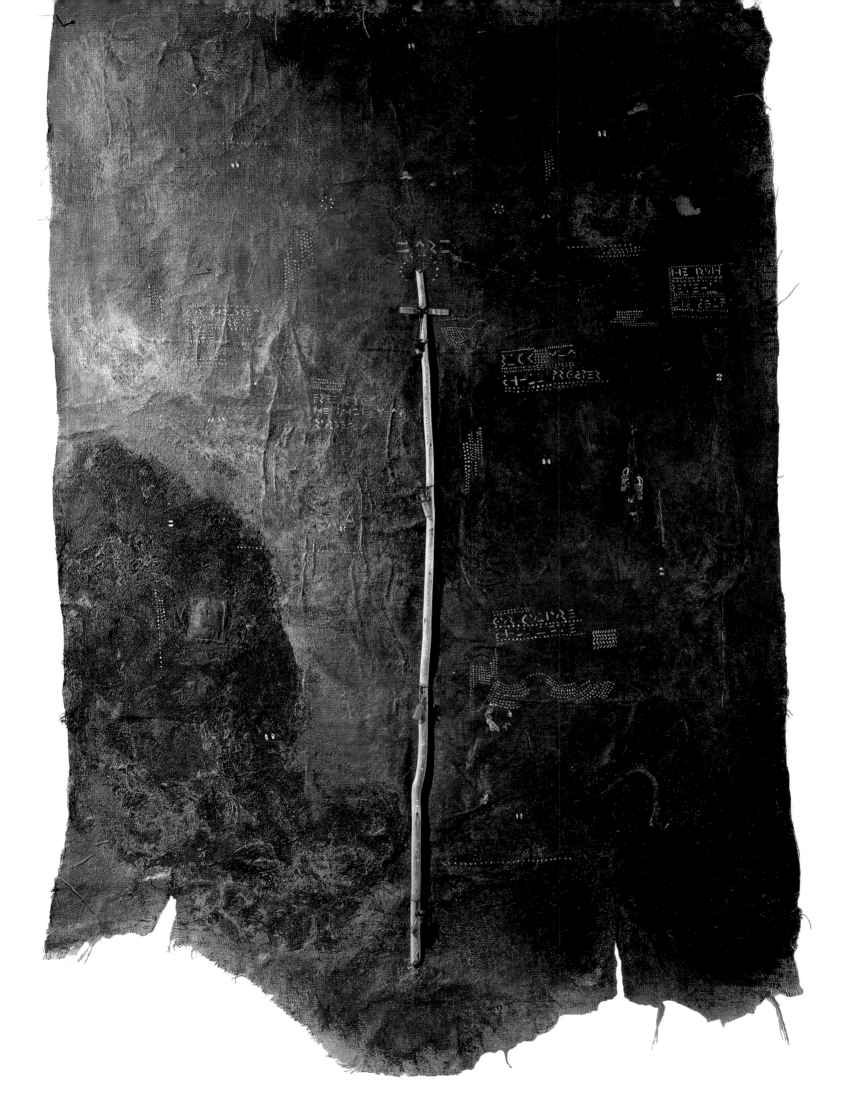

Samson Mnisi

Interviewed by Kristine Roome

come speak to me
child of the sun
relieve me of my bitterness
tell me that love
is not counterfeit joy
dispel hate-filled feelings
place a warm finger
upon my cheeks cold
take me away from
the valley of despair
fill me with passion
to let me walk
the trail of happiness
with joy-pronged spear
child of the sun
in need your warmth
to rid our land
of the white blight
take me to wells
filled with poisoned water

—from James Matthews, "Poisoned Wells," 1990

"The autonomy of art reflects the unfreedom of individuals in the unfree society," writes Herbert Marcuse (1978:ix), yet "by virtue of its aesthetic form, art is largely autonomous vis a vis the given social relations. In its autonomy art both protests these relations and at the same time transcends them" (ibid.:72). The art of Samson Mnisi embodies the notion of transcendence— that is, of achieving a state of being beyond society's pressing constraints, which, in South Africa, still reek of disempowerment and subjugation, the remnants of an unjust and unholy era.

In the present exhibition, the "liberated voices" of the participating artists both reveal and give meaning to the emerging views within this nascent state, affectionately coined "the New South Africa." One must remember, though, that each artist, with all of his or her racial, ethnic, and social associations, is still deeply embedded in his or her own individual history. It is the coupling of the perceptions of the individual with the interests of his or her community that results in the insightful fragments of the new social order that these artworks constitute. Moreover, the personal and collective history of an artist like Mnisi is associated with a certain conquest of the imagination regarding the history of African people in general: as an individual, and as an African, Mnisi tries to go beyond the reality of his own experiences and to connect with a history in which the people of this continent would have been permitted the freedom to continue and develop their traditions and to attain a state of happiness and tranquility unfettered by the colonial encounter.

CAT. 22
Untitled.
By Samson Mnisi, 1999.
Reeds, cloth, pigment, found objects. H. 246 x 168 cm.

Samson Mnisi

Mnisi's "voice" can be harsh when describing the reality that is his life. Plagued by apartheid and continuing economic oppression and social injustice as his community is, one really shouldn't expect anything less. Yet when discussing his art, a certain serenity prevails—an inner peace, which, to cite Marcuse again, allows a sort of "catharsis" that offers "a modicum of freedom and fulfillment in the realm of unfreedom" (1978:10).

A self-proclaimed romantic, Mnisi attributes much of his inspiration to nature, and to the sort of natural order in which all living things are associated with one another as a result of mediating a shared quality: the energy of being in the world. Victor Hugo wrote that romanticism "set out to do what nature does, to blend with nature's creations, while at the same time not mixing them all together: shadow and light, the grotesque and the sublime—in other words the body and the soul, the animal and the spiritual" (quoted in Hobsbawm 1962:304). Mnisi's works similarly combine elements of nature, which they couple with traditional markings of his culture, including special symbols and *muti*—traditional medicines and herbs. The works are the results of a spiritual process by which he attempts to rid himself of the hatred and anxiety left within both himself and his society by apartheid and the continued inequality and oppression of black people.

Mnisi's personal journey thus far highlights a continuum of violence and ambiguous morality. As a former member of Umkhonto we Sizwe ("MK," the armed wing of the African National Congress), turned criminal, turned artist, the twenty-eight-year-old Mnisi has experienced firsthand a multitude of the political and cultural changes that South African society has undergone in recent decades. Like a palimpsest, Mnisi bears marks both psychological and physical from that period. Perhaps, in fact, he should be dead: he literally bears scars—of a gunshot wound through his back, of numerous knife fights, of a wound to his left hand from a grenade. Yet seven years ago, after surviving the deaths of many of his young friends, he turned to art.

How does an artist like Mnisi absorb what he has seen and experienced and still believe in humanity?

> To be South African means you are very fucked up, by colonialism, apartheid, and by ourselves. The best thing you can do is realize that you are so fucked up you need to change. That's the problem with many South Africans: they don't want to arrive at the point where they say they are fucked up. I am fucked up. I am one of the most fucked-up persons in the world. I've seen so many fucked-up things. My friends have died, as young as they are. Most of my close friends, I would live with them, and they would die. And that was a trauma to me. It's only now that I realize I'm so fucked up, so full of angst, so angry. I'm so fucked. How can I expect all these things to happen to me and not get fucked?

> After that, I realize I am fucked. You might not be responsible for finding yourself where you are, but you are responsible for getting yourself out of that situation. I mean there is nobody who is going to try and get you out of it. Even if they put you there. It's you who have the responsibility of changing your life. As fucked up as we are, we can become something.

> I'm still very angry. But what I am trying to say now is that my anger now, I try to direct it. I was angry at my mother, father, friends, everybody. It only fucks your life more. You find yourself fighting. They want to help you but you fight with them. I think now I'm angry at a better point. I am more angry than before, but now I'm more strategic, diplomatic. And I think that is what we need.

> I was still at war when I started doing art. People are surprised to see me now. My friends who knew me when I was fucking people up say "Hey man, it's very funny how you were reborn." But I think it was art.

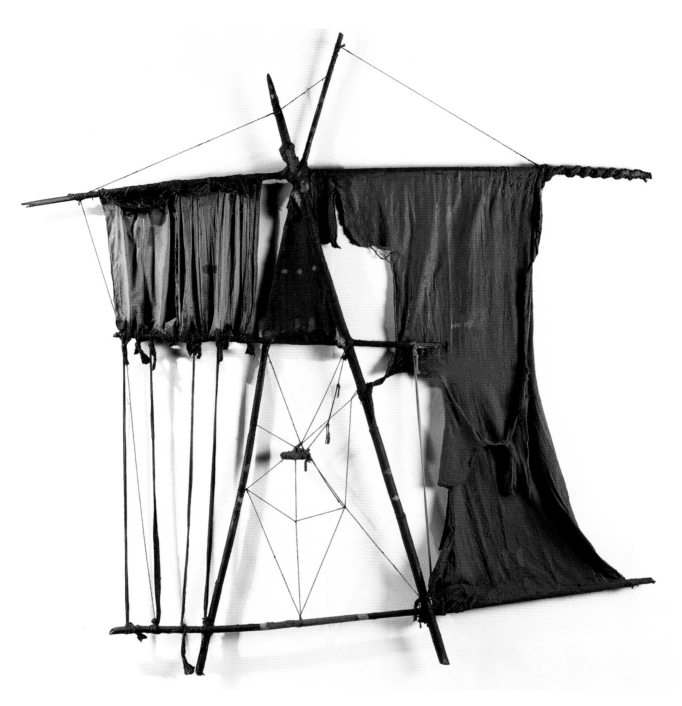

Cat. 23
Untitled.
By Samson Mnisi, 1999.
Reeds, cloth, pigment, found
objects. H. 197 x 189 cm.

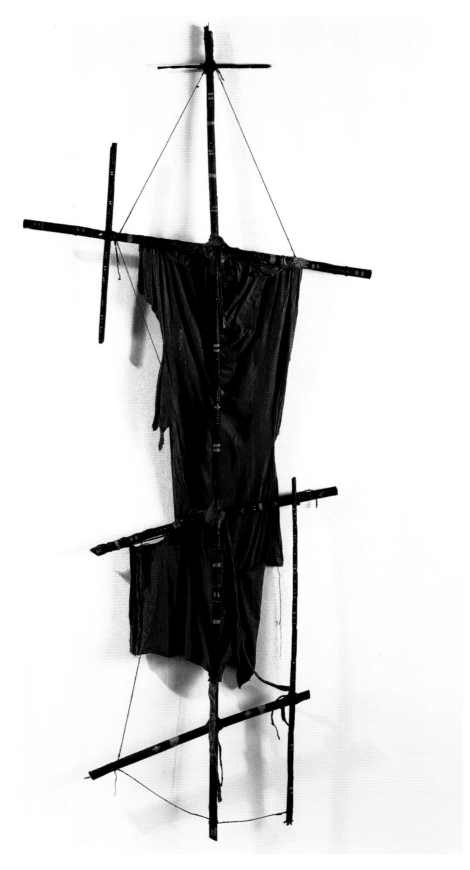

Cat. 24
Untitled.
By Samson Mnisi, 1999.
Reeds, cloth, pigment, found
objects. H. 216 x 90 cm.

erased are the songs of childhood
and bell-like laughter
their innocence cannonaded
filled with fire
are their eyes
too young they
have also become
bands of drinkers
from poisoned wells

—from James Matthews, "Poisoned Wells"

Unfortunately the realization of the inequalities in South African society, and the oppression of black people in general and throughout the world, robbed Mnisi of his childhood, as they did many children of the ghetto. Mnisi, though, seeks consolation through his own spirituality, and through nature.

Art is very powerful in terms of reshaping your mind. Not just art but nature. I was always inspired by trees, even when I didn't know art. You know, it's the only thing that I could look at and see there is God in this place. I've never seen anything as graceful as a plant. Everything they do they do with such grace.

When I was nine years old, I ran away from home, to the suburbs around Florida. I took a train, it dropped me somewhere around the suburbs. It was the first time I went to a suburb. And that is not a good suburb, not the best. I cried for two weeks when I came back; every time I looked at myself in the mirror I cried. I cried every time I looked. And I was very young. For me it was like a realization—I was like "Fuck, some people live like that!" Do you understand what I'm saying?. I mean, my world was Soweto, and I lived there all my life. Now and then I would go to my father's town, but it was not like that. I mean one day, I run away and go to the suburbs, at nine years. I thought I could find a job—as a gardener. Maybe some white man would like me and let me do the garden. And I walked there, and I came back there [to Soweto], and I was totally destroyed. I couldn't stop crying. I just couldn't believe that there are other people who live like that, and I live the way that I live. And people are telling me this is my country. You know what I am saying? And from that day onwards I began to look at white people differently.

the youth are not sacrificial
lambs
immolated to ensure the whorelords
rule
their answer that their children
shall
not live in bondage as
their father's father had endured shame's
pain
they transformed township streets into
battlefields
their eyes aflame with freedom's
fire
beaconing the way others must
follow
their bodies filled with
power

Samson Mnisi

gained from drinking at poisoned
wells

–from James Matthews, "Poisoned Wells"

In the mid-1980s Mnisi became involved in the political struggle. As a teenager in the White City section of Soweto, he grew up in the Movement; the MK deployed young adolescents to protect people and get rid of criminals. Young as Mnisi was, he became a leader in his community. He has produced drawings throughout his life, but during those brutal years making art was a luxury for which he did not have time.

In 1988, disillusioned and frustrated by internal fighting within the Movement, Mnisi left politics and began a life of crime. Ironically, he became friendly with the very people he had been trying to blow up just a few years before. But this was not so strange, given the circumstances of township life.

> *I didn't think I would make it to twenty-one. I thought I would die somewhere. I grew up in a really tough neighborhood. A lot of people die, next to you, around you, you know what I mean? You don't respect life. Especially at that time. Because where I grew up it was a hazard sometimes even to go to the shop. Hippos [armored cars] everywhere in the street. It was an adventure just to go to the shop. Violence makes violence. If you grow up in the streets with violence, you become very violent. That's the only way you can survive. If you become too soft, then you die. Really you die. When I moved from politics, I had friends who were criminals and stealing cars. So I started doing that and all that shit.*

> *But I got frustrated by that. I guess I didn't make money. There was no moral shit. I stole from white people. As far as I was concerned, white people stole a lot from me. So my conscience was very clear. I mean, I was not killing people. I don't like blood. I was a thief, not a murderer or something like that. And we stole a lot. I did it for money. I was very ambitious. So I threw myself into it body and soul. And then one day I found myself in a hideout. I was broke, wearing torn jeans. I like torn jeans, [but] I was very frustrated and I told them then, Guys, I think I am going to school. That was January 1992.*

Mnisi moved to Johannesburg and attended the academy run by the Federated Union of Black Artists (FUBA). He was very lonely the first year, having left everything he knew in the township. For about six months he lived in a shebeen (a speakeasy of sorts), and then in a small changing room in the African Cultural Centre.

Sundays were the worst. The townships are full of life on Sundays; everyone is outside, drinking, dancing, socializing. But Mnisi was alone in the city. He took out books from the Michaelis Art Library. He also taught himself meditation, which since then has played an important role in his life. At FUBA he was significantly influenced by his fellow students, developing not only as an artist but in the formation of his world view. Together the students would experiment with the integration of different modes of expression, including the visual arts, music, and film. It is also important to note that FUBA was premised on an ideology of black solidarity. The students introduced to one another to the ideas of Steve Biko, for example, and of the Jamaican poet Mutabaruka, all subjects for debate.

As an artist, Mnisi began by painting in primary colors with oils and acrylics. When he smudged his colors on the canvas, however, he saw that they became muddied and brown; this inspired him, and his palette grew softer and muted, like the earth. He started to mix colors with his hands, his canvas becoming thick with paint. The works looked old, as if they came from back in time. Giving up on the attempt to reproduce natural forms and surfaces, Mnisi moved to using actual materials found in nature, such as earth and sticks. He would perform rituals around his pieces, often for no one but himself.

Samson Mnisi

I try to retrace history—I do not have a history, you must understand, I am a man with no history.

When we talk about African civilization, African art, we talk about prehistorical history which, as it stands, has been solely the white man's responsibility. In a real sense, it is his-tory, the white man's story. It can be about me, but it is still a white man's story. In that sense I don't have any claim to history. So, in a way, I am trying to find a way of going beyond history, by actually going back as much as I can.

I believe that we have an ability to travel, and in that ability to travel we can be able to move backwards or move forwards. [This is] not really a dream in the sense of dreaming, but more like a trip. I become like an archaeologist. So I dig inside me. I find old pieces, ancient things, and then I bring them out to remind myself of who I was, who I have been, before I am what I am now. Because I think that this is important for me to try and find my dignity somewhere. And my dignity only lies before the white man arrived. That is when I can begin to be able to draw a sense of dignity—I can begin to feel now, If there was no white man, how would I feel? How would I walk? How would I be? Now that, for me, to be able to draw energy from that time—then I begin to feel dignified. Then I begin to feel the energy of that man if I was Samson living then, at that time—then I would be able to feel like this, and that would be such a dignified feeling. So what I am trying to do is get that feeling first—so that the pieces I do do not have problems of apartheid, problems of my life. They have their own life, their own time.

I sort of transcend my situation. I am able to draw from that history, that archaeological discovery, that travel, that trip, and I bring all those pieces of dignity. They are not yet pure, but my strategy is that—to arrive at purity, very authentic, those pieces that are timeless. That is how I will be able to bring out the dignity of a black man. To bring this energy forward, with rituals, to remind him of how honorable he is.

It is for myself as well. In my history I have no dignity, no morals, I am all of these bad things. I am also very poor. Now I can transcend that, through art. Art can do that for me. Art can make me feel like a noble man, a rich man, a powerful man. That is why I do these pieces. That is why I don't want to go into apartheid, I know about that—I lived with that. I want to bring something alive, something that will make us transcend that situation, without compromising our beliefs in a true sense. So I bring out these pieces now to be able to reconnect with that line which was broken at that time, and begin to move into another time and which I believe will be a situation of posthistory—that is, after the white man has written his story and we begin to write our story.

In several ways these ideas reflect points of the African Renaissance as proposed by incoming President Thabo Mbeki, who, in his now infamous speech at the United Nations University in Tokyo in April of 1998, explained his confidence in African people to reassert the strength of their humanity:

I would dare say that that confidence, in part, derives from the rediscovery of ourselves, from the fact that, perforce, as one would who is critical of oneself, we have had to undertake a voyage of discovery into our own antecedents, our own past, as Africans. And when archaeology presents daily evidence of an African primacy in the historical evolution to the emergence of the human person described in science as *Homo sapiens*, how can we be but confident that we are capable of affecting Africa's rebirth?

When the world of fine arts speak to us of the creativity of the Nubians of Sudan and its decisive impact on the revered and everlasting imaginative creations of the African land of the Pharoahs—how can we be but confident that we will succeed to be the midwives of our continent's rebirth? And when we recall that African armies at Omduraman in the Sudan and Isandhlwana in South Africa outgeneraled, outsoldiered, and defeated the mighty armies of

the mighty and arrogant British Empire in the '70s of the last century, how can we but be confident that through our efforts, Africa will regain her place among the continents of our universe? (Mbeki 1998).

As mentioned earlier, Mnisi associates a ritualistic process with his creations. The manner in which they are constructed is almost as significant as the final product. Victor Turner has discussed the basic semantic structure of the symbol in African ritual: first, it has multiple meanings, or as he calls them significata; second, essentially distinct significata are interconnected by analogy; and lastly, the symbol represents many ideas, relations, and actions simultaneously (1977).

The meaningful marks on Mnisi's works are inspired by his traditions. Though raised in Soweto, he was born in 1971 in a mud-and-thatch roundavel in Lesotho. Both of his grandmothers were *inyangas*, traditional healers, and they taught him many things now manifest in his art. The triangles in his works relate to the idea that all things must be in harmony and balanced, a moral and social order prescribed by his beliefs. The crosses are also important symbols, relating to the crossroads at which one may want to find good luck. In Mnisi's culture, specific rituals are enacted regarding the manipulation of luck, including the placing of *muti* where paths cross, so that one always leaves these spots with good luck. *Inyangas* also make these symbols on a person's body, for similar reasons. Again, the small hatchmarks or parallel lines in Mnisi's work represent the opposite of everything bad. Lines that never meet represent the hope that one never meets bad luck; and where they do meet, the hope is expressed that the encounter will be positive. In life one always hopes to walk parallel to bad luck. But when the situation occurs that one crosses luck's path, one hopes that luck will be good.

The materials that Mnisi incorporates into his works are also expressive. Natural elements often encompass human emotions. Rudolf Arnheim uses Van Gogh's two renditions of *Sorrow*—one a human figure, the second a sketch of bare trees with gnarled roots—to demonstrate the ability to express emotion in abstract metaphor (1974:452); Mnisi too transmits or, better, anthropomorphizes expression in his works.

Cattle have long been valued throughout South Africa. Historically a rich man would own many head of cattle, and a woman's value as a wife was recognized by the cattle a young man's family could pay to her family. The meat of cattle used to be distributed according to rank, with those of most importance taking the most valued parts. Mnisi's texturing of hessian material such that it nears the appearance of skin expresses a yearning for a time beyond the capitalistic commodification of such South African traditions. And the softness of the color in his work, with its rich earth tones, is analogous to a simpler, kinder time and evokes feelings of calm and tranquility. The addition of *muti*, with their subtle variations in color, invokes a quest to incorporate the spirit world with the world of man—a coupling of natural and supernatural, resulting again in a harmonious balance of power.

For another example, take the way the ropes in works by Mnisi seem to embrace the branches delicately, holding them together. Yet it is almost as if they would break if any more strain was placed on them. Perhaps this reflects the strain of a continent torn between an ancient past and the encroachments of modernity; or perhaps it suggests the precarious balance of a person in love. We may even describe the way a loved one tugs at our heart strings. The sensitivity of the strings may also reflect the feelings of an artist caught in a society that discourages free expression and encourages animosity—the constant constraint on an individual who wants to love but has to live with hatred, and who develops a means by which he can transcend this predicament and freely express these emotions.

About the works in this exhibition, Mnisi explains,

> I am very excited about these new works I am sending to New York. They are new and they are fresh for me. I don't know about the world, but they are new and fresh for me. I fall

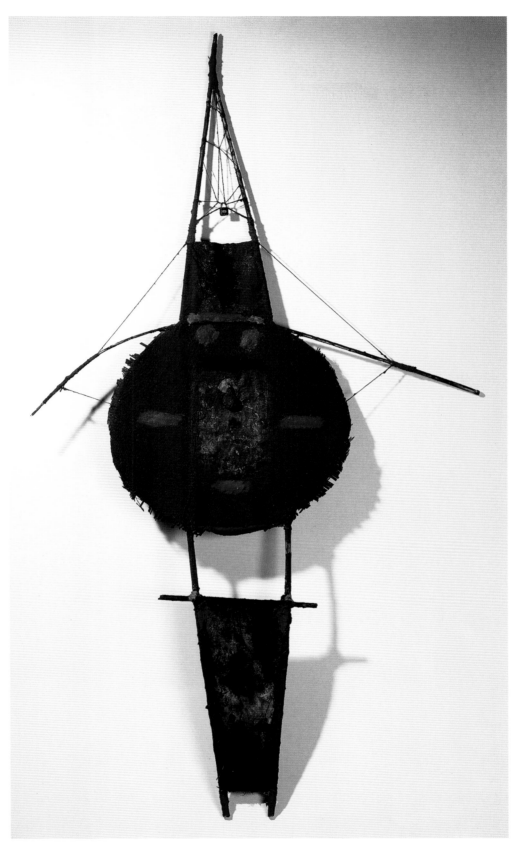

Cᴀᴛ. 25
Untitled.
By Samson Mnisi, 1999.
Reeds, cloth, pigment, found
objects. H. 243 x 138 cm.

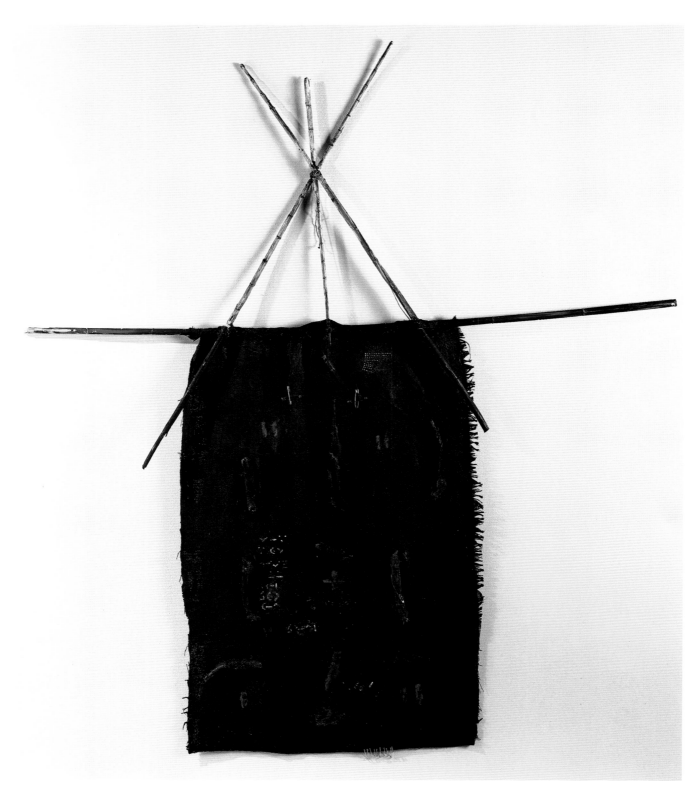

Cat. 26
Untitled.
By Samson Mnisi, 1999.
Reeds, cloth, pigment, found
objects. H. 208 x 182 cm.

Samson Mnisi

in love with them. And if everyone who sees them falls in love with them, then that will fulfill the purpose of the pieces. The pieces are about falling in love. And falling in love is not only about falling in love with a woman. I can fall in love with a tree, a flower, nature. My pieces are about that now—falling in love. I am not happy with it until I am in love with it, extremely in love with it, I mean so fucking in love. But they have all the controversies behind them, because love is like that—carries a lot of shit, but it's true. My pieces are about love, not beyond shit. Love is attached to shit. Forgive me the shit that is attached to love.

the land shall resound with joyful songs
of celebration
as flesh of many shades reach out
in trust
our spirit serene in the warmth of
freedom's glow
banners proclaiming faith and love
held aloft
no more need to slake our thirst at
poisoned wells.

—from James Matthews, "Poisoned Wells"

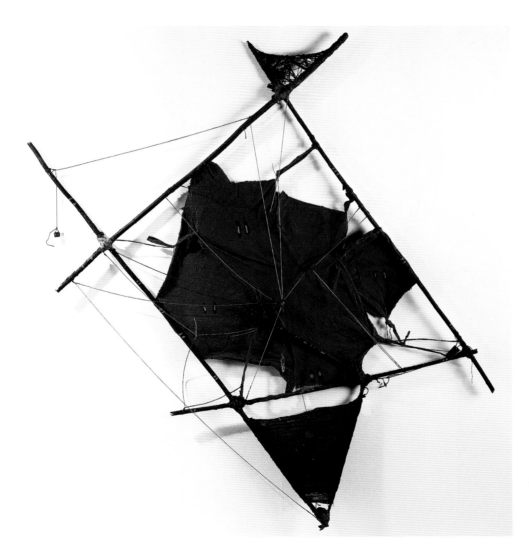

CAT. 27
Untitled.
By Samson Mnisi, 1999.
Reeds, cloth, pigment, found
objects. H. 202 x 208 cm.

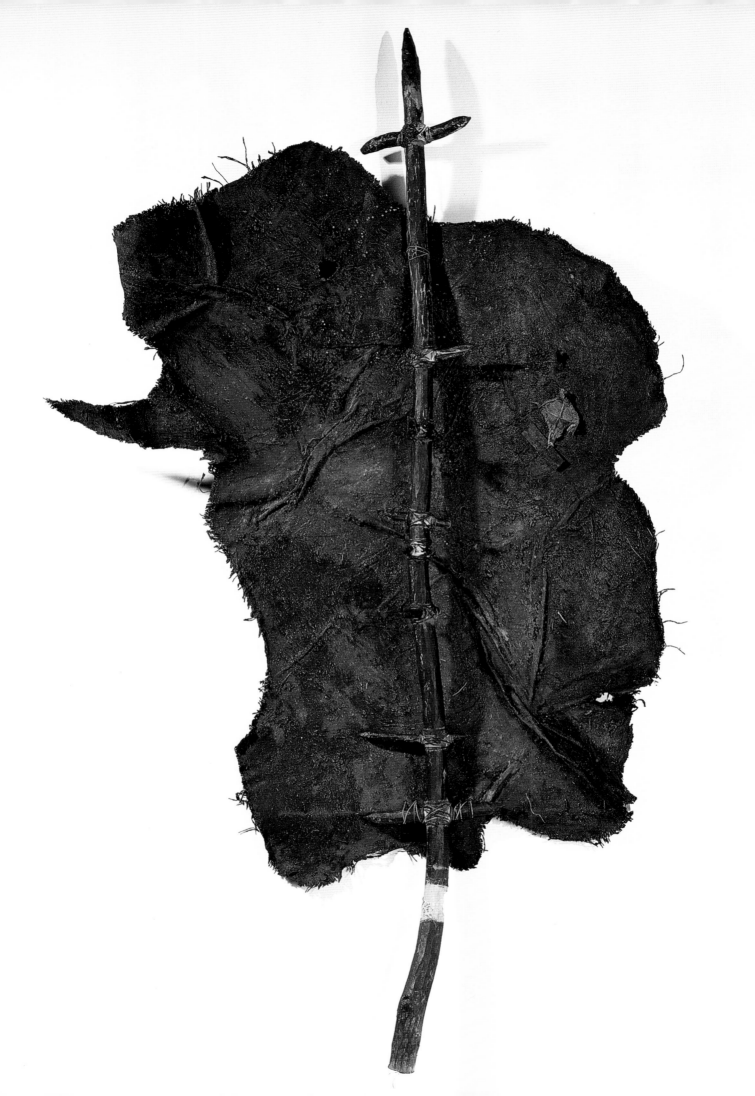

An Interview with Thabiso Phokompe, May 1999

David Koloane

David Koloane: Given the past history of South Africa's racial segregation and the denial of basic rights such as equal education, how did you train as an artist, and where?

Thabiso Phokompe: I first trained at the Federated Union of Black Arts, an informal art center located in the market theater complex, an arts complex of theaters, galleries, jazz clubs, and dance studios, in Johannesburg. The center was one of the few institutions available for black African students in the city and surrounding areas. I was at the center from 1987–90.

D.K.: What were the facilities and tuition like at FUBA given the fact that it could not have been government funded at the time?

T.P.: The tuition at the center was conducted at a very basic level, as most of the tutors were not qualified but were working artists themselves with little or no academic training. There was an evident lack of adequate resources, and materials such as canvases and various art supplies often had to be improvised and recycled to allow students to explore and experiment.

D.K.: After leaving the FUBA, you went for further training at the Johannesburg Art Foundation, which in many respects was a stark contrast to FUBA. First, it was situated in one of the most affluent suburbs of Johannesburg, the classes were integrated, its environment was conducive to learning, and it was relatively better equipped. How did this change and these differences affect you personally?

T.P.: I suppose, because I was so thirsty for knowledge and wanted to learn as much as I could, the radical change between the institutions had minimal effect on me as I was determined not to be overwhelmed by circumstances. Projects such as FUBA and other

Cat. 28
Tree of Life.
By Thabiso Phokompe, 1999.
Unmounted hessian, pigments,
sticks, rope. H. 170 x 91 cm.

Thabiso Phokompe

related nongovernmental structures were regarded as antiapartheid formations. The Johannesburg Art Foundation, though presenting to the world at large an opulent façade of a white liberal institution, defied the apartheid system by enrolling black African students and offering them equal tuition with their white counterparts.

D.K.: How can you describe the contribution of both institutions to your development as an artist?

T.P.: As far as I am concerned, the FUBA was initiated by black artists and white colleagues (such as Bill Ainslie) and business personalities, and because of its African orientation, it contributed to my identity and sense of belonging in relation to the continent. The art foundation exposed me to a new world of art movements involved in introducing the liberating abstract method of painting. I became fascinated by abstraction and this influenced my work.

D.K.: What role did the workshop concept play in your development at this stage? Was it positive or negative?

T.P.: The workshop concept exposed me to methods and techniques that one does not find in textbooks. I attended two important workshops—one in Botswana, and one in Zambia. The spirit of sharing and interaction among the artists has been a major source of inspiration in my development as an artist.

D.K.: When did your work shift from conventional or so-called traditional techniques to a more spatial or site-specific approach in which you introduced found objects?

T.P.: My exposure to the various workshops helped to change my approach. I acquired the idea of using found objects after being inspired by artists from other African countries. I am surprised that the concept of renaissance is only now gaining momentum in South Africa. The spirit of renaissance has, as far as I am concerned, been the beacon of the workshop concept in Southern Africa [see David Koloane's essay on page 26].

D.K.: So do you still believe the workshop concept has an important role for black African artists in the continent?

T.P.: The workshop concept has certainly played a major role in the development of artists. The only problem is that the workshop must also accommodate new trends and techniques.

D.K.: You did not experience the new trends from art magazines and journals and the two Biennale events recently convened in Johannesburg?

T.P.: I first experienced conceptual work and site-specific installations through various black African artists, and the Biennale concept was also an important source. The only problem with the Biennale is that there was a lack of consultation with different institutions and artists, resulting in it being too elitist and mostly attended by whites. It was, however, important for me to see work from Cuba and other Latin American countries.

D.K.: Given your experience with the workshop concept, do you think it is possible to initiate a pan-African biennale? Do you think this can become a reality?

T.P.: I do not see why not. Actually I think it can be one of the most significant events in this region. There is so much creative wealth that can be harnessed from mythology rituals and belief systems. The biennale can become the appropriate forum to explore this and other concerns.

D.K.: What do you think about the state of art in South Africa today?

CAT. 29
Rebirth.
By Thabiso Phokompe, 1999.
Unmounted hessian,
pigments, found objects.
H. 131 x 89 cm.

Cat. 30
Multi Pocket I.
By Thabiso Phokompe, 1999.
Unmounted hessian, pigments,
pockets. H. 120 x 102 cm.

Cat. 31
Multi Pocket II.
By Thabiso Phokompe, 1999.
Unmounted hessian, pigments,
pockets. H. 152 x 116 cm.

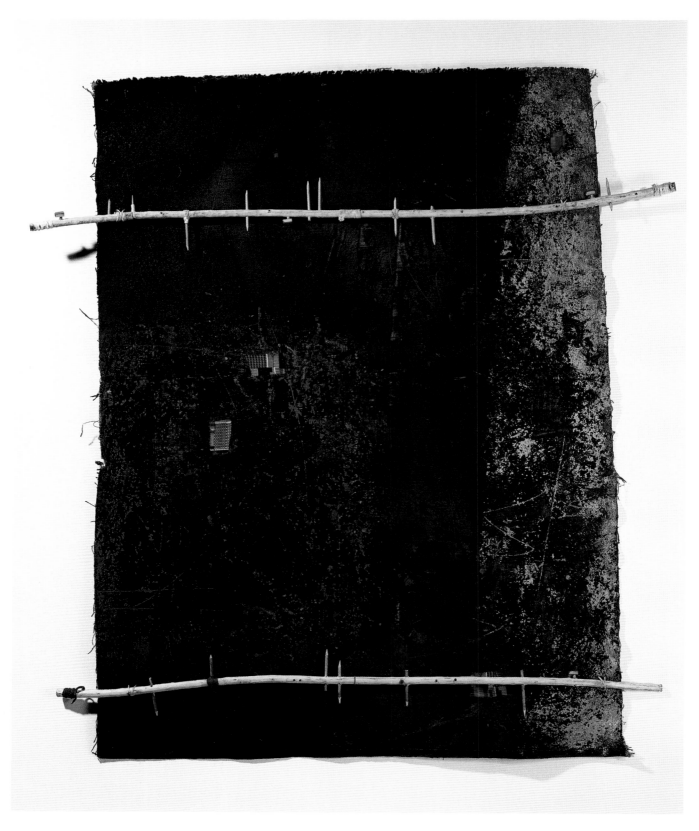

CAT. 32
Spiritual Journey I.
By Thabiso Phokompe, 1999.
Unmounted hessian, pigments,
sticks. H. 151 x 110 cm.

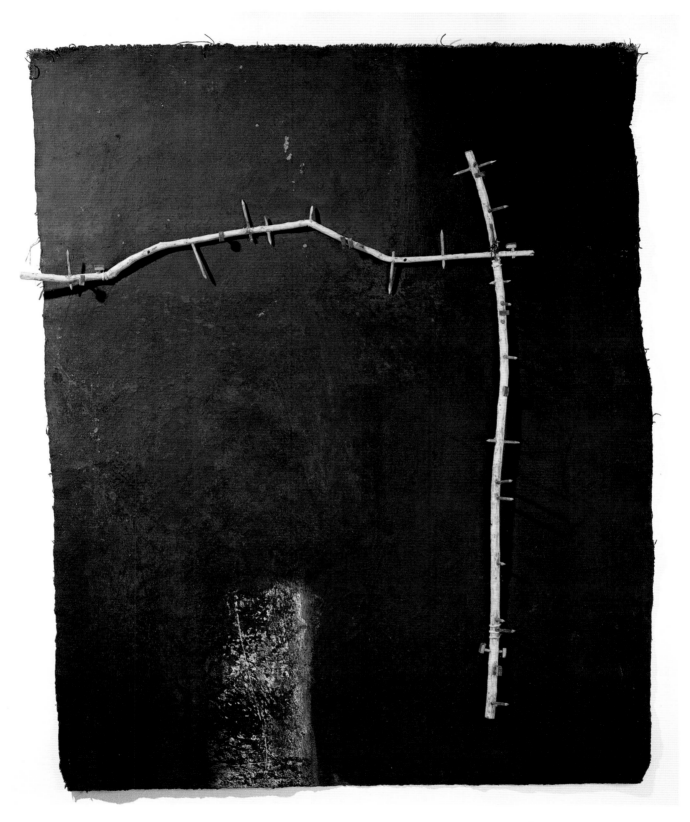

CAT. 33
Spiritual Journey II.
By Thabiso Phokompe, 1999.
Unmounted hessian, pigments,
sticks. H. 151 x 121 cm.

Thabiso Phokompe

T.P.: First, I would like to point out that there is no proper consultation and dialogue between artists. The result is basically two streams of expression and, to put it bluntly, one is from the haves and the other from the have-nots. The work by white artists is evident in its sophistication and presentation. The work by black African artists is a combination of innovative work and some conventional expression by artists without access to education and galleries. Although I think Jackson Hlungwani is the exception, because he was making site-specific work in his Mbokota shrine long before it became fashionable amongst artists in Southern Africa.

D.K.: What about access to exhibition space for artists? There are presently only two major commercial galleries, the Everard and Goodman galleries, and the other smaller galleries often have shorter life spans. What in your opinion can alleviate this problem?

T.P.: I think the government should play a role in subsidizing independent exhibition spaces for those artists who cannot be absorbed by commercial galleries.

D.K.: Your colleagues Samson Mnisi and Clifford Charles have been collaborating for some time; they eventually identified an empty office space in the building housing the Johannesburg stock exchange, in which they mounted an exhibition of their work. Should artists take the initiative to identify studio or exhibition space in the city in order to access a new avenue for independent exhibitions?

T.P.: Artists have over the years taken the initiative to locate and occupy exhibition or studio space where possible. A major problem with such ventures is that they seldom receive adequate funding, and without funding little or nothing can be done.

D.K.: Now that you are working with Samson, do you collaborate on certain projects or do you work individually?

T.P.: We first worked together in a space within the Newtown cultural precinct, but unfortunately, squatters started invading the place as well, and we eventually abandoned the space. Homeless people in the city have become efficient in identifying disused and vacant premises, which they immediately transform into a commune.

D.K.: Have you had any joint exhibitions with Samson, and what type of space did you employ?

T.P.: We had two exhibitions together. The first one was in a farmhouse in Zuurbekom, which is west of Soweto township, and the other was in a private residence in Melville, a city suburb. What was most surprising was the positive response we received from people living in the surrounding townships and who are not at all exposed to the visual arts. I think what made the people at the farmhouse relate to the work were the symbols and objects incorporated in the display, which evoked ritual, belief systems, and mythology. I am at the moment using soil in my work—all different kinds of soil. Soil, to me, is like a womb from which life flows. It is what gives birth to life.

D.K.: Do you think with time there will be an art market within black African communities?

T.P.: It is going to take some time and a few decades before any market can take shape. There are far more important issues, such as housing, which need to be addressed.

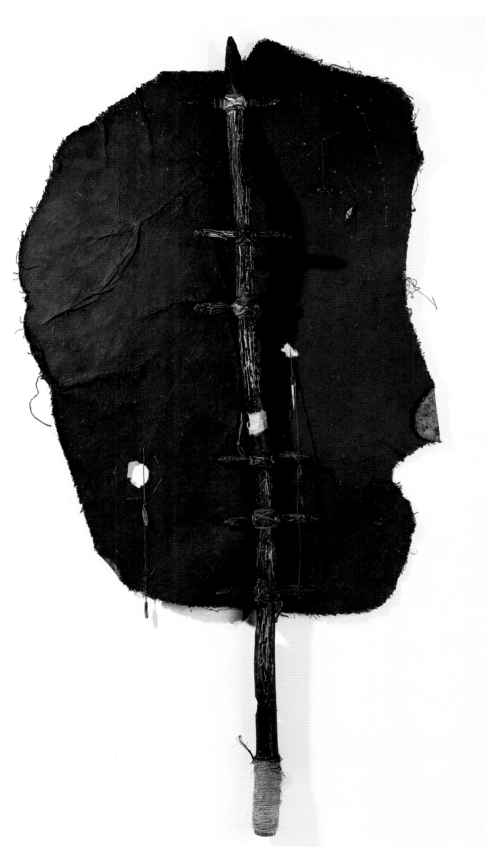

CAT. 34
Tree of Life.
By Thabiso Phokompe, 1999.
Unmounted hessian, pigments,
sticks, rope. H. 170 x 91 cm.

Bridget Baker

Clive Kellner

Simple truths and narratives are reflected in the work of Bridget Baker, and while exploring the trifling neuroses of everyday life, she scrapes the surface of things reaching for the common bond that ties families together. Combining reality and fiction, which has become her leitmotif, Baker conveys an obsessive approach to autobiography. At the age of five, Baker's father died from a heart attack leaving her with the only tangible memory of him—a photograph.

In *So It Goes*, 1996, a vague image of Baker as a child, harnessed in a red Bentley Belt and swimming with her father, lurks out from the tiny circular tin of a Vick's VapoRub container. As an act of remembering and survival, the artist "'commemorates'" memories of her father by objectifying her portrayal of him. Where Baker crocheted the neck of the Bentley Belt closed and added the embroidered words "Bridget (5) Swimming Without Dad," the artist's evocation of her father is preserved by the action of sealing the swimming apparatus. Similarly, a series of kickboards used for children's swim training have school merit certificates stitched into their surfaces to mark the artist's progression in life.

In *General Excellence Certificate*, 1997, the name of Bridget's high school in East London Clarendon, and the signature of the principal bare testimony to the vestiges of colonial legacy in Africa. An amalgamation of "official" documents pertaining to her schooling—remembrance and reconstruction of family memories and bereavement attributed to early childhood experiences—the artist has mapped her identity based on a variety of materials and influences linked to her personal history, creating a memoir of her life to date. Given the obsessive or repetitive gestures implied in sewing, stitching, and laboring, the artist's approaches to creating are inherently "feminine," offering more positivistic notions of traditional female tasks aligned to crafts. This reversal of representation of the feminine by conventional male-orientated readings can be compared to the works of artists such as

CAT. 35
Winter Project. (detail)
By Bridget Baker, 1999.
Ten hand-knitted woolen jerseys, foam, 10 wooden trays.
Installation: 62 x 541 x 50 cm.

Bridget Baker

Fig. 24
LEFT: *Wedding - (my mother's 2nd wedding ceremony - 1977: Anglican Church, Hermanus)*. By Bridget Baker, 1997.

Fig. 25
RIGHT: *Water Baptism - (1985: Christian Centre, Beacon Bay, East London)*. By Bridget Baker, 1997.

Sophie Calle, Annette Messager and Tracey Emin, albeit from a uniquely varied viewpoint. By comparison, Baker's process has also led to personal portrayals related to memory, archiving of objects, and questions around lived experience, which can also be found in the other artists. Similarly, Baker has invested and indeed derives meaning from the materials used in the creation of her installations and objects. Wool, ointments, discarded objects, and trophies are materials that inherently possess meaning, where smells evoke jarring recollections in the viewers own responses.

Suburbia—that constant nightmare of "middle-class," and more especially in South Africa, white middle-class is sternly reflected in the objects and materials that Baker so seemingly effortlessly disrupts. Attributed as much to lifestyle as to economic status, Baker's world, and that of the majority of the white population, was orientated around suburban life. As much as the artist's work resembles the values and morals implied by the middle class, it also poignantly reflects the anxiety underpinning that particular sector of the South African population. Competitiveness at school, religious dogmatism, family conservatism, and the obscured segregation of apartheid are only some of the symptoms of middle-class values. Identified by the lifestyle attributed to swimming pools, security fences, and associated privileges, Baker's personal chronicles do not pretend to represent anything beyond their own reality and history. Such honesty is refreshing amongst the myriad of artworks that claim political representation. Baker's production is not naïve nor unconcerned with social realities, rather her work represents the miraculous transition from the apartheid state to that of a democracy. Baker grew up in South Africa at a time when the political emergencies inherent to the unfolding drama of history were already taking place. And so it is that Baker, like many of her contemporaries, reflects a new moment and possibilities for the next generation not beholden to overtly political imagery. The post-apartheid state offers a unique opportunity for a new generation of "younger" artists to locate their production within a wider paradigm not predicated on racial and political imagery. It is an arduous task for the framing of discourse within South Africa, which is imbued with an intense racial fragmentation, and by necessity requires that artists reflect this political orientation in their work. Resistance art is a term that was used to capture a particular moment in South Africa's turbulent political history and defined cultural production by artists that opposed apartheid. However, given

the transition from an autocratic state to one of a democracy, many artists experienced a sense of dislocation. Up until the early 1990s apartheid had remained a constant reference, whereas the shift to a post-apartheid state had contributed to a new climate of reconciliation and transparency, and eventually a wide open field of references enhanced by a new international interest. It is in this current context that artists like Bridget Baker position themselves.

In a review of the artist's first solo exhibition, *The Shrill Sound of a Telephone at 3am*, 1996, Baker's works were described as "hovering poignantly between craft and art, commemoration and gift, quest and obituary." Other than the overtly Calvinist iconography—labor, sacrifice, and the search for the eternal—Baker has the uncanny ability to master complex codes that entrap the viewer in a visual sophistry where objects represent a series of narrative possibilities, each with a fractured memory of their own.

Sweaters displayed openly on shelves are haunting responses to child abuse, abduction, and torture. An identification parade archived. But the artist is playing a game with us—are these vestiges of a cruel crime? Are they again related to a personal hybrid the artist has reinvented through friends and family—a testament once again to her lived experience? The viewer is seduced into a coded portrayal that the artist has knitted together, comprised from jerseys that were borrowed from friends and family, unraveled and reconstituted.

Clive Kellner: Your work draws strongly on childhood experiences and especially on the memories you have of your father who died while you were still very young. One photograph remains linking you to your memory of him. Does the process of creating artworks replace the loss you experienced?

Bridget Baker: The process of making artworks seems to help me experience loss. You see, I don't actually remember much of my childhood. This is an extraordinary statement, but it is this absence of memory that is probably the driving force behind my making art, and often dictates the themes I choose.

I have no first-hand memories of my father when he was alive. What knowledge I have of him is factual, dug-up, researched, or re-told—but physically he never existed for me. I was five when he died, and we children weren't allowed to attend the funeral. It was as if he had vanished. My mother never spoke about him, and we respectfully didn't inquire about him.

Fig. 26
LEFT: *Graduation Ceremony -
(receiving a BAFA degree - 1993: University
of Stellenbosch, Stellenbosch).*
By Bridget Baker, 1997.

Fig. 27
ABOVE: *Christening - (1971: Anglican
Church. East London).*
By Bridget Baker, 1997.

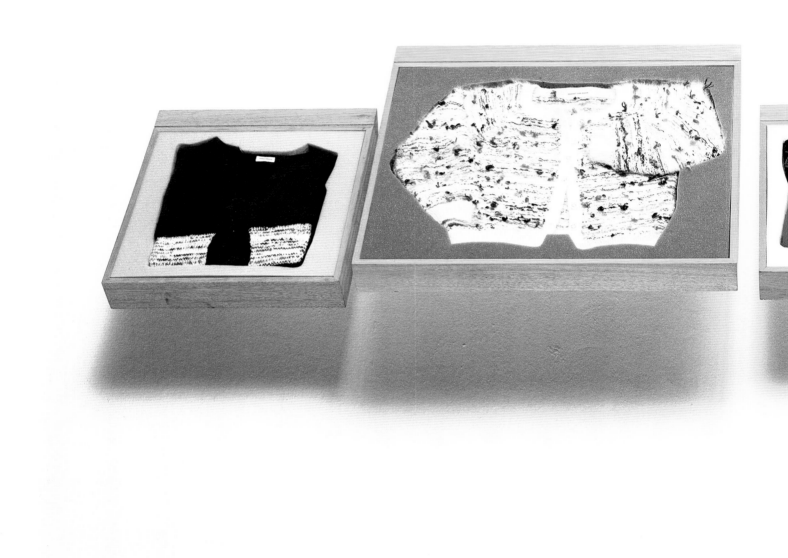

CAT. 35
Winter Project. (detail)
By Bridget Baker, 1999.
Ten hand-knitted woolen
jerseys, foam, 10 wooden trays.
Installation: 62 x 541 x 50 cm.

CAT. 36
Stitch. (detail)
By Bridget Baker, 1998-99.
Eighteen embroidered running
belts, video projections, 'winter
green' aromatherapy oil. Installation
room, 230 x 280 x 450 cm.

Bridget Baker

We broke with family traditions like having Sunday lunch with next-door neighbors, and my mother escaped into Christian never-never land, taking us with her. So in a sense, one day we had a father, and the next we had a substitute: a heavenly father. The past became a "no-go" zone. A way of coping with "forgetting" was by reading obscure goal-oriented verses from the bible: "Forget what lies behind and move on to the prize."

Our stepfather, a minister of religion, became the "chosen one" in this monstrously idyllic family setup. We children had to impress him in order to placate my mother and be acknowledged by our heavenly father. With very few secular involvements as a family we became solely exposed to Christian dogma (with distinct charismatic and Victorian overtones). Having no other reference points I presumed that these codes of living were normal and healthy.

When I left home naturally I severed connections to repressive Christian notions—I studied, made art, and traveled. The real turning point came in 1995, when I became more politically aware and involved in a reconciliation process with my own history. This process involved revisiting my past—picking up the issues that, as a child, I was not allowed to deal with, which included experiencing grief for the death of my father. Through the process of artmaking, I could visit my father's funeral in my mind. I was free to imagine myself swimming with him. These "visits" offered me a way into and through the grief.

Even in my artmaking process now I always seem to work with memory as a major component. The reason for this is that I am trying not to forget those things that I do remember. I also want to remember those things I have been told. I don't want the recollections I do possess to disappear, no matter how distorted they might be from the original experience.

CK: There is a sense of autobiography throughout your work that maps a seemingly chronological development of your upbringing from images of yourself as a baby through your school years, and finally adulthood. Are there particularly strong feminist elements in your work or thinking?

BB: Domestic occupations like sewing and knitting are historically the terrains of the virtuous woman. My own mother instilled in her young daughters' minds the virtues of handcraft by encouraging us to make our own clothes. At art school I experimented with traditional "fine art" techniques, but remained drawn to approaches like hand-embroidery.

Fig. 28
Bridget Baker - B.A.F.A. (Stell.), B.A. Hons. (FA) (Stell.), M.F.A. (UCT) cand.
By Bridget Baker, 1996-7.
Porta-pool. 17 embroidered kickboards, plastic, cotton, valves.
15 x 35 x 30 cm.

Fig. 29
So It Goes. By Bridget Baker,
1996. Vicks vapor rub, four tins,
photographs.
3.5 cm diam. x 2cm each tin.

Cᴀᴛ. 36
Stitch. (detail)
By Bridget Baker, 1998-99.

Bridget Baker

This is a time-consuming process and the repetitive nature of the work allows me to contemplate and work through issues I am dealing with.

CK: Given your upbringing in "white" suburban South Africa and the relatively privileged position that is implied by "white" suburbia during the apartheid period, do you think that it is now possible to speak of post-apartheid, and more compelling, of art that is not overtly political?

BB: I was brought up materially privileged. I was also brought up *unaware* of the dire inhumane situation happening in the country. The type of work I made until the end of 1993 manifested a personal unawareness. I was never consciously aware of the reasons for my making art. This dulled vision began to clear in 1995—a significant period in South Africa's political history because the Truth and Reconciliation hearings had just begun and everyone was talking about "finding a common ground." I became involved with a religious action group of students. We would relay stories about our diverse upbringings. This sparked in me an understanding of the commonality of existential human experiences such as loss, mortality, and grief. By hearing others speak about their loss I became aware of my own sense of loss. Consequently, these experiences significantly impacted my artmaking process. My reasons for making art became clearer on a personal level.

CK: You use a variety of "smells" that are representative of childhood remedies for ailments, such as Vick's, Deep Heat, and other medical ointments used to soothe and heal, please expand.

BB: Smell is an immediate and compelling means of triggering memory, perhaps more powerful than visual images in terms of unlocking memory. It evokes a response without any conscious effort or intellectual understanding. Used as an element in the work *Stitch*, Deep Heat muscle rub evokes different responses linked to memories about soothing sore muscles. Artworks that contain an element of smell are often haunting, evoking a persistent presence that continues outside of its immediate physical environment.

CK: Referring to an article by Andrew Putter, to what extent do you agree with him that your works "hover poignantly between craft and art, commemoration and gift, quest and obituary"?

BB: This refers to the paradox at the heart of most of my work and thinking: wanting to be separate from my childhood, and wanting to reconstruct memories. Motivated by such inconsistent emotions I constantly revisit sites of my childhood in order to remember and at the same time abandon them.

CK: Do you suppose that the conventions of high art categories such as fine art and craft are rendered obsolete in a post-apartheid state where the empowerment of women, hand-made objects, and tradition are being so stridently revisited?

BB: I have all but discarded the false superiority of European "fine art" traditions that we were taught at art school. I regard that legacy as redundant. I feel more at ease following the craft traditions of my childhood. I consider these as more honest—not lowly—forms of expression. Now that the boundaries between categories such as "fine art" and "craft" are disappearing there are very few restraints when it comes to artmaking. Also, artists need not go to art shops ever again. We have the freedom to use any material. In contemporary artmaking the materials perform an essential conceptual role because of their own innate history. The issues I discuss in my work are usually of a domestic nature, so it makes sense for me to use mostly household materials.

CK: Colonialism brought a vast legacy to the African continent, it also brought Western cultural traditions and methodologies to South Africa. Do you think the majority of artists in South Africa work within a Eurocentric framework: painting, installation, and video for example?

Fig. 30
Not A Life Preserver.
By Bridget Baker, 1995.
Bently belt, cotton thread.
Diam. 35 cm.

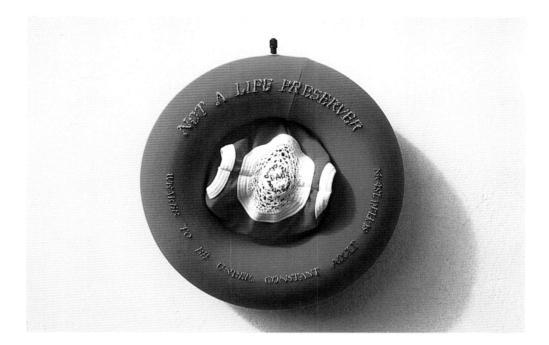

BB: Weaving, knitting, sewing—the primary mediums I work with—are neither specifically European nor African traditions. It is quite apparent that my influences come both from Europe and from Africa—my heritage and my experience—in roughly equal proportions.

The desire to create installations comes from an impulse to surround the viewer, to draw them into the work by creating an environment which is all encompassing. I am not concerned whether this is a European or an African impulse. I remember very clearly going for supper in a shack in an informal settlement outside Stellenbosch, and having a sense that I was somehow in an installation. The rusted, unlivable exterior opened to reveal an immaculate and spectacularly decorated interior. Out of financial necessity, found objects had been used with incredible resourcefulness and ingenuity. I remember being acutely aware of the artistic richness of the shack, getting the sense of being surrounded by someone else's materials, chosen and selected from their lives. The aesthetic was so complete and coherent and so different from my own. Since then I've wanted to make installations.

CK: There is so much talk of the global and local today, what sort of changes do you think have occurred during South Africa's transition period toward becoming a democracy? Are we finally a part of the world? Is internationalism important? How does a "young" artist survive in the "new" South Africa?

BB: If I compare my mother's generation to my own, I'm struck by the humbleness of my condition. It seems that there was once a lot more money (inheritance and legacy). I don't think my mother ever had to *look* for anything—any material object—be it furniture, paintings, television, car, clothes, these just came to her. By contrast, I live on the bones of my bottom—art grants are impossible to come by, corporate sponsorship goes mainly to sports—it's not at all conducive to making art, especially not for a white, "historically privileged" artist. So I eke out a living from hand to mouth, constantly in debt. But what that does is it forces me to be resourceful. Like the woman who had decorated her shack with packaging paper, I am forced to take what I can from the environment. I cannot afford elaborately expensive art materials. I must take what is beautiful, poetic, resonating from the abundance of "stuff" that surrounds my life. I most often use found materials—things I can get for free—to make art. I

use letters, certificates, old jerseys, the "leftovers." In this way I am thrust into my environment. My work becomes African by virtue of it being made of African junk.

CK: Are we finally part of the world?

BB: Yes. Curators from around the world are very impressed when they come here. But there's a sense that it's the curators in the Northern Hemisphere who decide that we're part of the world. We're "allowed into the fold." We still live with a complex that we aren't good enough, unless we are told that we're good enough. There is a lack of confidence in our product. Until we decide to allow ourselves to be part of the world, we live constantly in opposition to the idea of the world, and thus still isolated.

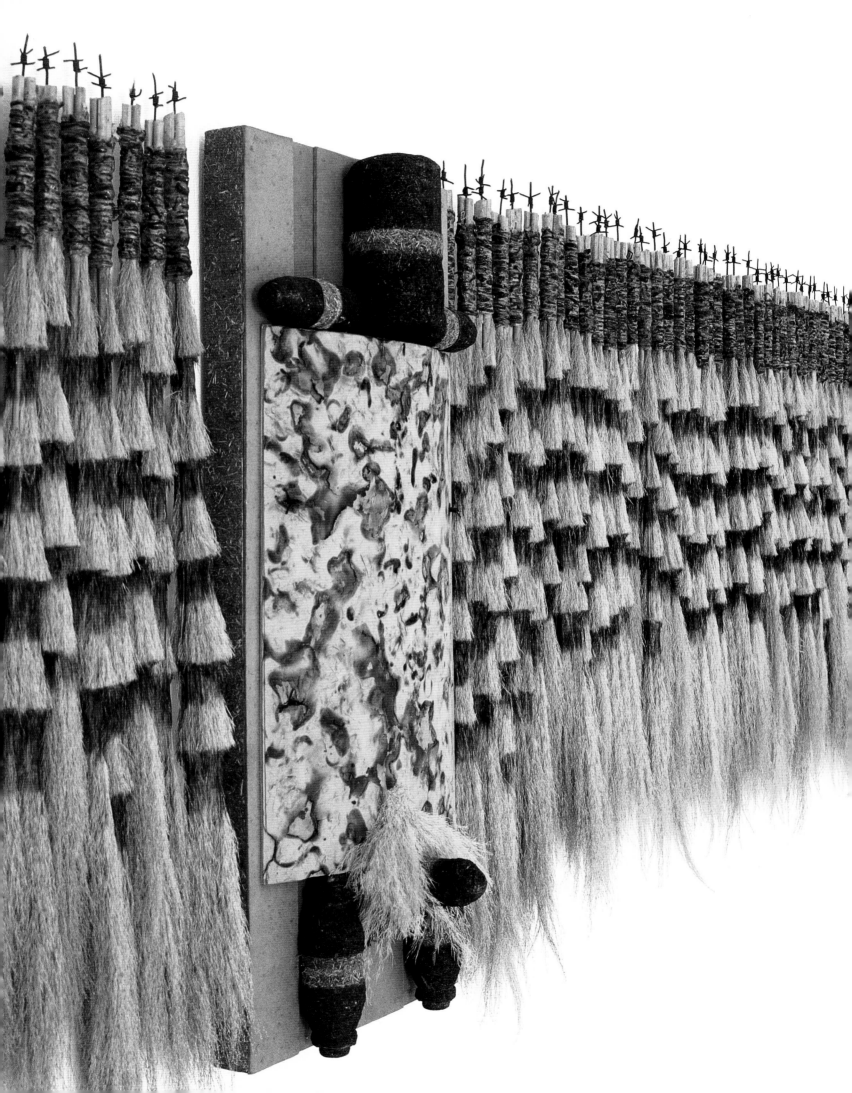

Sandile Zulu: Incendiary Devices

Colin Richards

The light above the candle is fire in a chain; consuming that it consumes itself.

–Leonardo da Vinci, "Fables," *The Notebooks of Leonardo da Vinci* (1954:II:421)

I have had enough of the fire
Its warmth brings memories of bodies
Tortured, killed, maimed and burnt

–Nolizwe Mnyaka, "Am I Hallucinated" (1994:89)

Each winter the long dry grass around the Amakhona Art Centre–home and studio for Sandile Zulu–is deliberately set on fire. This drives the snakes away. Controlled fires also create firebreaks: there is a constant danger of fire on the highveld, where flames are fanned by water-less seasonal winds and fed by grass mortified by cold. Many fires are lit; for warmth, for light, for mischief. Many go wild. A pall of smoke often hangs over the veld on the way to the Centre.

Amakhona itself lies in no-man's-land. Somewhere between the eroding frontiers of Soweto's sprawl and the fenced, manicured, once white suburb of Maraisburg, southwest of Johannesburg, it is built on dead ground–old goldmining property fallen on hard times. Wall-and wire-enclosed enclaves of industry generate haphazard islands of activity round about.

Eternally peeling eucalyptus trees grow randomly or in ranks in the parched, ashen grass-land. The ranks recall their original cultivation for props in mineshafts and the million gutted tunnels of gold greed running far below the surface. These trees are alien. Their roots soak up precious water. They imperil indigenous growth already struggling for moisture in soil sterilized by the side-effects of extracting precious metal from fortified veins of rock.

Mine dumps yellowed by iron pyrites ("fool's gold") lie scattered across "a wasteland secreted in the suburb's groin… shallow, violent, bleak, a drained and shadeless wedge of earth, uncultivated, mired by money-miners" (Abrahams 1986:259–60). Some dumps are patterned by grids of stiff pampas grass (*Cortaderia agentea*) hopelessly entangled with tenacious "weeping love grass" (*Eragrostis curvula*). The grids trap shifting sand, retarding erosion and the stinging cyanide-inflamed dust from blowing where it doesn't belong. Some dumps–"sterile and brilliant with residual poison and gold" (ibid. :260)–are being recycled, eking out whatever gold remains vulnerable to new and cheap technologies of purification. Leftover soil, residue of residue, is dumped in abandoned mineshafts. Below the blackened,

CAT. 37
Frontline with Centurion Models.
By Sandile Zulu, 1997.
Fire, water, wind, soil, metal,
wire, reed. 600 x 100 cm.

flaking skin of the land, the earth is now the last resting place of pulverized toil, filled with the barren powder of dead energy. Some migrant workers remain forever deep underground, violently and prematurely entombed with their last labors. South Africa is a land both of unmarked graves and of riches beyond imagining.

The dark mouths of disused shafts exhale hot air. Protected by barbed wire brandishing rusted red skull-and-crossbones signs (Danger / Gevaar / Ngosi), some are camouflaged by improbably verdant vegetation. But the greenness is a giveaway. The only green grass around is that moistened by the meeting, in the shaft mouth, of bowel vapor and outdoor air. Weathered trenches furrow the ground like evacuated fortifications from unfinished battles.

If you raise your eyes and look, really look, beyond the false horizon of smog, you can see wide open spaces, a clear sky, agriculture. Fire, wind, water, grids, grass, roots, recycling, barbed wire, alien growth, graves… industry, agriculture, migrant labor, frontiers, camouflage, struggle, anthropomorphic nature; the allegorical rubble of Sandile Zulu's art.

The Elements

Sandile Zulu's aesthetic entwines art, ecology, and politics. Many of his two-dimensional "fieldworks" may be said, in a loosely knit metaphor, to be cool flatbed abstract "fire" landscapes. A number of his three-dimensional "objects," whether single or in combination, recall dangerous devices as well as forms of defense: incendiary limpet mines, flares, rockets, as well as more archaic military paraphernalia—the arrow, the stabbing spear, the plumed and patterned cowhide shield. But whether his works are field, object, or installation, we can read history in them; be it of landlessness, land hunger, or land enclosure, of cultural cultivation or destruction, of urban or agrarian industry riven by the tracks of migrant labor in search of secure subsistence. And that reading can run into very deep time indeed.

Taken together, Zulu's materials, processes, and structures constitute an elegy to the edgy ambiguities of natural and cultural interaction, where military and industrial treacheries confront or simply inhabit more tranquil and agrarian registers of time and place. Within his elemental, sometimes sly aesthetic economy there is also, perhaps unexpectedly, a transcendental, redemptive, affirmative spirit. A furrow, for example, like the one running through *Frontline One: Grassroots Rising* (1997), can recall a trench dug as much for fortification as for seeding. It can suggest a fertile, generously soiled sexuality as well as a defensive line. Grass can signal abundance, growth, harvest, as well as camouflage. A fire-scorched surface may be extremely delicate, and can suggest a leopard's skin, as in *Indluyemgwe* (1998). The term means "lair of the leopard," and often connotes royalty; reading the work as faunal camouflage, Zulu also tracks the reference to a nineteenth-century imperial Zulu regiment named after this graceful, endangered carnivore. *Indluyemgwe* suggests the "lair" of both animal and army, but also, beyond this, the domestic hut and hearth, through the image of a rolled-up reed mat above the camouflaged field. What links these allusive, referential flows is, improbably, a strong desire both to conserve and to look forward, beyond the immediate cultural horizon; hence its redemptive aspirations.

It might reward us at this point to consider more closely Zulu's own words about his work. In an early statement (Zulu 1997), he introduces an eccentric couple of concepts to articulate his artistic interests: "*artomism*" and "*artomic*." It is worth taking a look at these notions, not so much to direct our readings as to ignite sparks that might illuminate the more obscure reaches of pleasure and meaning in his work.

Zulu derives the word "artomic"—fire, burn marks, "pyrotechnic effect"—from "atomic," pointing, at the term's incendiary extreme, to nuclear energy. This energy, by far the most

powerful harnessed by human society, can be mobilized for good and ill, for creation and destruction. Zulu works this ambivalence with great deliberation and subtlety, mainly, but not only, through the carefully harnessed action of fire and water on natural materials. By "artomism" the artist wants to address something more fugitive: the "psychological struggle of imagining and desire." He relates this notion, perhaps surprisingly, to an early psycho-physical theory of atomism that seems to have held that all states, whether mental or material, interrelate, and are made of elementary units and space.[1]

I fancy part of what Zulu is trying to grasp in "artomic" and "artomism" is what Gaston Bachelard (1987) characterizes as the "dialectic" of fire (perhaps Zulu's principle active medium)—that is, the relation between inner and outer world, between subjective feeling and objective knowledge. Zulu is also searching for the profoundly elemental, in both materials and relations, both interior and exterior.[2] Through the action of fire, air, and water, he means to annex and activate the fertile, allusive, and more directly historical referential field that his art embraces. These primary elements, perhaps above all others, catalyze "decay, destruction, renewal and purification" (Zulu 1998:15) in an "atavistic," affective, aesthetically compelling alchemy of a very material kind.[3]

Conjoining "artomic" and "artomism," Zulu desires, through primary, often rhythmical arrangements of discrete elemental processes and forms, to start afresh. But afresh from what? Certainly it is not history that is stale. Zulu speaks quite explicitly of "socio-historical issues," of "colonization and decolonization" (ibid.). If, as Frederic Jameson puts it, history is what hurts (1981:102), Zulu would not want this hurt or the violence it betokens to be simply forgotten. But then he would also not want history frozen, the rigid ballast that chains "the dog… to its vomit" (as Samuel Beckett once wrote of habit; 1965:19). Nor would he wish, in his devotional coolness, to move away from the ancient, messy, mutable archive of the mind. For we should be reminded that Zulu speaks of "the social *and psychological* struggle for freedom of creative desire and imagining" (1998:15; my italics).

A History of the Moment

Sandile Zulu's project, then, in this reading, lacks neither an intimate nor a public dimension, and speaks both of time now and of deeper time. Perhaps it is within these mutable spaces and relations that he seeks renewal; a fresh start. Risking generalization, this kind of dynamic dialectic between the personal and public, between intimate and social "biography" or narrativity, may have shaped a good deal of South African art since that auspicious date of April 1994.[4]

But there is an edge to this newness. Zulu's project is almost perversely novel in its obstinate continuation of at least one major tradition in South African art preceding April 1994:[5] insofar as his aesthetic politics are of piece with "resistance art" of the predemocratic period, they may be considered anachronistic in current "cutting-edge" arts circles. "Resistance art"—the title of a book by Sue Williamson, published in 1989—has become something of a leaden tag, applied like a millstone to what were, and remain, highly differentiated practices. The art so tagged is now at constant risk of being caricatured through routine oversimplification. Williamson and Ashraf Jamal admit that "'stuck in the struggle' is a disparaging phrase used more than once by critics seemingly eager for an all-new, all-fresh artistic vision of the born again-land," and follow with the well-worn question, "If the resistance narratives of the past have lost their potency, what has taken their place?" (1996:7). This current of opinion has become a critical reflex in many readings of contemporary South African art, and contains much of value. But it must be said: resistance to resistance art is almost a new orthodoxy in the reception of current work by South African artists. The cost of this orthodoxy is difficult to estimate, but it does include the risk of failing to appreciate the complexity of "resistance"

Sandile Zulu

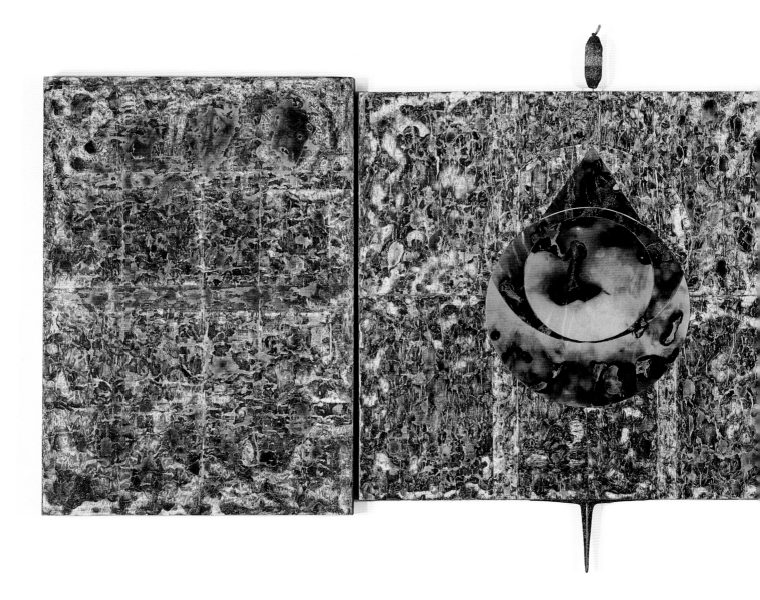

work, which, it must be said, should avoid falling into an all-too-easy, sentimental essentializing of locality and history.[6]

Any such "orthodoxy" notwithstanding, Zulu still speaks of achieving a "critical mass," of aspiring to "critical, creative mass consciousness" (1998:15). To what end? To the end of "revolution and liberation" (where such things are possible) through "purgation and cleansing… purification and renewal" (ibid.). For all its apparent recidivism and utopianism, Zulu's ambition for the imagination should not simply be dismissed as rhetorically passé and aesthetically out of touch. It can be seen to engage, for one thing, a cultural politics that might resist certain readings of the "local"-to-"global" relationship, including the residual "primitivism" that still seems to inflect the reception of so much "African" art abroad. And perhaps when the artist speaks of a "critical and theoretical framework for the analysis of my offerings" (ibid.), he should and should not be taken at his word. In the context of his theory of "artomism," the phrase "critical mass" carries a hint of punning irony, and from it a viewer could spin different yarns. This is the case with the titles of many of Zulu's works, which often read on multiple levels. We should perhaps not take this multiplicity, nor the play it embraces, too lightly. Nor, in the spirit of that play, should we make too much of it.

Sandile Zulu

CAT. 38
Abduction of the Text: Total Eclipse.
By Sandile Zulu, 1997–98.
Fire, newspaper, metal, reed, wooden
board. Triptych: 110 x 354 cm.

At any rate, Zulu's statements loosely describe an aesthetic position uncomfortable since 1994, in that they refer to something less than "new," for those slave to such things. Since around 1994, the "new," for some local artists at least, has been the fetishized residue of an ahistorical neoconceptualism, the most ardent—and rather banal and conventional—desire of which is to exchange fluids with a rapacious "globalism." Such a desire has little use for "struggle" politics and "resistance art" (however impoverished these labels) beyond their simulation as global commodity. More seriously, if we read in Zulu's works and words a more didactic and public aesthetic of "struggle," they might be seen to be of a piece with, and a response to, what writer Njubulo Ndebele once called the "hegemony of spectacle" (1991:47) characteristic of South African culture in the 1980s. For Ndebele, this hegemony obliterated intimacy, detail, and contradiction and overdetermined matters of form, content, and address.

Putting it slightly differently, as the capitulation of the imagination to reality, J. M. Coetzee had occasion to write, just over a decade ago, that the "*crudity* of life in South Africa, the naked force of its appeals, not only at the physical level but at the moral level too, its callousness and its brutalities, its hungers and its rages, its greed and its lies, make it as irresistible as it

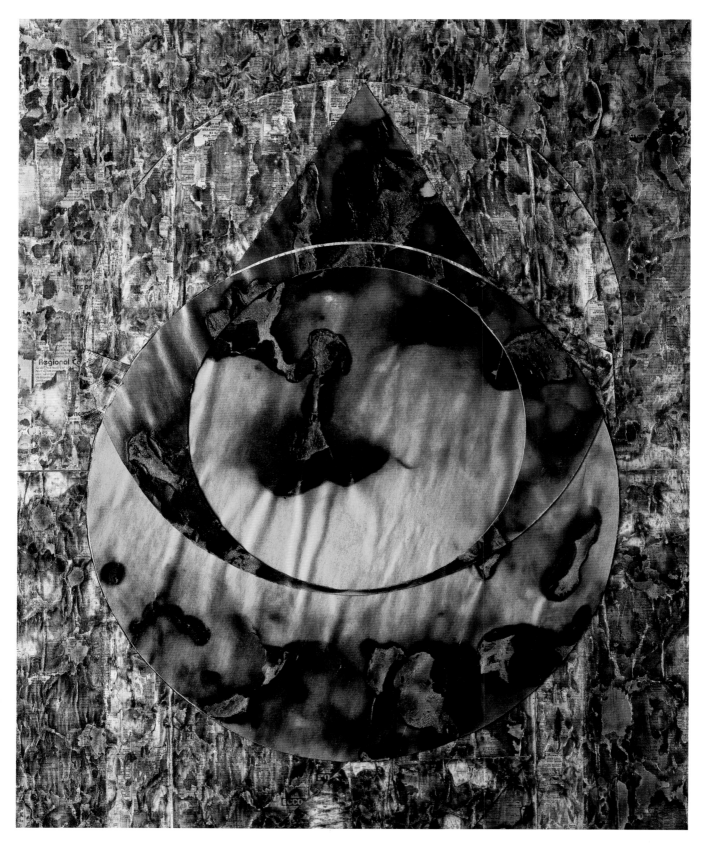

Cat. 38
Abduction of the Text:
Total Eclipse. (detail).
By Sandile Zulu, 1997–98.

is unlovable.… We have art, said Nietzsche, so that we might not die of the truth. In South Africa there is now too much truth for art to hold, truth by the bucketful, truth that overwhelms and swamps every act of imagination" (1992:99). The swamping of imagination by "truth" is still with us. The not uncontroversial Truth and Reconciliation Commission (TRC) has given us a fuller measure of this moral quagmire.[7] Certainly callous brutality, greed, rage, hunger, lies, and corruption remain with us, but the possibilities of the imagination are being liberated.

This is supported by recent comments by Ndebele himself. In a recent discussion of the TRC and narrative, Ndebele recalls both himself and Coetzee noting years ago that "day-to-day life under apartheid often outdid the efforts of the imagination to reduce it to metaphor" (1998:19). But for Ndebele at least, now (finally) "time seems to have rescued the imagination" (ibid.:20), and he points to a yet future time when a fuller rescue of the imagination might be achieved, a time when those bitter "facts" of lived experience "will be the building blocks of metaphor" (ibid.:21). So the "facts" (callous brutality, greed, rage, hunger, lies), while always with us, are now interleaved with other, shyer, more ordinary facts, aspirations, desires, wants.

All of the former "facts" remain part of Zulu's careful, purposeful, time-consuming, modulated aesthetic of accretion, but we would be deceived if this was all we could see. What also seems palpably new is his confrontational claim to rescue an imaginative space through a spare, essentially nonfigurative, but not nonreferential or nonmetaphorical syntax, iconography, and affective economy. Zulu's cool, calculated systemic passion points to a more properly minimalist mentality, quite different from the often bombastic and overblown rhetoric and figurative craftiness that characterized much of South African visual art before the turn of this remarkable decade. It was not without reason that overblown representation characterized the past era, but such inflationary symbolics are, as Ndebele and others have noted, now ending. There is now a painstaking, uneven restoration and realignment of more open relations between internal and external, private and public being. Our conflicts are, in a sense, normalizing.

Zulu's use of aesthetically unsung materials (grass, reeds, roots, soil, water, newsprint, barbed wire, various bindings) and elementary, sometimes immaterial processes (fire and wind) thus signals a committed but reflective aesthetic of immolation, purification, and renewal. It is one that wants to recolonize or reclaim interiority even as it engages public experience and refers to historical processes. Fire, water, wind, and earth are ancient media for such aesthetic ambitions, and while we shall return to them in due course, we should not forget that these media are *situated*. They have specific, differentiated histories and localities. This is South Africa, after all.

This said, and acknowledging that the materiality and specific history of fire itself is crucial to a full engagement with Zulu's work, we might not want to forget the rich historical association between fire and knowledge, be it carnal or, and this is important, spiritual.[8]

Cool Arson

For all his allusions to atavism, inflammation, combustion, Zulu remains (as I have said) cool, detached, unsentimental, almost prosaic in word and work. Part of his distancing desire, or desire for distance, lies in his elaboration of relatively simple systems, and with it his implication of ritual. For it is clear that his dominant aesthetic syntax (as with historically prior moments of minimalism, one cannot confidently speak of "composition") is systemic and often works by elementary accumulation. This is frequently expressed as a set of discrete, repetitive (or quasi-repetitive) elementary arrangements. Yet if system is about relation, what then of objects? Here we might want to speak of a modular impulse, something also consonant with minimalism, although the idea of the module is perhaps too mechanical a

Sandile Zulu

notion for Zulu's carefully cut, trimmed, and marked units of construction.[9] For his modular sensibilities include natural or organic morphologies, much as his "grids" might refer to the patterns of land cultivation as much as to the mapping of a pictorial surface. Both modularity and system in fact point to the strong presence and importance of the grid in much of his work.

The grid, and all it implies aesthetically, could refer here to specifically modernist dispositions largely hostile to figuration or representation as conventionally understood. Certainly there is a quality of anonymity, an insistence on the trace after the fact in much of Zulu's work; but something more humane is also operative. Marks on a field or surface might be "postevent" but are not postexpression. Indeed, equating fire with life, we might want to see in such traces post-mortem relics of expressive presence. Grids—and the allover, poly-accented "fields" of high modernism that they frequently embody—are anthropomorphically inflected here. This anthropomorphism regards "mass production" as not exclusive to the industrial plant but also pertaining to agrarian production, and understands the organization of space in both its metropolitan and its rural modalities.

Thus while this grid might well be understandable as "an emblem of modernity" (Krauss 1978:n.p), its modernity would not only be some taken-for-granted, metropolitan, "first world" one. And while it might be true that "the bottom line of the grid is a naked and determined materialism" (ibid.:n.p.), that materialism is here entirely more capacious, capricious, and dissident than would probably be sanctioned by modernist purism. Here the Structuralist (c. 1978) Krauss might perhaps be more to the point when she acknowledges that "by now we find it indescribably embarrassing to mention 'art' and 'spirit' in the same sentence… the peculiar power of the grid… arises from its potential to preside over this shame: to mask and reveal it at one and the same time. In the cultist space of modern art, the grid serves not only as emblem but also as myth" (ibid.:n.p.). To be sure, Krauss would likely not have had anything like Zulu's work in mind when she penned these words some two decades ago, and they doubtless spin differently when seen through the prism of his work; but I would hope not radically so.

To come to better terms with the question of modularity and grid, it would be useful to look at specific works in some detail. Part of Zulu's modular impulse is captured in his use of particular natural forms, for example the accumulations of root and rhizome that made up *Endangered Roots*, part of an installation for the "Graft" exhibition held at the South African National Gallery in 1997 (for the second Johannesburg Biennale). In this gridded structure the viewer found an ordering, in lateral layers, of neatly sectioned bamboo tubers. In each case the cut surface was cleanly cauterized or branded; interleaved among these surfaces were ranks of sweet potatoes, staple food for many South Africans. Impaled at one or both ends of each potato (and occasionally elsewhere as well) was a cut section of weathered barbed wire, long exposed to the elements. Barbed wire and its various offshoots are ubiquitous industrial and suburban "flora" hereabouts, there being so much post-apartheid property to defend.

Let's examine these elements further. The branded cut surfaces suggested systematic scarification, recalling practices both agricultural and somatic (plowing the earth and marking the body respectively)—practices familiar to us, albeit mostly outside the metropolis. (Of course bodily scarification and other forms of tampering with skin are currently urban designer atavisms.) At any rate, each element was carefully layered to construct an organic cube, recalling not least those neat piles of vegetables sold on the streets of Johannesburg since the liberation of public space around 1994. Added to this, both root and more particularly rhizome encouraged anthropomorphic projections, not unlike those solicited by, for example, the mandrake root.

Sandile Zulu

When exhibited in the South African National Gallery, this organic conglomerate actually grew. Purple, green-leafed shoots emerged from various nodes of the sweet potatoes, slaves to invisible organic energies and the artificial light of that particular "white cube." One effect of this growth was to camouflage the violence done by the barbed wire to the skin and flesh of the sweet potatoes; although some of the entry wounds grew weeping molds, the barbed wire seemed of a piece with the shoots. As a whole, the work staged a kind of organic insurrection, a generative violence invoking the potential organic reclamation of a hitherto anesthetized cultural space.

Like structure, surface matters in Zulu's work. In *Abduction*, a metal case similar to those used by migrant workers or soldiers (called a "trommel") is covered with finely shaved grass, subtly toned through a delicate burning process. Process and concept are important here, and one might usefully link this activity to other artists who have used fire, and perhaps also to the use of modest, close-to-hand materials in recent offshoots of *arte povera*.[10]

Another important interest here—as with many of Zulu's works—appears to be camouflage: were it secreted in the veld, this box would be invisible. The need for camouflage suggests that visibility is dangerous, invisibility an advantage. One might reasonably imagine such a box to contain weapons, or, more painfully, human remains—there is, tragically, a traffic in both in South Africa—but the contents of Zulu's grass-covered casket are in fact quite different: they are carefully cut, sectioned, sorted, and tied "modular" bundles of barbed wire, laid side-by-side in rows. These recall, of all things, bundles of flowers, and the surprisingly sentimental associations accompanying that image.

Zulu typically works with object and field, and often systematically between the two. His installation for "Graft" exemplified many of his maturing interests in this regard. On the floor between *Abduction* and *Endangered Roots* stretched a long double row of "knots" of long grass, partly burned, titled *Frontline One: Grassroots Rising*. These were arranged root to root, with the fine, fibrous, complex roots "containing" the furrow between. The suggestion of hair and nest stimulated a strongly sexual and gendered reading of the space.

Arranged on the wall above were serried ranks of what looked like weapons. Titled *Frontline Three with Centurion Models*, this work actually comprised finely grass-covered and fire-branded industrial molds, marsh reeds, barbed wire, and sharpened metal shafts. The South African collective imaginary includes almost clichéd images from, among other things, school-book illustrations showing ranks of shielded, plumed, armed indigenous warriors camouflaged in the long grass of the South African veld; in *Frontline Three* Zulu invoked this image lexicon of colonial conflict in a directly material and semiotically complex way, concretizing and institutionalizing the historical imagery and ultimately rendering it disquietingly museal. All the elements of Zulu's developing aesthetic language figured in his "Graft" installation: found nature and culture, surface as field (or vice versa), camouflage, grid structure, repetition, rhythm, agrarian and industrial conflict, forms processed by elemental materials—wind, water, earth, fire, and their various symbolic and material harvests.

Part of the "Graft" work *Frontline One: Grassroots Rising* enjoyed a reprise at the Vita Art Now Prize exhibition (August–September 1998), though Zulu played it out differently this time. In the new work, *Abduction of the Text: Main Theme from "Grassroots Frontline," fire and water, wind and dust/soil* (Zulu often, and significantly, includes media in his works' titles), folded and knotted wads of local newspapers were evenly arranged alongside the "grassroots frontline" axis. The knots themselves were lightly scorched, giving the sensation of burned and flaking skin. Burning paper itself had a particular value during the struggle years in that one way of neutralizing the effects of tear gas was to hold a flaming clump of newspaper in front of

one's face. But there is a deeper archive of fire in South African culture that Zulu accesses and cites, and it brings us to an apt conclusion.

Timely Fires

Colonialism and the control of fire appear inextricably related. Brian Van Wilgen and Robert J. Scholes, for example, write that the

> colonization of Africa by European peoples, many of whom brought an abhorrence of fire with them, was marked by attempts to prevent fires. Such attempts were made for various reasons—to protect forest resources, to prevent the putative destruction of grazing, to protect infrastructure or crops, or in often misguided attempts at the conservation of indigenous plants. As an understanding of the role of fire in the ecology of African vegetation developed, these strategies were replaced by others that recognized and utilized fire as an integral process in the ecology and management of vegetation (1997:44–45; see also Payne 1993).

This colonial control, both in its material and in its metaphorical dimension, and the resistance it occasioned, are things Zulu would want to explore and exploit. The relationship between human culture and fire more generally is of course a rich and complex one, and again Zulu would want to tap this rich complexity. Rather than fall into some dualistic or manichean view of fire, he calls attention to its transformative power, its place in rituals of passage, trial, initiation—indeed all its manifold ramifications.

Stephen Payne observes, "As a dialectic between humans and nature, fire regimes express the values, institutions, and beliefs of their sustaining societies" (1997:19). Differences matter between, say, Aboriginal burning in Australia, pastoral and agricultural fires in Africa and India, the blazes that sweep across North American landscapes, and the "colonizing fires in new settlements" (ibid.:20). According to Payne, there is an economy at work here, one deeply significant and signally persistent:

> Ultimately, settlement *exchanged* one fire regime for another. Colonizers could not, in the end, deny the logic of an earth fluffed with combustibles and marinated in oxygen. There might be more fire or less fire, there might be efforts to suppress certain kinds of undesirable fires kindled by natives, malcontents, and ignorant immigrants, but there was no expectation that fire itself would disappear, or that fire practices could vanish like old smoke. Fire would simply be glossed into the text of the new landscape, the rubrics of a flame-illuminated manuscript (ibid.:24).

Seen differently, doubtless, Zulu's fireworks would be read as part of the "rubrics of a flame-illuminated manuscript." Such a "manuscript" would be a subtle one, a palimpsest perhaps, in which traces of erased fire-texts were still faintly legible.

Here, for example, we might read at a textual register other than politics "proper," and see how that politics might play out in the public domain. We might, for instance, want to delve into a more intimate, more domestic, and perhaps more enduring psychological space. Here we might find the warm, convivial glow of the hearth, the importance of fireside and fireplace in local cultural discourse, perhaps (speculatively) as a nodal point for oral narrativity and intimate social exchange. Such a fireplace is central, for example, in a seminal work by local artist Durant Sihlali, where it engages an intricate web of memory, creative desire, and identity.

It becomes apt here to refer again to Bachelard's discourse on psychoanalysis and fire, to better consider the more occult and idiosyncratic textuality of fire in Zulu's work. As Bachelard puts it (albeit to different ends), "The reverie in front of the fire, the gentle reverie that is conscious of its well-being, is the most naturally centred reverie" (1987:14).

Sandile Zulu

Fire is for the man who is contemplating it an example of sudden change or development and an example of circumstantial development. Less monotonous and less abstract than flowing water… quick to grow and to change… fire suggests the desire to change, to speed up the passage of time.… In these circumstances the reverie becomes truly fascinating and dramatic; it magnifies human destiny; it links the small to the great, the hearth to the volcano.… For [the fascinated] destruction is more than a change, it is a renewal (ibid.:16).

This well captures Zulu's self-confessed interest in temporal duration, in rites of passage, in change, in renewal. His installations require both the pensive and the active, mobile body and eye of the viewer. They also require an intimate but sociable and social openness. Bachelard's "reverie" stages the mingling of internal and external between nature and culture; early in his text he observes that "fire is more a *social reality* than a *natural reality*" (ibid.:10).

Moving from this rather idiosyncratic register, it must be said more pointedly that fire looms historically large in Southern African culture. Not too distant from Amakhona, at the Swartkrans Caves, archaeologist C. K. Brain discovered signs of the tending and control of fire by very early hominids (perhaps the earliest). Brain speculates "that the early stages of fire-management would have relied on gathered fire from naturally occurring conflagrations," and while "the gathering of fire is not as impressive an intellectual achievement as deliberate fire-making, it must nevertheless have been an immensely important milestone in the manipulation of the natural environment by early hominids" (1993:262). The renowned Raymond Dart, working at Makapansgat (also nearby), in fact named one of the early hominids *Australopithecus prometheus* (see Dart 1957), appropriating the name of the legendary Greek who stole fire from the gods; Dart noted that he "was commemorating the discovery of carbon in the breccia from this same site twenty-two years before. It seemed likely in view of the carbon that *Australopithecus* had discovered the secret of fire but this is an angle I have never been able to confirm satisfactorily despite subsequent investigations of bones for carbon" (quoted in Wheelhouse 1983:67–69).

From such deep and speculative time we might step rapidly if randomly through a local history on which fire leaves its mark. We might, for example, mention Autshumat's lighting of crucial signal fires as an agent for the English (c. 1632) on the infamous Robben Island over three centuries ago (Penn 1996:13). Then, at Makapansgat again, we have the Boer revenge burning of a group of Ndebele who had sought refuge in the caves after the massacre of a Boer party, an incident deeply mythologized in narratives of Afrikaner nationalism (see Hofmeyr 1993). From here we might leap to the notorious "farm burning" associated with the appalling innovation of the "concentration camp" during the second Boer War (1898–1902), a war in which Lord Kitchener "vigorously pursued [Lord Robert's] 'scorched-earth' policy and greatly extended the scope of what were started as refugee camps for burghers loyal to Britain, and their families" (Hobhouse 1984:443, note 2). As a marginal but important note in this rather arbitrary fire history, we might add the symbolically significant contribution of Sol T. Plaatje, who had occasion to refer indignantly to the screening of that "inflammatory bioscope film" *Birth of a Nation* in Johannesburg in 1931 (1986:133).

Fire is prolix in the even darker, more recent history of South Africa. One of the more incendiary acts of early defiance during apartheid was the spectacular public burning of the "dompas"—a document that all black people were legally required to carry, to enable them to travel, live, and work in specific regions of South Africa. Chief Albert Lithuli, Nelson Mandela, and other leaders, as well as countless ordinary people, set fire to their passes during the defiance campaign of the late 1950s (see Harker, ed., 1994:58–59, and Weinberg 1981:182–87). But it must perhaps be the Soweto uprising of June 16, 1976, that occasions arguably *the* primary moment in establishing our archive of historical fire: burning buildings, burning brush, burning barricades, burning buses,

Sandile Zulu

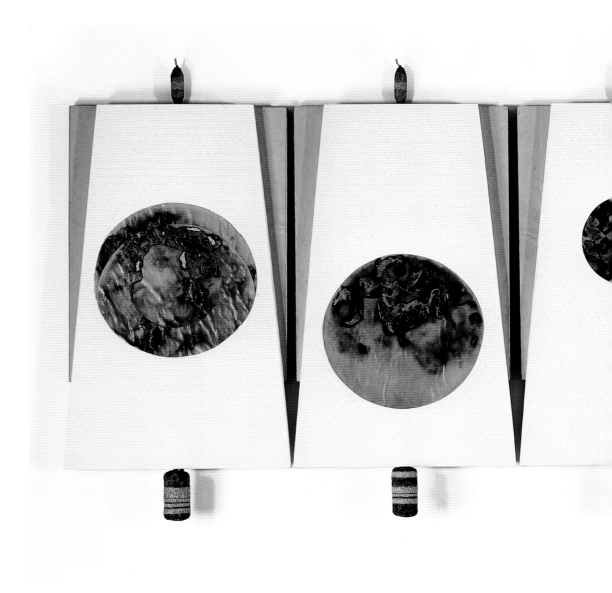

burning bodies. Plaatje's embers flamed in rage in the "June's blaze" (Ndlazi 1986:109) of June 16, 1976. This event provoked many poets and writers to harvest the rhetorical potency of fire. For Mbuyiseni Oswald Mtshali (prominent among these), "The ghetto was ablaze, rising flames were gigantic tongues, licking the soft bellies of hovering helicopters" (1986:43).[11] Artist and writer Matsemela Manaka (recently tragically killed) also turned to incendiary metaphor: "The flames of your fire reared and raged on, your enemy could not douse only daze the blaze" (1986:72).

Then there was the unspeakable act of "necklacing," wrought from the pressure-cooker of pain of those years. Winnie Madizikela Mandela's (infamously) fiery words echo down these years still. On April 13, 1986, she stated that the "time for crying is over" and the people "can no longer waste our tears"; a week later she proclaimed, "We have no guns—we only have stones, boxes of matches and petrol…. Together, hand in hand, with our boxes of matches and our necklaces we shall liberate this country" (quoted in Gilbey 1993:145).[12]

It goes without saying that this particular history has made its mark on art. Billy Mandindi, for example, created a three-dimensional image of this excruciating instrument of death (see Younge 1988:17), while an arguably more sanitary fiery tire figures in William Kentridge's drawing *The Boating Party* (1985). Fire is in the blood of South African art, and perhaps

Sandile Zulu

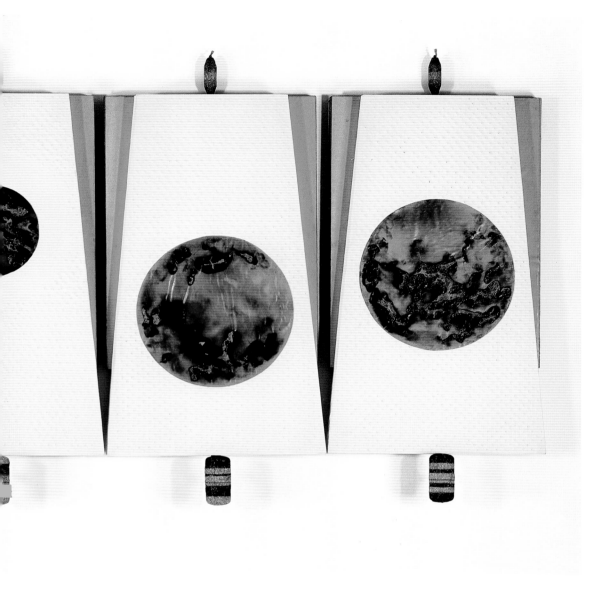

Cat. 39
Artomic Passage, Nos. 1, 2, 3, 4, 5.
By Sandile Zulu, 1997-8.
Fire, newspaper, textured
canvas, compressed grass.
Installed: 136 x 406 cm.

a major trope in narrating our lived experience. It would be difficult to overestimate its power—whether benign or malignant—in the image bank of this part of the world.

In his short text for Zulu's exhibition "Fire!," Laurent Devèz, then director of the Institut Française d'Afrique du Sud (IFAS) and the French cultural attaché, wrote that the "fire of a braai [barbecue] and that of a riot are both to be found in our arsonist's quasi initiation quest" (1995:n.p.) The appalling proximity of these—entertainment (braai) and trauma (riot)—in what Devèz characterizes as a "quest" became horribly real in revelations arising from the Truth and Reconciliation Commission. In one painful and now notorious account, a distraught mother cried, "They braaied my son while they drank and laughed" (quoted in Pauw 1997:153). Jacques Pauw writes,

> In a dry ditch on the slightly elevated river bank, a shallow grave was dug with bushveld wood and tyres. The two corpses were lifted onto the pyre and as the sun set over the Eastern Transvaal bushveld, two fires were lit, one to burn the bodies to ashes, the other for the security policemen to sit around, drinking and grilling meat. "Well, during the time we were drinking heavily, all of us, always, every day. It was just another job to be done. In the beginning it smells like a meat braai, in the end like the burning of bones. It takes about seven to nine hours to burn the bodies to ashes. We would have

our own little braai and just keep on drinking" (1997:154).[13]

Zulu's use of fire refers to these traumatic, barely utterable histories specific to South Africa. But his work also refers beyond our immediate history, and beyond the colonial enterprise, to a deeper time where fire and "civilization" are intimately related (see Payne 1997 and Goudsblom 1992).[14] Embedded in fire and its relation to art is a force and symbol of profound and deeply destabilizing ambivalence. Zulu's incendiary devices, in which fire is both image and process, give us pause to meditate on this ambivalence.

Fire is not a source of illusion in Zulu's work. When the chains of Plato's prisoners are struck,[15] fire offers more than disillusionment; it is an active force, not least because it shows precisely the need for and the presence of shadows. Zulu's combustible enterprise also finds deep sympathy in Bachelard's ruminations on fire:

> Fire and heat provide modes of explanation in the most varied domains, because they have been for us the occasion of unforgettable memories, for simple and decisive personal experiences. Fire is thus a privileged phenomenon which can explain anything.... It is intimate and it is universal. It lives in our heart. It lives in the sky. It rises from the depths of the substances and offers itself with the warmth of love. Or it can go back down into the substance and hide there, latent and pent up, like hate and vengeance. Among all phenomena it is really the only one to which there can be so definitely attributed the opposing values of good and evil. It shines in Paradise. It burns in Hell. It is gentleness and torture... it can contradict itself (1987:7).

In the two epigrams at the head of this article, Nolizwe Mnyaka's view of fire makes him want to turn away from the violence of the historical moment. That violence is also traceable in Leonardo's self-consuming "fire in a chain"; enlightenment and racist colonialism were, after all, not strangers (see *inter alia* Goldberg 1993 and Malik 1996). But perhaps now we can begin to turn again, through Zulu's work, to face fire as a fertile phenomenon. And perhaps Eduardo Galeano is right when he writes that the "sword of fire opens up an avenue" (1985:71). Zulu's work opens just such an avenue, and takes bold steps to a vivid meditation on histories in the making.

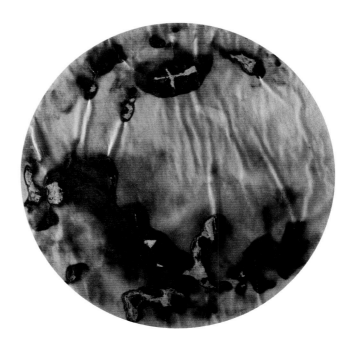

Cat. 39
Abduction of the Text:
Total Eclipse. (detail).
By Sandile Zulu, 1997–98.

Sandile Zulu

1. The ancient origins of one "theory" of atomism are interesting here, although they are not the explicit source of Sandile Zulu's thinking on the subject. This notion seems to have survived mainly through the writings of the Roman poet Lucretius (98–55 B.C.), the pre-Socratic Greek philosophers Leucippus and Democritus (c. fifth century B.C.), and others. Atomism, put simply, holds that matter exists as four elements: air, earth, fire, and water. The "atomic" economy is characterized by substance and void; without void, no space would be available for dynamic interaction and changing relations. For Lucretius in *De Rerum Natura*, "Creation out of nothing is nonsense. So is destruction of things to nothingness" (1976:22). Lucretius's mode is poetic, and his poem addresses "matter" in all its multidimensionality, including *animus* (mind) and *anima* (soul) (ibid.:11). This resonates in many ways with Zulu's creative enterprise.

2. As Gaston Bachelard concludes, "Inner fire is dialectical in all its properties, a replica, as it were, of this fundamental dialectic of subject and object— so much so that it only has to flame up to contradict itself. As soon as a sentiment rises to the tonality of fire, as soon as it becomes exposed in its violence to the metaphysics of fire, one can be sure that it will become charged with its opposite" (1987:111).

3. In his 1998 statement for the FNB Vita Exhibition, Zulu writes, "Fire and water, wind and soil are essential elements for life. These elements… offer not only a context for engaging with socio-historical issues, but also the criteria by which to enter the emotional, theoretical and critical framework for analysis." "As psychological elements, fire and water, wind and soil allude to life, to creation and destruction, to colonization and decolonization, to revolution and liberation, to purgation and cleansing, to purification and renewal." "My interest is in evoking… the social and psychological struggle for freedom of creative desire and imagining the essentials that stand for life" (1998:15). 4. Readers may recall that this is the date of the first democratic elections held in South Africa, marking what seems to many a miraculous passage from tyranny to liberation. Much has been written on the elections as event and symbol; see *inter alia* Brink 1994 and 1995, Reynolds 1994, and Bell and de Villiers 1995.

5. "South African art" as a cultural category is both descriptive and more: at least in its use since 1994, it signals a relation to the discourse of nationalism within the specific framework of democratic nation-building. This has been the subject of much discussion, not least around the problematic of "nationalism" within a postnational and postcolonial moment, with all the attendant questions of globalization, internationalism, and so on. A great deal of unpacking is required here. For fuller but still passing comments, see Richards 1997 and 1999, which refer to other relevant literature.

6. There are many complex issues here. The rhetoric of rupture, of a critical break with the past (however conceived), is itself hardly new in art practice. While the introduction offered by Williamson and Jamal 1996 is valuable, the question is often oversimplified. This is a complex cultural moment, and there is a tendency among artists claiming specifically "avant-gardist" credentials to reduce "resistance art" to caricature. This tendency (itself quite various) continues a process that popularly began with a debate on culture, change, and freedom initiated in 1990

(see de Kok and Press eds. 1990, and Brown and van Dyk, eds. 1991). There is much that is necessary about it, for both art practice and art criticism in South Africa. Many "international" events since around 1990 have energized local art, and have had a marked impact on both the reception and production of the work of South African artists locally and abroad. One might begin here with David Elliott's courageous "Art from South Africa" exhibition, held in 1990 in Oxford, England, and go on to include both the first and second Johannesburg Biennales, and the participation of South African artists in the Biennales of Istanbul, São Paulo, Havana, and KwangJu. Each of these events has raised a number of important questions and debates, and the present show in New York will doubtless do the same, as well as generate some new ones. There have also been other important if uneven shows presenting "South African art" beyond our continental boundaries—for example Marith Hope's "Contemporary Art from South Africa" (1997). See, *inter alia*, Breitz and Bowyer, eds, 1995; DeLiss, ed., 1995; Hug and Vogel, 1996; Rosengarten 1996; De Bord and Bester, eds., 1997; and Lundström and Pierre, eds, 1998.

In the process of trying to develop practices and a set of critical languages that really do articulate the "local" and the "global" in a critically and aesthetically productive way, much of the capacity of hitherto "political" (resistance?) art for an ill-fitting, doubt-ridden relationship with the orthodoxies of social power have been and are being seriously (and perhaps strategically) misunderstood. This is a mistake for which (in my view) Zulu's art makes little room.

7. See Boraine, Levy, and Scheffer 1994; Boraine and Levy 1995; Asmal, Asmal, and Roberts 1996; Krog 1998; and Nuttal and Coetzee 1998. Truth is a difficult term. In her *Country of My Skull*, Antjie Krog writes, "The word 'truth' makes me uncomfortable. The word 'truth' still trips the tongue. 'Your voice tightens up when you approach the word "truth,"' the technical assistant says, irritated. 'Repeat it twenty times so that you become familiar with it. *Truth is mos jou job!* ["Truth is your job, after all!"].' I hesitate at the word, I am not used to using it. Even when I type it, it ends up either *turth* or *trth*. I have never bedded that word in a poem. I prefer the word 'lie.' The moment the lie raises its head, I smell blood. Because it is there… where the truth is closest" (1998:36).

8. The connection between fire and spirit would take us into arcane and gnomic realms of discourse, ranging from Mircea Eliade's rather anachronistic but stimulating work on fire (1964) to the ruminations of Jacques Derrida's "deconstruction." While we need not be detained by these thoughts here, it might be worth mentioning Carl Raschke's writing on "postmodern religious thinking," in which he speculates that Derrida "himself has alluded to the end of deconstruction itself within his cryptic discussion of 'spirit' as 'fire'" (1992:105; see also Hodge 1992:144). Joanna Hodge writes of Derrida's identification, in "Heidegger's discussion of the poetry of Trakle, of *Geist* with *Flamme*, flames. This is no longer the spirit which moved over the water. This is spirit as vengeance and destruction, obliterating any resource not caught up in its internal logic. It is the denial, by destruction, of both distinction and difference" (1992:144). European literature, modernist and postmodernist, is replete with

Sandile Zulu

imagery of conflagration, textual and bodily. Such imagery is undoubtedly part of our millennial moment, with perhaps one of the more florid examples being Umberto Eco's *Name of the Rose*: "And so the cries of regret for the many riches burned were now joined by the cries of pain at seared faces, crushed limbs, bodies buried under a sudden collapse of the high vaults" (1984:490). Another example of a burning library mixing with bodily mortification appears in Elias Canetti's *Auto da Fé*: "If only there were a learned censorship the paper would be half blank.... The second headline began with a V and close to it an R: Fire. Murder and arson lay waste the papers, the land, the minds... if there's no fire after the murder their pleasure is incomplete... no one should read the papers; then they'd die of themselves, of a Universal boycott" (1978:424). Eduardo Galeano is another major contributor to the discourse of fire. As with Raschke's discussion, fire is linked here with language and the body: "The cold cut onto the flesh and words of men:... to deserve fire, men must cut open their chests with obsidian daggers and surrender their hearts" (1985:11–12).

9. If we had to inventory the literalism and facticity of Anglo-American minimalism, through notions of mechanism, literal and transparent method, decreased emphasis on self-expression, containment, with "no veiled allusions, covert references or subjective content" being "accommodated within the strict confines of the logical system" (Colpitt 1990:59), and so on, the links would seem ever more tenuous, yet are not, I believe, entirely irrelevant in this context.

10. Tony Godfrey locates *arte povera* within a European conceptual tradition (1998:177), though not unproblemetically, as *arte povera* embraces a romance rather at odds with the cool "abstraction" of much conceptualism. Still, its relevance—with its emphasis on commonplace materials and, interestingly, its "appeal to the poetic associations that cling to objects and materials" (ibid.)—to Zulu's work seems suggestive and worth entertaining. With respect to "fire-works" within the earlier conceptual traditions of Anglo-American and European art, one might mention Jan Dibbets's *TV as a Fireplace* (1969), John Baldessari's *Cremation Project* (1970), and Susan Hiller's *Monument* (1980–81). The latter work incorporates an arrangement of plaques dedicated to people who have sacrificed their lives for another; one is of a man who burned to death trying to save his little sister's life (see ibid.:361, fig. 210). Another example would be Joseph Beuys's performance *Hearth II* (1978), including *Feuerstätter II* (see Tisdall 1979:236–37). On the use of natural processes—wind, air, etc—used by Hans Haacke in his early years see Burnham 1983. For fire in "ritual" see Mary Beth Edelson's *Fire Flights in Deep Space* (1977) and *Where Is Our Fire?* (1979), in Lippard 1983 and Tucker 1992. See also selected works of Dennis Oppenheim's from the early to mid-1970s, including *Polarities* (1972), *Radicality* (1974), and *Pretty Ideas* (1974), in Sondheim 1977. Finally, and perhaps most obviously, is Yves Klein's use of fire in, for example, the two fire fountains and a fire wall produced in full-size models at the Museum Haus Lange, Krefeld, in 1961 (see Gottlieb 1976:302–9). Klein also "painted" with fire.

11. Fire seems to have inspired much of the more significant poetry in Mbuyiseni Oswald Mtshali's collection *Fireflames* (1980). See especially "Flames of Fury" (written in 1975 and translated from the Zulu), "I'm a Burning Chimney," "Uhuru," and "The Three-Legged Pot."

12. The "necklace," a car tire filled with gasoline, was used to burn political opponents, especially those regarded as collaborators and informers (Krog 1998:284). For one account of a necklacing see ibid.:140. For further information see Schärf and Ngcokoto 1990, which states that "'necklacing' became a form of execution in the townships from 1984 onwards and was used by both pro and anti-government groups" (371; see also 360ff and note 43). Nelson Mandela, on *The Donahue Show* in New York in 1990, said that "necklacing was 'brutal and barbaric' and 'no sane person would ever approve of that'" (Gilbey 1993:opposite p.121; see also pp.145–49). According to Gill Straker, "The incidents of necklacing were so horrifying and numerous... that the origins and roots of the practice in common social processes have been all but obscured. They were not confined to the urban areas. While in the towns the usual rationale was that the victim was an informer or *impimpi* [informer], in the rural areas witchcraft accusations were common. Wherever burnings took place, however, similar social processes were involved. The burnings of putative witches and *impimpis* all occurred in contexts of massive social upheaval and catastrophic community disruption, after traumatic and violent events had threatened the entire community and led to the injury and death of some of its members" (1992:114).

13. The quotation refers to two men, Vuyani Mavuso and Nkosinathi Dlamini, who were earmarked to "disappear." The two were poisoned, with little effect, and were ultimately executed by gunshot to the head: "One of the policemen stepped forward, placed his foot against the neck of one of the captives, pressed the barrel of the Makarov against his head and pulled the trigger.... Seconds later, the other man was executed in the same manner" (Pauw 1997:154). Pauw is discussing death-squad operatives Dirk Coetzee and, among others, Almond Nofomela Joe Mamasela, who were notorious in the activities at Vlakplaas, a farm near Pretoria used as a base for hit-squad activities. Coetzee was handpicked in August 1980 to establish Vlakplaas, ostensibly as a base for "askaris" used, among other things, to identify and arrest trained "enemy" infiltrators. (An askari is a "former guerrilla recruited by the security forces" [Krog 1998:282].) According to Pauw, "Because of the unit's secret nature and the fact that the askaris were already trained soldiers and were at the mercy of their captors, the unit became the ideal base from which operations against the enemy could be launched" (1997:151).

14. The relationship between fire, creativity, and civilization in deep forms of human mythologizing is rich but often double-edged. Speaking of the denigration and heroization of the "mythological artist," for example, Ernst Kris and Otto Kurz speak of the punishment meted out by the "gods" against those who harbor "the ability to make images" (1979:87). This punishment, they write, should "be seen in a wider and more sublime context: it appears to be intimately linked with the symbolic significance of

Sandile Zulu

fire, as a sign of creative potency, and the harnessing of fire as one of the earliest cultural accomplishments in the history of mankind" (ibid.).

15. Fire and its relationship to light and vision are indeed articulated in one of the founding "Western" myths about art, freedom, and "the real." But in this myth, art comes off poorly—as deception. For Iris Murdoch, Plato's *Republic* explains the pilgrimage that restores knowledge of the real, as opposed to the "artful" world of appearances, "by images of the Sun and… the myth of the Cave" (1977:514). In this allegory, prisoners in a cave are chained to face the back wall, where all they can see are the shadows, cast by a fire behind them, of themselves and of the objects between them and the fire. Later they manage to turn around and see the fire and the objects that cast the shadows. Later still they manage to escape the cave, see the outside world in the light of the sun, and finally the sun itself" (ibid.:4). Here the artist and art "exhibit the lowest and most irrational form of awareness, *eikasia*, a state of vague image-ridden illusion" (ibid.:5). The relation between fire and light in this text is a complex of negative illusion and nondelusional revelation. But fire and light can also be quite differently linked: see Zajonc 1993:42–43.

Claudette Schreuders: Artist's Statement

Claudette Schreuders

Most of the sculptures selected for this exhibition form part of a body of work entitled *Family Tree*. The "family" of the title refers to the autobiographical content of the work. Thematically the sculptures were inspired by family photographs and childhood memory. They are portraits, but are presented in such a way that they refer to an identity within a specific social circle. In this sense they serve to examine the broader context of the society I grew up in. "Tree" refers to my choice of wood as medium for figurative sculpture. The works are mostly composite pieces, assembled from carved and painted wood, which often include extraneous materials such as iron, leather, and nails. My use of materials consciously evokes an African context, emphasizing the dislocation of the white "family" I examine.

Herbert Cole identifies five icons that represent prevalent themes in African art: the couple, the mother and child, the forceful male, the outsider or stranger, and the leader.[1] Under the category of "outsiders" or "ambiguous aliens," we find the Colon figures of West Africa. These carved and painted figures are widely understood to be depictions of Europeans by African people. As "ambiguous aliens," the Colon can be related to the status of whites within the South African experience. This idea is illustrated by a quote taken from an article written by South African artist Ruth Rosengarten: "I grew up in Johannesburg with an inbuilt sense of dislocation.... I suffered only a little more acutely from what was experienced by many white South Africans: an uncomfortable sense of not knowing who they were. It is not at all insignificant that white people in South African were called Europeans."[2]

This sense of dislocation was not only the result of a European heritage within an African context, but also the marginalization that formed part of a restrictive society that set limits and threatened to reject those who did not conform.

CAT. 40
Lokke.
By Claudette Schreuders,
1994. Yelutang wood, steel
and pine (school desk), oil paint.
H. 124 cm. (including desk).

Claudette Schreuders

Lokke, a sculpture completed during my final year at the University of Stellenbosch, is presented in the form of a martyr like those common to the Western tradition of religious woodcarving. The figure is dressed in a school uniform and stands on a desk, this scenario is based on a specific event. On my first day of high school in 1986, a girl nicknamed "Lokke" (referring to her anachronistic hairstyle) was made to stand on a table in front of the school and mocked because of her unshaven legs. She was tormented and teased the entire time that she attended our high school. The highly emotive images of martyrs found in religious sculpture (especially Spanish and South American) reminded me of Lokke's position in our school. While at school I felt relieved that I was not in her shoes, a fate I felt I only narrowly escaped. The oppressive nature of that school, and the way in which it reflected apartheid society of the 1980s, is something I only realized once I had left and then more clearly during the slow and arduous process of carving the figure from a block of wood. The position of an individual within a specific social milieu remains a theme in the work that followed. While all the works can be said to fit into the category of "outsider or stranger," some overlap into the different categories mentioned by Cole.

Mother and Child combines the Virgin and Child of Western tradition with the mother and child icons found throughout African art to create a black mother holding a white child. In my own family album, the only image of a black person is my nanny holding me as a child. The title of the work refers to the intimacy of this short-lived relationship, but also to the fact that the nanny is in reality a mother whose own child is being raised by someone else in the townships. Like Lokke, *Mother and Child* explores the way in which the divisive nature of South African politics manifested itself on a personal level.

The Hero is a portrait of my father who came to South Africa from Holland when he was sixteen. He was part of a program initiated by the South African National Party to enlarge the white population by bringing orphans to the country. Although he was not an orphan, my father had nurtured a dream of living in Africa since he was very young, and convinced his parents to let him leave Holland. *The Hero* is depicted astride a leopard, referring to the West African cultural traditions depicting leaders riding leopards as symbols of power. In this context, the hero image depicts the West's exotic ideal of Africa and also ironically, the precarious position of the white male in contemporary South African society.

In *Speel-speel*, four children play a game where they toss a gollywog doll with a blanket. The formation of three girls and one boy is based on my siblings, and the blanket game comes from Goya's *The Straw Manniken* painting. Translated directly from Afrikaner words, "speel-speel" becomes "play play" and refers to the subtle way in which negative stereotypes (like the gollywog in Enid Blyton's *Noddy* books) form part of popular culture.

Like *Speel-speel*, the sculpture *Marky-Boy* presents an image of compromised and doomed innocence. This schoolboy figure carries a small portrait of his father lodged in his chest. The father's head looks like an older version of himself looming menacingly as the boy is faced with choosing between the "cherished myths" of his father or "standing firmly, yet standing nowhere." The notion of two as one is explored in icons of couples found in African art: two people in a relationship become one entity, a couple. In *The Couple*, the frailty of human relationships is explored in terms of my own experience. I feel that my use of specific individuals as subjects for sculptures lends credibility to the stories that they tell.

Accordingly, David Freedberg notes that devotional images are not generalized and standard types, but their very individuality forms the focus of the beholder's attention, "the more distinctive the better.... We do not extend our empathy to humanity at large."[3]

CAT. 41
Mother and Child.
By Claudette Schreuders,
1994. Obeckhe-cypress wood,
enamel paint. H. 91 cm. Lisa
Brice Collection.

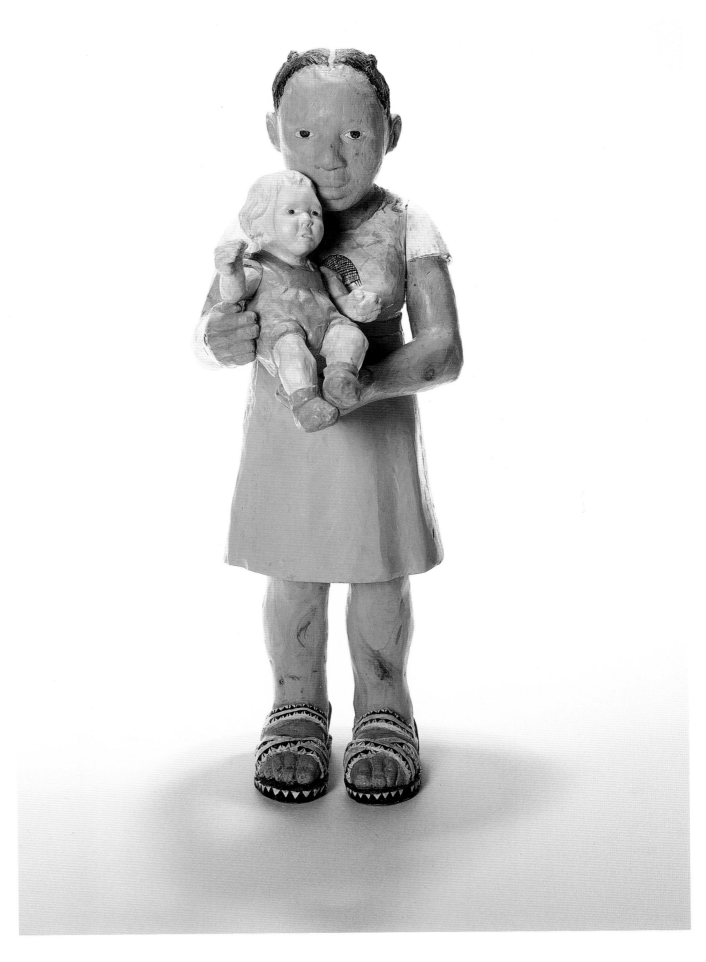

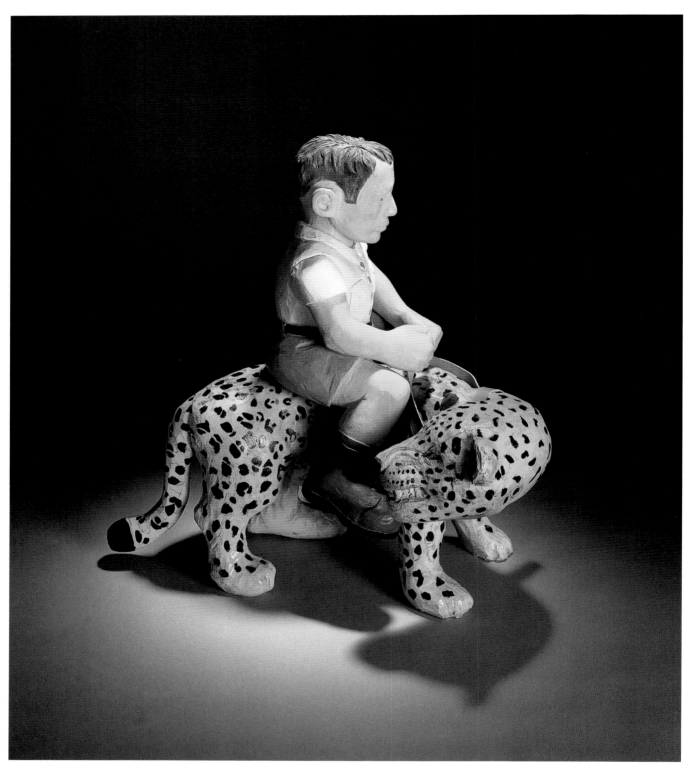

CAT. 42
The Hero.
By Claudette Schreuders, 1994.
Yelutang-Jakaranda wood,
leather, enamel and oil paint.
H. 61 cm. University of Cape
Town Works of Art Collection.

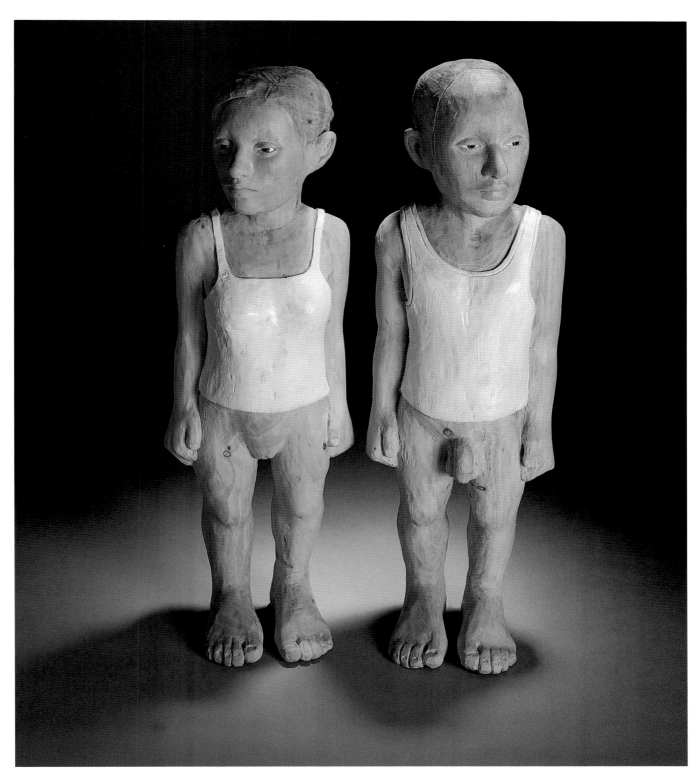

CAT. 43
The Couple.
By Claudette Schreuders, 1997.
Yellow wood, enamel paint.
H. 71 cm. Hildeke Schreuders
and Andre Vorster Collection.

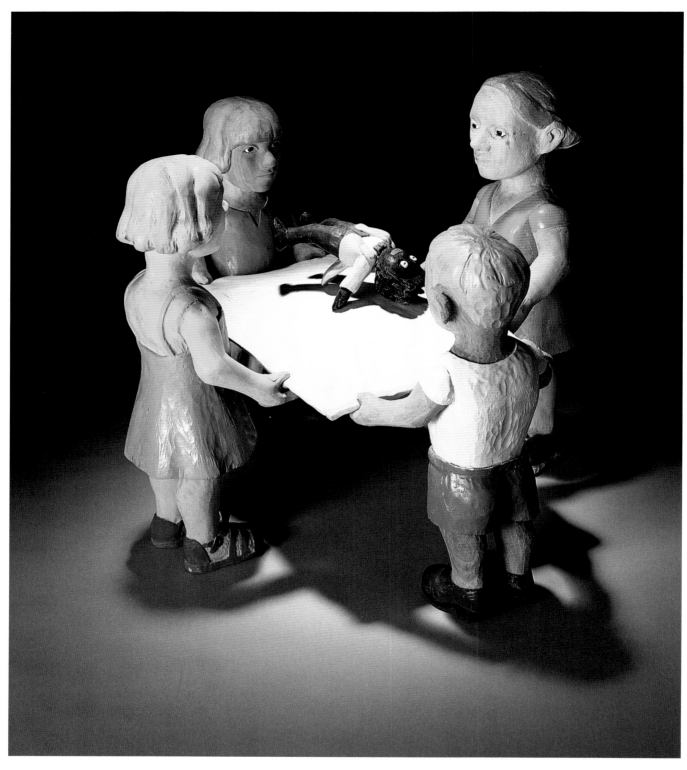

Cat. 44
Speel Speel.
By Claudette Schreuders, 1996.
Yelutang, avocado, lime, poplar
woods, enamel paint.
H. 29 cm. Private Collection,
United Kingdom.

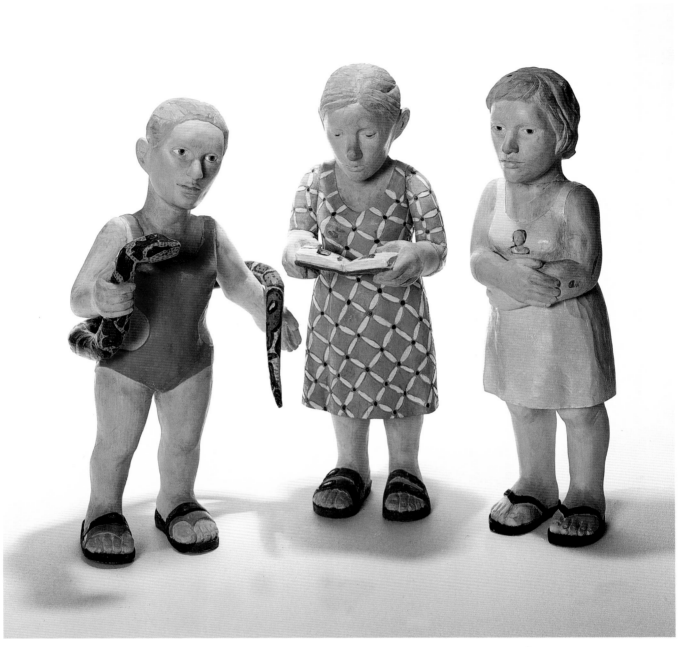

CAT. 45
Three Sisters.
By Claudette
Schreuders, 1999. Jakaranda
wood, enamel paint.
H. 70 cm. Jerome and
Ellen Stern Collection.

Claudette Schreuders

CAT. 46
LEFT, *Marky-Boy*.
By Claudette Schreuders, 1998.
Pear wood, enamel paint.
H. 65 cm. Jerome and
Ellen Stern Collection.

CAT. 47
RIGHT, *Ma-Trix*.
By Claudette Schreuders, 1998.
White stink wood, enamel paint.
H. 80 cm. Jerome and
Ellen Stern Collection.

Ma-trix takes the form of a devotional sculpture. The woman figure's hand is held over her chest like the Virgin Mary, but the flaming heart is replaced by a pink bar of soap. The soap signifies a life of luxury, implied also by the brand name LUX, while associations of cleanliness and purity links to the religious theme and to the colonial ideal of bringing civilization to Africa.

The Three Sisters are my two sisters and myself. The identity of each figure is realized by a juxtaposition of the other two figures, very similar to the way that one's perception of oneself is determined by shared relationships. Like the other sculptures in this group they are portrayed as both individuals and stereotypes. The figure holding the snake recalls imagery of the "treacherous woman," as personified by Eve in Western culture and by the West African cult figure, Mammy Wata. Like *The Hero*, an existing theme is reinterpreted so that the icon becomes a recognizeable figure lodged in South African experience and modified by a combination of Western and African symbology.

1. Herbert M. Cole, *Icons: Ideals and Power in the Art of Africa* (Washington, D.C.: Smithsonian Institution Press, 1989), p. 12.

2. Ruth Rosengarten, "Inside Out," *Frieze* (London 1995), vol. 23, pp. 45, 49.

3. David Freedberg, *The Power of Images: Studies in the History and Theory of Response* (Chicago: The University of Chicago Press, 1989).

Artmaking in South Africa: Shifting Divisions and the Role of Education

Andries Walter Oliphant and Kristine Roome

At the conclusion of this study, I want the world to recognize with me the open door of every consciousness.

—Frantz Fanon (1967:232)

his text, written from the liberated space of postapartheid South Africa, dwells on the role of education in shaping art practices in this country. It is triggered in part by the art in this exhibition.

These works reveal marked divergences of modality, among them a split between the articulation of intimate aspects relating to the personal lives of the artists, on the one hand, and the invocation of broader social affiliations and references, on the other. This divergence echoes the polar positions of internal and external space. While it sometimes constitutes opposite extremities, there are also instances in which it is bridged, so that the one position shades into the other. These moments Fanon likens to "a flash or so" seeking to overcome the divides in racially constituted societies (1967:45). Are such attempts to overcome racial isolation and division "threatened at the source," as Fanon said they were in colonial society? This essay will try to respond to this question with regard to South Africa.

The essay will focus on four interrelated topics: first, an overview of art education, from missionary schools and academies to the Bantu Education Act; second, a reflection on the role of community-based forms of art education; third, an exploration of how different forms of education shaped some of the work in the exhibition; and fourth, a brief assessment of the current situation. Despite South Africa's recent liberation from more than three centuries of colonial domination, this is a fraught terrain.

1

Detailed studies of education are not usually found in exhibition catalogues. In conventional art history, however, the identification of formative influences on artists is standard practice. This is usually done to place the artists in question within the prevailing practices of a given period, and at the same time to set them aside. It is, in other words, a procedure enlisted to mark the artists' individuality. At best it provides only a glimpse into the aesthetic and material impact of education as a formative force in artmaking.

The lack of attention to education as a crucial factor in the artmaking process stems, in part, from the romanticism that invaded European aesthetics in the nineteenth century. Insisting on the notion of the unmediated and spontaneous creativity of the individual artist, this current of thought institutionalized the notion of the artist as endowed with the genius of original creativity. Such a person could not be the product of cultural conventions and the kind of conditioning that comes with education.

This ideology survived critical dissection because it served as a strategy for positing the individual artist as a superior instance of creative being, one capable of rising above the homogenizing routines of modern life. Within a colonial setting like South Africa, this notion functioned in a complex and often contradictory manner. Guided by the changing strategic objectives of the colonial project, it did not pre-vent the establishment of a European-styled art education for whites. Why? Because the idea of the artist as creative

genius, formulated by art circles in Europe, had to be culti- vated locally among the settler population. How else would the colonies remain within the cultural orbit of the imperial centers? It was, after all, by importing ideas from the colonial centers that the colonizers retained their intellectual and cultural ties with those centers. The romantic notion of the artist as genius may underplay the role of education, but this notion is nevertheless the product of a late-eigh- teenth-century artistic discourse produced by lay philoso- phers and artists reacting to aspects of the education they had themselves received. To give currency to this notion in the colonies, educational institutions were required.

In the case of arts education for Africans, meanwhile, the ideal of original creativity was, at the outset of colonialism, not applicable. Again we may ask why? For the simple reason that the prevailing colonial view, as expressed by Jadocus Hondius in 1652, was that "the local natives have everything in common with dumb cattle barring their humanity… handicapped in their speech, clucking like turkey cocks" (1952:26). This view, applied by Hondius to the Khoisan, is a metonymic trope for the extreme racial Otherness that informed colonial perceptions of indigenous people. Were these depraved natives not then desperately in need of education? The reply to this is the colonial history of South Africa.

The civilizing mission could not have been justified without a denial of the existing local culture. As a result, the tradi- tions of rock art, wall paintings, carvings, clay works, ceram- ics, and metalwork, all of which formed parts of the indige- nous people's material and symbolic culture, were for the most part disregarded. Meanwhile, of course, in the latter half of the nineteenth century, art academies were set up for the settler population. Established in centers of colonial settlement such as Durban, Port Elizabeth, and Cape Town, in the first half of the twentieth century these academies were incorporated into universities and other tertiary institu- tions as fine art departments. Aping Western art education, they privileged painting and sculpture. Today there are twenty such state-funded departments in South Africa.

From the very onset of colonialism, the European overlords introduced a discriminating differentiation (see Govender and Woker 1987:235): the children of colonialists were educated to become masters; the children of slaves, to serve. African artists had to work their way through or around this order if they were to emerge from its oppressive calculations. Regardless of color, no artist with any sense of social and historical context could reside in this order without complicity.

Consequently, in the first quarter of the twentieth century, many early African artists such as Gerard Sekoto and George Pemba were faced with dilemmas. Trained at missionary schools to produce accurate pedagogical illus- trations rather than to nurture and develop their means of

artistic expression, they neverthelss turned this limited education to great effect, adapting the pictorial lessons they had received as trainee teachers to forms of figurative painting that drew on some of the formal experiments of early European modernism. In this way they negotiated their respective ways between their African heritage and their newly acquired identities as African Christian converts.

Moving with the currents of their times, these artists were far from passive colonized subjects. They were subtle, self-reflective, and critical artists simultaneously shaped by and resisting the constraints of colonial society and culture. They were, as H. I. E. Dhlomo put it, profoundly suspicious of the "pernicious doctrine propounded by those notorious so-called friends of the Africans"—the doctrine that African artists would be doing themselves a favor if they remained "natural" by avoiding the spoiling affects of education and training (quoted in Couzens 1985:253). Sekoto, Pemba, and others of their generation also viewed paternalistic advice on what themes could be appropriated by African artists with the same skepticism. To a white admirer's unsolicited advice, in the 1920s, that he refrain from painting landscapes since this was a European genre, John Koenafeefe Mohl responded by asserting his right to paint whatever took his fancy (Couzens 1985).

Sekoto, sensitive and perceptive but never an overtly political artist, anticipated the extent to which apartheid legislation would soon turn South Africa into a place of unbearable oppression. Upon leaving the country for Paris, in 1947, Sekoto said, "A man's good place is where a man is free, where man finds freedom" (according to Mohl, quoted in Couzens 1985:252). The few freedoms that Africans enjoyed would come to an abrupt end in 1948, when the Afrikaner-dominated Nationalist Party came to power, with a mandate to implement apartheid.

The art produced by Africans during this phase, in which mission schools played a pivotal role, is inscribed with the ambiguities of complicity, with subtle forms of self-assertion, and with discreet gestures of defiance. Meanwhile the white art community, snugly ensconced in academies and university art departments, was absorbed in assimilating the nonfigurative phase of modern European art.

2

The Bantu Education Act formed the cornerstone of apartheid policy. It was designed—in the infamous words of Hendrik Verwoerd, then minister of native affairs and later prime minister—to ensure that "native education should be controlled in such a way that it should be in accord with the policy of the state.… If the native in South Africa today in any kind of school is being taught to expect that he will live his adult life under a policy of equal rights, he is making a big mistake.… There is no place for him in the European community above the level of certain forms of labor" (quoted in Ormond 1985:80). Such a conception of educa-

tion of course excluded training in the arts as well as in the sciences. So, almost three centuries after the arrival of the European settlers, bringing with them the institution of slavery, the social status of Africans was still defined as that of menial laborers and servants. This policy, conceived to secure white supremacy permanently, was aimed at reversing some of the advances Africans had made under previous regimes.

In 1953, when the Bantu Education Act was passed, there were, as Gavin Younge observes, "over 5,000 state-aided mission schools; by 1965, this number had been reduced to 509" (1988:19). When this is compared to the total of 7,222 state-run black schools that existed in the late 1980s, the apartheid state's decimation of independent educational institutions for Africans is staggering. In addition, the Separate Amenities Act (also passed in 1953), along with the Separate Universities Act of 1957, made it virtually impossible for Africans to gain access to art education, to visit public galleries, or to show their work in white-owned private galleries. So complete was this exclusion that in 1970 the Johannesburg Art Gallery, according to Ivor Powell, "possessed only one single work by a black artist, a Gerard Sekoto acquired 30 years earlier" (1995:14). A similar situation applied at the South African National Gallery, founded in 1871.

In response to this repression, a restive and increasingly militant African population mobilized against the apartheid government in the defiance campaigns of the 1950s. The state responded with even greater repression. By 1960, all political opposition was suppressed through the imprisonment of leaders like Nelson Mandela, the exile of others, and eventually the outlawing of the liberation movements and all other antiapartheid organizations. A disquieting silence descended over the country, as practicing African artists were pushed to the extreme margins. The future of aspirant artists seemed very bleak indeed.

Below the surface of this ruthless process of cultural and political engineering, renewed attempts were made to establish forms of art education operating beyond the reach of the state. In 1940, well before this period, Mohl had established his own school of art, in Sophiatown. He called it the White Studios. The school was short-lived, and the future possibility of such a facility in the area was violently uprooted in 1955, when the neighborhood was demolished to clear space for white resettlement. Once a place of writers, painters, musicians, priests, political activists, and gangsters, Sophiatown had had a vibrant cosmopolitan life.

The white-supremacist state, now occupying center stage in public life, inevitably made its own efforts to capture the field of arts and culture for its ethno-nationalist ideology. In 1948, even before the apartheid curriculum for primary and secondary education was drawn up, J. W. Grossert was appointed educational organizer for arts and crafts in Natal.

Grossert suspended the colonial distinction between arts and crafts and encouraged the recovery of traditional skills. Viewed from a postapartheid perspective, the strategy strikes many as progressive, but was in fact designed to enlist rural craft into the agenda of reinventing ethnicity as a counter to the transethnic solidarity of the ongoing struggle for liberation. (Waning ethnic affiliations, however, were an ineluctable consequence of the increase in urbanization.)

In Johannesburg, home of many urbanized Africans, the Local Committee for Non-European Education, which included the famous antiapartheid clergyman Trevor Huddlestone, applied for and received funds from the Union Department of Education for literacy and craft classes. In 1948, a disused hostel in Polly Street became the Polly Street Art Centre. The now leading artist Cecil Skotnes, appointed as cultural officer of the Non-European Affairs Department in 1952, assumed responsibility for the center that same year. Assisted by the gifted sculptor Sydney Khumalo, Skotnes began his personal search for an African visual idiom at the Polly Street Art Centre. Given the times, however, he soon ran into Grossert, who advised him that African artists, with their natural talents, required no teaching. Thus the romantic notion of the noble savage, previously suppressed, was now restored to justify a cynical strategy of withholding certain forms of education from Africans.

Skotnes embraced this "methodology of not teaching art," according to the long-exiled Louis Maqhubela, who also remarked, "I was always at loggerheads with Skotnes on his insistence that black artists did not require any kind of tuition because of their natural ability to paint. What annoyed me most about this fallacy was that it did not apply to white artists, but only to us blacks" (quoted in Koloane 1989:219). Maqhubela's response is identical to that voiced earlier by Dhlomo. But time was in any case running out for the Polly Street Art Centre: in 1951 the subsidy was cut by half. To survive, the hall was rented out to choirs participating in the annual Bantu Music Festival. Responding to the popularity of this religious music, with its themes of suffering, forbearance, and acquiescence, Matsemela Manaka argues, artists developed a "victim" aesthetic produced for a guilt-ridden and patronizing white art market (1987:15).

In 1960 the Polly Street Art Centre was closed. Two years later, its artists and teachers relocated to the Jubilee Street Social Centre, which, in 1985, moved to Soweto and became the Mofolo Art Centre. The Polly Street Art Centre, despite its shortcomings, is widely recognized today for the role it played in the emergence of urban African art.

Meanwhile a new missionary initiative was launched in the rural areas. Peder and Ulla Gowenius established the Evangelical Art and Craft Centre in 1962 at the old mission station known as Rorke's Drift, scene of a historic battle between Zulu warriors and British imperial forces in the late

nineteenth century. The purpose of the Rorke's Drift center, as expressed in a brochure, was "to nurture the unique artistic heritage of Africa" and to "extend this heritage with new influences so that it will find its rightful place in an evolving and changing society" (quoted in Lundbohm n.d. [c. early 1970s]). In practice, however, it was founded on training in weaving, pottery, and printmaking, conceived as means to provide Africans with skills in forms of artmaking that would provide employment and income for both them and the school.

When the arts section was closed, in 1982, Rorke's Drift came to embody the colonial approach of limiting art teaching for Africans to the field of craft production. Still, it nurtured the talents of Azaria Mbatha, Johan Muafanjejo, Lionel Davis, Tony Nkotsi, Paul Sibidi, Kay Hassan, Dumisani Mabaso, Sam Nhlengethwa, Bongiwe Dhlomo, and Pat Mautloa.

By the early 1970s, when apartheid seemed unassailable, new energies of resistance were accumulating in all spheres of South African life. A suppressed labor movement was being revived. In culture, the anticolonial psychosocial vision of Steve Biko and the Black Consciousness Movement was giving new direction to the domestic struggle. This movement, Biko wrote, sought to counter "the lie that black is an aberration of the 'normal' which is white" (Biko 1979:49). Its aim was to instill "in the black community a new-found pride in themselves, their efforts, their value systems, their culture, their religion and their outlook to life" (ibid.) It was therefore a political movement aimed at the reconstruction and affirmation of African culture and identity.

This ethos inspired the Soweto Uprising of 1976, which was triggered by a revolt of schoolchildren against the imposition of Afrikaans as the language of instruction in African schools. In the wake of this insurrection, clusters of community-based arts centers and training facilities were established. In 1976, the Federated Union of Black Artists was founded. The Community Arts Project was started in Cape Town in 1977, the same year in which the Kathlehong Centre was launched in Germiston, on the East Rand. A decade later, in 1984, the African Institute for Arts (which later became the Funda Arts Centre) opened in Diepkloof Soweto. The same year, David Koloane set up the Thupelo workshop to provide opportunities for artists from different parts of the country to work together and exchange ideas with artists from other parts of Africa and the world. ("Thupelo," the name given to workshops that took place in various sites throughout South Africa, whenever funding was available, comes from a seSotho word that according to Bongi Dhlomo, a workshop organizer and participant, roughly translated means "teaching by example" or "training.") The Alexandra Art Centre in Johannesburg and the Durban Community Workshop opened their doors in 1986.

These initiatives were designed to amend the lack of art facilities for Africans and to serve as countervailing forces to the Bantu Education Act. The founder of the Johannesburg Art Foundation, which was registered in 1982, was the outspoken antiapartheid artist and teacher Bill Ainslie, who in fact had sought to make available a nonracial and modern art education to all South Africans since he set up his first studios, in 1965.

These centers functioned without any public support. Their income derived from the meager fees they charged their impoverished students, supplemented by international antiapartheid donors, solidarity funds, and other philanthropic support. The facilities were basic, and remain so: a few scattered books; bare and cramped spaces; limited and often obsolete equipment; a paucity of materials. The centers offered both part-time and full-time courses, but had difficulty attracting and keeping well-qualified staff. Their diplomas and certificates were not recognized by the educational institutions of the apartheid state (unless the center was linked to a university, as Funda was).

In contradistinction, university art departments were subsidized by the state, and were furbished with state-of-the-art equipment, well-stocked libraries, and spacious buildings. Leading artists served as teachers, providing white students with the best possible practical and theoretical training permitted under apartheid. Fort Hare, established in 1916 as the first university for Africans, established an art department only in 1976, which catered to no more than twenty-five students. This relatively late development seems to contrast with the fact that the university's African Studies Centre built up an impressive collection of African art—but only if one forgets that the collection was basically ethnographic. Today Fort Hare and the University of Durban Westville are the only "historically black" universities offering art education. The rest of the facilities are in the former white institutions. This is the inequality produced by the educational policies of apartheid.

As in the past, these underresourced art centers, guided by an ethos of community empowerment, taught artists that a limiting environment need not limit resourcefulness and creativity. Thus bits of paper, discarded magazines, scrap metal, and other waste materials were harnessed for artmaking. These modest institutions launched artists like Lucky Sibiya, Dumile Feni, William Kentridge, Helen Sibidi, David Koloane, and many others. They were also the sites from which the visual arts participated alongside the internal resistance movements, such as the United Democratic Front, labor organizations, student bodies, and anticonscription and other mass democratic campaigns, in the final push to end minority domination.

3

Against all expectations, South Africa emerged from what Jacques Derrida, in the catalogue to the exhibition "*Art Contre*/Against Apartheid" (a United Nations–sponsored traveling exhibition now housed in Parliament in Cape

Town), characterized as a "system of partition, barbed wire, crowds of mapped out solitudes" (1986:331). This system was finally consigned to history when Nelson Mandela was inaugurated in the autumn of 1994 as the country's first democratically elected president.

Does this historic event mean that the systematic divisions and inequalities of the past, now struck from the statutes, have also been erased from South Africa's social and cultural face? Have the "mapped out solitudes" been dissolved and replaced by a new sense of community and a common undivided humanity?

Part of the answer to these questions is readable in this exhibition. As suggested at the outset, a division marked by a personal and social thematics seem to run through the art. Does this suggest that the fixed divisions of colonialism have remained unchanged in South Africa? A closer look at some of the art may provide some perspective on this question.

Claudette Shreuder's sets of wooden sculptures, modeled on colonial figures in West African carvings, depict members of her family. A grandfather rides a leopard, signifying the colonial enterprise of taming a mythical wilderness. The artist's niece and the child of her domestic worker are clad in the same dress; seen against the actual difference in their social status, this highlights the naïveté of the sentimental notions of equality that colonials are fond of invoking when referring to their childhoods. In depicting and narrating family scenes, Shreuder's work looks at the world from the perspective of interpersonal relations. Similarly Brigette Baker, using her own sweaters and those of her friends, examines the relationship between personal and bodily identity and the role of cultural costumes in constructing identities. In Brett Murray's work, 130 framed photographs of the artist, titled *Guilt–Innocence 1962–1989*, explore aspects of the self as it emerges from personal portraits spanning two decades of life as a white under apartheid.

Compare these works with those of Samson Mnisi and Thabiso Phokompe, who use natural materials, soil, the traditional potions called *muti*, discarded objects, and beads to suggest efforts to reconnect with the land, culture, and history of a people disrupted by colonialism. A related approach can be seen in the natural materials used by Sandile Zulu. Richmond Buthelezi uses plastic waste melted by fire to encode a process of transforming elements from a degraded environment into aesthetic objects. In different ways these works encode transpersonal references concerned with communities, large social groups, and whole classes of people living in the traumatic environments created by apartheid, environments that persist despite the dramatic political changes.

In their themes and materials these works seem to reflect a racial divide, and, further, a binary order of university as opposed to community-center education. But a reading

locked in these surfaces is problematic. The photographic work of University of Cape Town–trained artist Zwelethu Mthethwa, for example, straddles this divisive order in his recordings of the lives of dispossessed Africans living in shacks; Mthethwa uses a medium located in the university center yet explores social themes associated with the community-center-trained artists. We also see this in the work of Sandile Zulu, who was originally trained at Rorke's Drift before receiving his degree from the University of the Witwatersrand, and who now resides at the Amakhona Art Centre. In focusing solely on a black/white divide, then, one misses the connections among these works, and the way they relate to current forces in South African society. The key to this is the shift of potential power from a racial minority to the majority in a nonracial democracy.

The end of apartheid necessitated a radical reorientation in South African art. The trend in the work of both black and white artists to address overt political themes opposed to apartheid gave way to a range of new subjects, including an introspective turn away from grand social themes and issues; a quest for the reinvention of South Africa as a postcolonial African state; a concern with the persistence of inequalities; a reassessment of the past; the examination and reconstruction of personal and group identities; and the exploration of matters relating to social and cultural upheavals and transitions.

Some of these shifts are illustrated in, for example, the works of Penny Siopis and Kay Hassan. These artists address a similar issue, displacement, although in one case the displacement was voluntary, in the other, forced. Both also explore the ways one determines what is valuable in the immediacy of being cut off from the physical and social environment of one's past. Yet the artists diverge in their depictions, both in medium and in form. Siopis starts with the personal, Hassan with the collective. In her installation *Charmed Lives* (cat. 20), Siopis uses sophisticated technology to marry video images, sound, text, and objects. Most notable in her depiction of the theme is its introspective and immediate personal associations; film, voices, and objects are all her family and familial possessions. Hassan, on the other hand, in his various manifestations of *The Flight* (not in this exhibition), creates figures that could be anyone, from Alexandra Township to Rwanda to Kosovo. And wherever *The Flight* has been assembled—Berlin, Korea, Johannesburg—he uses objects and discarded billboard paper found locally. In these artists' works, then, the visceral public theme of displacement is informed by memory and personal experience. Both artists offer insights into the varying spatiotemporal relations of present-day South Africa, into the immigrants who have chosen to make their lives here and the population movements caused by coercive forces. Their work is conducted from different social spaces, but both bring into view the motif of division that runs through South African history and art. They encode shifts, transitions, and deeper transformations of a society once founded on

division, and now faced with the most difficult challenge of change, the eradication of accumulated inequalities.

4

Since this essay is concerned with art education, it is, in conclusion, apposite to ask what changes have occurred in this area since the end of apartheid.

The doors of education have been flung open. The eighteen ethnic State Departments of Apartheid Education have been consolidated into a single nonracial National Department of Education and Training. Art is now recognized as one of the core learning fields at all levels of education. The White Paper for Arts, Culture and Heritage—informed by the Report of the Arts and Culture Task Group, established to devise a new art policy for South Africa—recommended that visual-art education be made all embracing, to include painting, sculpture, graphic art, photography, drawing, mural painting, paper work, performance art, fiber art, video installation, computer graphics, and all other conceivable practices. Amid protest aimed at preserving racist standards, the doors of the former white universities have been prized open.

Yet the real chances African students have of gaining entrance to art programs remain limited. The mere fact that art education is not available in the schools in which the majority of the country's youth continue to receive their schooling perpetuates the inequalities of the past. Elsbeth Court has established that in 1991, "fewer than 0.14 percent of black students sat for art at matriculation level (compared to 66 percent for agriculture)" (1995:294). While the figure is higher for white students, the overall number remains far below countries like Ghana and the United Kingdom, where approximately a fifth of the school-leaving population take exams in art.

So what on earth did Walter Benjamin intend when he enigmatically claimed, in the spring of 1940, "There is no document of civilization which is not a document of barbarism" (1992:249)? If one considers the persistent inequalities between an affluent, largely white minority and a poverty-stricken, largely African majority in South Africa today, the achievement of constitutional equality five years ago, important as it is, may prompt one to think that Benjamin had this society in mind. The manifold and mutually reinforcing histories of domination, the vicious displacements carried out in the name of civilization, and, against this, the search for the doors connecting people who live in different spaces, are among the persistent strands in the visual narratives of South African art. In this context, self-portrayal must be seen as a matrix for subjective and social currents that have destabilized identities once fixed within the hierarchies of apartheid. The exploration of social, cultural, and environmental themes relates to the reconstruction of African agency.

Fanon's desire for an "open consciousness," which floats above this essay, is, as Homi Bhabha suggests, " a deep hunger for humanism" (1994:120). It is a desire to reach out across the ever-shifting divides of societies founded on inequality; to touch and embrace the Other. In South Africa, the nominal triumph of the majority over minority domination has broken down the political divides of colonialism. It is now faced with the unfinished task of reconstituting the material and symbolic order in the image of an open society based on equality.

Epilogue
The Exhibition Liberated Voices: Contemporary Art from South Africa

Frank Herreman

In 1995, the Museum for African Art first conceived of the idea to devote an exhibition to art from South Africa. Several thematic possibilities were considered, including a general overview—starting with the earliest forms of artistic expression through contemporary art—or an overview of the art of one or more traditional cultures. After much consideration, we decided on a third option, an exhibition on contemporary South African art.

There were several underlying reasons behind our decision to choose contemporary art. In 1991, the Center for African Art (now our Museum for African Art) organized the exhibition *Africa Explores: 20th Century African Art*. It focused on various forms of modern and contemporary artistic expression which had developed in a number of sub-Saharan countries, starting in colonial times through independence. However, because of the international cultural and economic embargo, *Africa Explores* did not include any works by South African artists.

On April 27, 1994, Nelson Mandela was elected president of the New South Africa in the first democratic national elections. Since Mandela's release in 1990, South Africa's international relations had been improving steadily, and the country's period of cultural and economic isolation gradually came to an end. In the first years following 1990, a number of exhibitions on contemporary South African art were organized in several European cities, including London, Nantes and Berlin. When South Africa organized Biennales in Johannesburg in 1995 and 1997, the country showed its interest in the most current forms of artistic expression, and its desire to make a place for itself in the international contemporary art scene.

I traveled to South Africa for the first time in January 1998. In the course of two weeks, I met with about forty artists, curators, gallery owners and directors active in contemporary art. From the collected material, I wanted to distill a concept covering one or more aspects important in contemporary South African art. I was especially struck by the rapid succession of emotional states I went through during my meetings. The great diversity of the featured art works provided rich seeds for intense conversations with the artists. The impressions gathered in this way forced me to continually reevaluate and add to the exhibition concepts that were developing in my mind. At most of these meetings, I asked my interviewees which artists they considered representative of the new South Africa. Unbeknownst to each other, the members of this unofficial selection committee often brought up the same artists. This information was very valuable in determining the final selection.

Upon my return to New York, I sorted through and pondered the information I had gathered. It became more clear than ever that the traumatic fifty-year experience of Apartheid as well as the legacy incarnated by the activities of the Truth and Reconciliation Commission had left significant marks on the contemporary art of South Africa.

Before my departure, I had read Gordon Metz's speech, "Learning to Live Without the Enemy," (African Arts: Winter 1996, p. 57). The following quotation became a guiding principle in my search for a theme:

> Whereas recent international art-making and cultural discourse (including debate on the issue of representation) have been characterized by convoluted intellectual debate around "the other," our cultural expression has primarily been starkly and unavoidably determined by the brutal confrontation with "the enemy." But after April 27, 1994, the "enemy" was all of a sudden gone. What do we now paint, photograph or write about? If you think postmodernism is problematic, try postapartheidism! Apartheid and violence made powerful images, poignant stories, stirring poems, heart-stopping film. The subject matter was here, there, everywhere. Even though black artists were excluded from the mainstream, the apartheid theme (especially in the 1980s, as the balance of power changed) opened up avenues for people. Are we now to paint about reconstruction and development? Are we now saddled with a neutered negotiated culture? And can we learn to create again without "the enemy?"

Gordon Metz brings up a number of questions that I hope to answer, at least partly, with **Liberated Voices**. More than four years have passed between March 1995, when he pronounced these words at the conference *Bua! Emerging Voices*, and September 1999, the opening date of our exhibition. This period is concurrent with Mandela's term of office as the first President of the new democratic South Africa. During this period, the world has followed with interest how the democratization process has developed and maintained itself. Postapartheid has been around for five years now, and artists have not stopped painting, photographing and writing. Political themes and the fight against injustice are still prominent in those artists who were already active in the 1980s. They now offer critique on the horrors brought to light by the Truth and Reconciliation Commission, or on the failure of the social and economic improvements promised by the new democratic government.

Outsiders cannot be part of daily life in South Africa. One can only observe and attempt to discern the dominant traits that characterize this country's contemporary art. There is nothing new in the statement that there is a difference in how black and white artists approach their themes and give shape and form to their creative ideas. This difference cannot and should not be ignored. It is the result of three centuries of forced segregation between the indigenous African and European cultures of South Africa, culminating in Apartheid between 1948 and 1994. This segregation was based on skin color without any regard for intellectual abilities. The legitimization of the existence of these different worlds was at the basis of flagrant economic, educational and social inequalities. Blacks and people of color were intentionally denied access to knowledge, or severely restricted. Aside from a few isolated initiatives, there was no real organized fine arts education for them. What little there was, suffered from a severe shortage of materials. At the same time, the white population put in place an educational system comparable to that in Europe and North America.

Judging contemporary art in the context of the era of its creation remains a delicate matter. The important element of detachment is lacking. One attempts to compensate for this lack by sizing up the situation and trying to get a finger on the pulse of the tendencies and thoughts underlying current creative activity. I have tried to distill, from the information and the impressions I have gathered some of the most prominent elements characterizing contemporary South African art.

The introduction provides a link between the art of the Apartheid era and that of postapartheid. Paul Stopforth's "Interrogators"(cat. 4, p. 42) is the only featured work of art that was created during Apartheid. The works of David Koloane (cat. 1, p. 20-24) and Sue Williamson (cat. 3, p. 33-35) were created after 1994, but these more recent works show the artists' continuing preoccupation with denouncing the injustices of Apartheid. Willie Bester's work (cat. 2, p. 27)remains equally critical. His criticism, previously directed at racial inequality, has now shifted to the failure of the new government to make good on their promises to improve the social, economic, and housing situation in the townships.

The exhibition proper is composed of works created between 1994 and 1999 by nine South African artists. In some cases, the character of their works show similarities to one another; in other cases, they may be completely different. There are nevertheless unifying elements, in form as well as in content.

Different racial, social and economic backgrounds operate as a major source of themes in the works of several artists. One of the first themes involves the incorporation of recycled materials as an important characteristic of the works of several township painters and sculptors. The use of residual elements replaces traditional materials such as paint and clay; materials that township artists could not afford or were often denied to them by white authorities. The use of refuse reflects the poor conditions under which many of the people in these environments have been living for nearly half a century. Therefore, the artists' choice of media can also be considered a conscious component of their association with the society they live in.

Some of the black South African artists return to their roots and incorporate motifs and materials found in the life of their ancestors. They consciously reject elements and themes reminiscent of industrial society. Traditional religious symbols, healing devices, and geometric signs symbolizing identities

are all part of their visual language. This artistic current can be described as idealistic in the search of a new identity.

Among several white artists, a major theme is that of personal introspection. These painters, sculptors and installation artists grew up in white suburban communities. Their work reflects the social reorientation taking place within the New South Africa. For them, art provides a vehicle to confront personal histories as well as a source for understanding of and reconciliating with their past and the new society of which they are a part.

Liberated Voices does not pretend to be a complete overview. It tries to catch a particular moment between 1994 and 1999 in which South Africa began to reshape itself. The new political situation and the impact of the Truth and Reconciliation hearings are strongly reflected in today's art of South Africa which now gives place to the feelings of the individual.

Artists

Bridget Baker

Bridget Baker received a Master of Fine Art from the Michaelis School of Fine Art, University of Cape Town. She has exhibited work in many solo and group exhibitions in South Africa and Europe. Most recently, her work was featured in the exhibition Graft, at the second Johannesburg Biennale, Trade Routes, 1997, and in the publication Art in South Africa: The Future Present, by Sue Williamson and Ashraf Jamal. Ms. Baker's work is included in the public collection of the South African National Gallery.

Willie Bester

Willie Bester was educated in Montagu and went on to study part-time for one year at the Community Art Project in Cape Town. His works have been shown extensively in solo and group exhibitions. In 1993, Mr. Bester was an invited artist to a solo workshop held at the South African National Gallery Annex in Cape Town. His work is widely recognized and has been published in several seminal texts including Sue Williamson's Resistance Art in South Africa and Williamson and Jamal's Art in South Africa: The Future Present. His work is in private, public and corporate collections.

Mbongeni Richman Buthelezi

Mbongeni Richman Buthelezi is currently pursuing an Advanced Diploma Course in Fine Arts at the University of Witwatersrand and is a Fine Arts Lecturer at FUNDA Community College, Soweto. His work has been shown in many group exhibitions in South Africa and Europe, including the Electric Workshop during Africus, the first Johannesburg Biennale in 1995. Mr. Buthelezi's work is in several private collections in France, the U.S. and South Africa, and corporate collections such as Coca-Cola South Africa and the Development Bank of South Africa.

David Koloane

See Contributors at beginning of catalogue.

Samson Mnisi

Samson Mnisi studied art at the Mofolo Art Center and the Federal Union for Black Artists (FUBA) in South Africa. Since 1992, Mr. Mnisi has shown his work in many solo and group exhibitions in South Africa and the United States. His work is in collections at the Johannesburg Art Gallery, the French Institute and Boston University.

Zwelethu Mthethwa

Zwelethu Mthethwa studied art at the Michaelis School of Fine Art, University of Cape Town, where he received a Diploma and Advanced Diploma in Fine Art. In 1989, he received a Master of Fine Art from the Rochester Institute of Technology. Recently, his artwork was featured in Trade Routes, in 1997, and in several gallery shows in New York, Oslo, Los Angeles, London and in Cape Town, South Africa. Mr. Mthethwa's work is in the collections of the Durban Art Gallery, and the South African National Gallery.

Brett Murray

Brett Murray studied at the University of Cape Town where he was awarded a Master of Fine Arts degree. He has exhibited extensively in South Africa and abroad including the 1994 Havana Biennale, the 1995 Venice Biennale, and Trade Routes in 1997. Mr. Murray's work also was shown in exhibitions at the Ludwig Museum of Contemporary Art, Germany, and the Museum of Contemporary Art, Santiago, Chile. In 1986, he established the sculpture department at the University of Stellenbosch. He curated an exhibition titled 40 Sculptors from the Western Cape at the University of Stellenbosch in 1992. His work is represented in many national collections.

Thabiso Phokompe

Thabiso Phokompe studied art at the Federal Union for Black Artists (FUBA) and the Johannesburg Art Foundation. He also participated in several art workshops. Since 1990, his work has been shown in several group exhibitions in South Africa, Zambia, and Norway. Mr. Phokompe's work is in private, public and corporate collections in Africa and Europe including the Botswana National Museum, and the Meridian Bio Bank.

Penelope Siopis

Penelope Siopis studied Fine Arts at Rhodes University, Grahamstown. In 1978, she studied at Portsmouth Polytechnic on a British Council scholarship. Her international reputation was established through exhibitions including the Art from South Africa show at the Museum of Modern Art, Oxford in 1991, Private Views as the Standard Bank Gallery, Johannesburg in 1994, and Africus in 1995.

Claudette Schreuders

Claudette Schreuders received a Master of Fine Arts degree, with distinction, at the University of Cape Town in 1997. Previous to this achievement, Ms. Schreuders exhibited her work in several group exhibitions in South Africa, Japan, and Germany. This year, she had a solo exhibition at the Civic Gallery in Johannesburg, South Africa.

Paul Stopforth

Paul Stopforth is currently a visiting faculty member at the Carpenter Center for the Visual Arts at Harvard University. He received a National Art Teachers Diploma from the Johannesburg College of Art (now Technikon Witwatersrand) and has also completed one year of post graduate work at the Royal College of Art in London. Mr. Stopforth's work has been exhibited in numerous individual and group exhibitions including a 1998 show titled *Essential Gestures* held at the Creiger-Dane Gallery in Boston. He is a recognized artist with work in both private and public collections.

Sue Williamson

See Contributors at beginning of catalogue.

Sandile Zulu

Sandile Zulu received his Bachelor of Arts in Fine Arts, with honors, at the University of Witwatersrand in 1993. His work has appeared in many solo and group exhibitions in South Africa, New York, Atlanta, Paris, and London. Most recently, his work was featured in *Trade Routes*, in 1997, and was written about in *Art in South Africa: The Future Present*, a book by Sue Williamson and Ashraf Jamal. Mr. Zulu's work also is in several other public, private and corporate collections including the South African National Gallery.

Bibliography

Abrahams, Lionel
1986 "Place." In *Reef of Time: Johannesburg in Writing.* Compiled and ed. Digby Ricci. Craighall: Ad. Donker.

Ades, Dawn
1995 "Surrealism: Fetishism's Job." In *Fetishism: Visualizing Power and Desire.* Ed. Anthony Shelton. London: The South Bank Centre in association with Lund Humphries Publishers.

Anderson, Benedict
1983 *Imagined Communities: Reflections on the Origin and Spread of Nationalism.* London: Verso.

Araeen, Rasheed
1995 "What Is Post-Apartheid South Africa and Its Place in the World?" *Africus: Johannesburg Biennale.* Exh. cat. Johannesburg: Greater Johannesburg Transitional Metropolitan Council.

Arnheim, Rudolf
1974 *Art and Visual Perception: A Psychology of the Creative Eye.* Berkeley: University of California Press.

Asmal, Kader, Louise Asmal, and Ronald Suresh Roberts
1996 *Reconciliation through Truth: A Reckoning of Apartheid's Criminal Governance.* Claremont: David Philip, and Belleville: Mayibuye.

Atkinson, Brenda, and Candice Breitz, eds.
1999 *Grey Areas: Representation, Identy and Politics in Contemporary South African Art.* Johannesburg: Chalkham Hill Press.

Bachelard, Gaston
1987 *The Psychoanalysis of Fire.* London: Quartet.

Barnes, Rachel, Phaldon, Tony Godfrey, et. al.
1996 *The 20th Century Art Book,* San Francisco: Chronicle Books.

Bauman, Zygmunt
1995 "Broken Lives, Broken Strategies." *In Life in Fragments: Essays in Postmodern Morality.* Oxford: Blackwell Publishing.

Beckett, Samuel
1965 *Proust and Three Dialogues with Georges Duthuit.* Reprint ed. London: John Calder, 1970.

Bell, Paul, and Riaan de Villiers, eds.
1995 *An End to Waiting. The Story of South Africa's Elections: 26 April to 6 May 1994.* Johannesburg: The Independent Electoral Commission.

Benjamin, Walter
1992 *Illuminations.* Hammersmith: Fontana Press.

1995 "The Work of Art in the Age of Mechanical Reproduction." In *Art in Modern Culture: An Anthology of Critical Texts,* Eds. Francis Franscina and Jonathan Harris. London: Phaidon 1992, reprinted 1995.

1998 "Untidy Child." In *One Way Street.* London: Verso 1979, reprinted 1998.

1999 "Unpacking My Library: A Talk About Book Collecting," "Theses on the Philosophy of History." In *Illuminations.* London: Pimlico 1955, reprinted 1999.

Bhabha, Homi
1994 "Remembering Fanon." In *Colonial Discourse and Post-Colonial Theory: A Reader.* Ed. Patrick Williams and Laura Chrisman. Hartfordshire: Prentice Hall/Harvester Wheatsheaf.

Biko, Steve
1979 *I Write What I Like.* London: Heinemann Educational Books.

Boraine, Alex, and Janet Levy, eds.
1995 *The Healing of a Nation?* Cape Town: Justice in Transition.

Boraine, Alex, Janet Levy, and Ronel Scheffer, eds.
1994 *Dealing with the Past: Truth and Reconciliation in South Africa.* Cape Town: IDASA.

Bradley, Fiona
1997 *Surrealism: Movements in Modern Art.* London: Tate Gallery Publishing.

Brain, C. K.
1993 *Swartkrans: A Cave's Chronicle of Early Man.* Pretoria: Transvaal Museum.

Breitz, Candice, and Allan Bowyer, eds.
1995 *1995 Africus Johannesburg Biennale.* Johannesburg: Transitional Metropolitan Council of Johannesburg.

Brink, André, comp.
1994 *SA 27 April 1994: An Authors' Diary.* Pretoria: Queillerie.

1995 *27 April: One Year Later.* Pretoria: Queillerie.

Brown, Duncan, and Bruno van Dyk, eds.
1991 *Exchanges: South African Writing in Transition.* Pietermaritzburg: University of Natal Press.

Burnett, Ricky
1984 *Tributaries (A View of Contemporary South African Art).* Exh. cat. Munich: BMW Kultur Programm.

Burnham, Jack
1983 "Hans Haacke—Wind and Water Sculpture." In Alan Sonfist, ed. *Art in the Land: A Critical Anthology of Environmental Art.* New York: E. P. Dutton. Originally published in *Triquarterly,* 1967, pp. 105–24.

Callinicos, Luli
1987 *Working Life 1886–1940.* Johannesburg: Ravan Press.
1991 "Representing 'People's History.'" Exh. cat. *Art and the Media.* Johannesburg: Gertrude Posel Gallery, University of the Witwatersrand.

Canetti, Elias
1978 *Auto da Fé.* London: Picador.

Clarke, Nancy L.
1997 "The Economy." In *South Africa, A Country Study.* Ed. Rita M. Byrnes. Washington, D.C.: Federal Research Division, Library of Congress.

Coetzee, J. M.
1992 "Jerusalem Prize Acceptance Speech." In *Doubling the Point: Essays and Interviews: J. M. Coetzee.* Ed. David Attwell. Cambridge, Mass.: Harvard University Press.

Cole, Herbert M.
1989 *Icons: Ideals and Power in the Art of Africa.* Washington, D. C.: Smithsonian Institution Press.

Colpitt, Frances
1990 *Minimal Art: The Critical Perspective.* Seattle: Washington University Press.

Court, Elsbeth
1992 Personal notes.

1995 "Notes." In *Seven Stories About Modern Art in Africa.* Ed. Clementine Deliss. London: Flammarion Press.

Couzens, Tim
1985 *The New African: A Study of the Life and Work of H. I. E. Dhlomo.* Braamfontein: Ravan Press.

Couzens, Tim, and Essop Patel
1982 *The Return of the Amasi Bird.* Johannesburg: Ravan Press.

Da Vinci, Leonardo
1954 *The Notebooks of Leonardo da Vinci*. Vol. II. Arranged, trans., and with an introduction by Edward MacCurdy. London: The Reprint Society.

Dart, Raymond A.
1957 *The Osteodontokeratic Culture of Australopithecus Prometheus*. Pretoria: Transvaal Museum.

De Bord, Matthew, and Rory Bester, eds.
1997 *Trade Routes: History + Geography. 2nd Johannesburg Biennale 1997*. Johannesburg: Greater Johannesburg Metropolitan Council and the Prince Claus Fund for Culture and Development, the Netherlands.

De Kok, Ingrid, and Karen Press, eds.
1990 *Spring Is Rebellious: Arguments about Cultural Freedom by Albie Sachs and Respondents*. Cape Town: Buchu Books.

Deliss, Clémentine, ed.
1995 *Seven Stories about Modern Art in Africa*. London: Whitechapel Art Gallery.

Derrida, Jacques
1986 "Racism's Last Word." In *"Race" Writing and Difference*. Ed. Henry Louis Gates, Jr. Chicago: at the University Press.

Devèz, Laurent
1995 "A Researcher's Work." In *Fire! An Exhibition of Burnt Paintings by Sandile Zulu*. Exh. cat. Johannesburg: Rembrandt van Rijn Art Gallery.

Dhlomo, Bongi.
1995 "Emerging from the Margins." *Africus: Johannesburg Biennale*. Exh. cat. Johannesburg: Greater Johannesburg Transitional Metropolitan Council.

Dikeni, Sandile
1997 "Winnie cracked—the rest is all dialectic." In *Cape Times* (1 December 1997).

Eagleton, Terry
1997 *Marx and Freedom*. London: Phoenix.

Eco, Umberto
1984 *The Name of the Rose*. London: Picador.

Eliade, Mircea
1964 *Shamanism: Archaic Techniques of Ecstasy*. Princeton: The Bollingen Foundation.

Elliot, David, ed.
1990 "Babel in South Africa." *Art from South Africa*. Exh. cat. Oxford: Museum of Modern Art.

Enwezor, Okwui
1997a "Travel Notes: Living, Working, and Traveling in a Restless World." *Trade Routes: History and Geography*. Exh. cat. South Africa: Greater Johannesburg Metropolitan Council.

1997b "Reframing the Black Subject: Ideology and Fantasy in Contemporary South African Representations." In *Third Text* 40, Autumn.

Fanon, Frantz
1967 *Black Skins White Masks*. New York: Grove Press.

Ferguson, Lorna
1995 "Reflections on the Question: Why a Johannesburg Biennale?" *Africus: Johannesburg Biennale*. Exh. cat. Johannesburg: Greater Johannesburg Transitional Metropolitan Council.

Fischer, Tibor
1997 *The Collector Collector*. London: Secker & Warburg.

Freedberg, David
1989 *Power of Images: Studies in the History and Theory of Response*. Chicago: The University of Chicago Press.

Freud, Sigmund
1991 *On Sexuality*. London: Penguin.

Galeano, Eduardo
1985 *Memory of Fire: Genesis*. New York: Pantheon.

Geers, Kendell.
1990 "Art as Propaganda Inevitably Self-Destructs." *Art from South Africa*. Exh. cat. Ed. David Elliot. Oxford: Museum of Modern Art.

Geyer-Ryan, Helga
n.d. "Counterfactual Artefacts: Walter Benjamin's Philosophy of History." In *Visions and Blueprints*, Edward Timms & Peter Collier, eds. Manchester: Manchester University Press.

Gilbey, Emma
1993 *The Lady: The Life and Times of Winnie Mandela*. London: Jonathan Cape.

Godfrey, Tony
1998 *Conceptual Art*. London: Phaidon.

Goldberg, David Theo
1993 *Racist Culture: Philosophy and the Politics of Meaning*. Oxford: Blackwell.

Gottlieb, Carla
1976 *Beyond Modern Art*. New York: E. P. Dutton.

Goudsblom, Johan
1992 *Fire and Civilization*. London: Penguin.

Govender, K., and T. A. Woker
1987 "Race and Social Rights." In *Race and the Law In South Africa*. Ed. A. Rycroft. Cape Town: Juta.

Grundy, Kenneth
1996 "Cultural Politics in South Africa: An Inconclusive Transformation." In *African Studies Review* 39 (April).

Harker, Joseph, ed.
1994 *The Legacy of Apartheid*. London: Guardian.

Harris, Michael D.
1998 "Memories and Memorabilia, Art and Identity: Is Aunt Jemima Really a Black Woman?" In *Third Text* 44 (Autumn).

Hobhouse, Emily
1984 *Emily Hobhouse: Boer War Letters*. Ed. Rykie van Reenen. Cape Town: Human and Rousseau.

Hobsbawm, E. J.
1962 *The Age of Revolution 1789–1848*. New York: New American Library.

Hodge, Joanna
1992 "Genealogy for a Postmodern Ethics: Reflections on Hegel and Heidegger." In *Shadow of Spirit: Postmodernism and Religion*. Ed. Philippa Berry and Andrew Wernick. London: Routledge.

Hofmeyr, Isabel
1993 "Testimony into Text: The Making of the Makapansgat Legend." In *"We Spend Our Years as a Tale That Is Told": Oral Historical Narrative in a South African Chiefdom*. Johannesburg: Witwatersrand University Press.

Hondius, Jadocus
1952 *A Clear Description of the Cape of Good Hope*. Trans. L. C. van Oordt. Cape Town: Van Riebeeck Festival Book Exhibition Committee.

Hope, Marith, ed.
1997 *Contemporary Art from South Africa*. Oslo: Riksutskillinger.

Hug, Alfons, and Sabine Vogel
1996 *Colours: Kunst aus Südafrika*. Berlin: Haus der Kulturen der Welt.

Huyssen, Andreas
1995 *Twilight Memories: Marking Time in a Culture of Amnesia*. New York and London: Routledge.

Jameson, Frederic
1981 *The Political Unconscious: Narrative as a Socially Symbolic Act*. London: Methuen.

Koloane, David
1981 "Interview with Lucas Seage." In *Staff Rider* vol. 4(3): 18.

1984 *The Organization of Printmaking Workshops in the Urban Areas of South Africa*. Dissertation for Diploma in Museum Studies, University of London.

1989 "The Polly Street Art Scene." In *African Art in Southern Africa: From Tradition to Township*. Ed. A. Nettleton and D. Hammond-Tooke. Johannesburg: Ad Donker.

1990 "The Thupelo Art Project." *Art from South Africa*. Exh. cat. Oxford: Museum of Modern Art.

1997 "Walking the Tightrope." *Trade Routes: History and Geography*. Exh. cat. South Africa: Greater Johannesburg Metropolitan Council.

Kopytoff, Igor
1986 "The Cultural Biography of Things: Commoditization As Process." In *The Social Life of Things: Commodities in Cultural Perspective*, Ed. Arjun Appadurai. New York: Cambridge University Press.

Krauss, Rosalind E.
1978 "Grids, You Say." In *Grids: Format and Image in 20th Century Art*. New York: The Pace Gallery.

Kris, Ernst, and Otto Kurz
1979 *Legend, Myth, and Magic in the Image of the Artist: An Historical Experiment*. New Haven: Yale University Press.

Krog, Antjie
1998 *Country of My Skull*. Johannesburg: Random House.

Kundera, Milan
1984 *The Unbearable Lightness of Being*. London and Boston: Faber & Faber.

Law, Jennifer A.
forthcoming "Genealogy and the Artis's Archive: Strategies of Autobiography and Documentation in the Work of a South African Artist." In *Rethinking Age in Africa: Colonial, Post-Colonial and Contemporary Interpretations of Cultural Representations*, Ed. Mario I. Aguilar. Lawrenceville: Africa World Press.

Leslie, Esther
1999 "Telescoping the Microscopic Object: Benjamin the Collector." In *The Optic of Walter Benjamin, Volume 3 de-, dis-, ex-*, Ed. Alex Coles. London: Black Dog Publishing.

Lippard, Lucy
1983 *Overlay: Contemporary Art and the Art of Prehistory.* New York: Pantheon.

Lucretius
1976 *De Rerum Natura: A Poem on Nature.* Trans. C. H. Sission. Manchester: Carcanet New Press.

Lundbohm, Otto (principal)
n.d. (c. early 1970s) *KwaZulu Art of Rorke's Drift.* Catalogue/brochure.

Lundström, Jan-Erik, and Katarina Pierre, eds.
1998 *Democracy's Images: Photography and Visual Art after Apartheid.* Umeå: Bildmuseet.

Macleod, Fiona
1998 "Our Winners." In "Greening of the Future." In *Weekly Mail and Guardian.* October 2–8.

Malala, Justice
1999 "Down with the People." In *The Sunday Independent* (May 23).

Mack, John
1995 "Fetish? Magic Figures in Central Africa." In *Fetishism: Visualizing Power and Desire.* Ed. Anthony Shelton. London: The South Bank Centre in association with Lund Humphries Publishers.

Magnin, André, and Jacques Soullilou
1996 *Contemporary Art of Africa.* New York: Harry N. Abrams Inc.

Malan, Robbie, ed.
1997 *The Essential Steve Biko.* Cape Town: David Phillip Publishers.

Malbert, Roger
1995 "Fetish and Form in Contemporary Art." In *Fetishism: Visualizing Power and Desire.* Ed. Anthony Shelton. London: The South Bank Centre in association with Lund Humphries Publishers.

Malik, Kenan
1996 *The Meaning of Race: Race, History and Culture in Western Society.* New York: New York University Press.

Manaka, Matsemela Cain
1986 "Hope for Your Return." In *One Day in June: Poetry and Prose from Troubled Times.* Ed. Sisa Ndaba. Craighall: Ad. Donker.

1987 *Echoes of African Art.* Braamfontein: Skotaville.

Marcuse, Herbert
1978 *The Aesthetic Dimension: Toward a Critique of Marxist Aesthetics.* Boston: Beacon Press.

Martin, Jean-Hubert
1995 "Art in a Multi-Ethnic Society." *Africus: Johannesburg Biennale.* Exh. cat. Johannesburg: Greater Johannesburg Transitional Metropolitan Council.

Matthews, James
1990 *Poisoned Wells and Other Delights: A Collection of Feelings.* BLAC Publishing House.

Mauss, Marcel
1967 *The Gift: Forms and Functions of Exchange in Archaic Societies.* New York and London: W.W. Norton & Co.

Mbeki, Thabo
1998 "The African Renaissance, South Africa, and the World." Speech given at the United Nations University, Tokyo, Japan, April 9.

Meintjies, Frank
1990 "Albie Sachs and the Art of Protest." *Art from South Africa.* Exh. cat. Ed. David Elliot. Oxford: Museum of Modern Art.

Merleau-Ponty, Maurice
1977 "Cézanne's Doubt." In *Symbolic Anthropology: A Reader in the Study of Symbols and Meanings.* Eds. Janet Dolgin, David S. Kemnitzer, and David M. Schneider. New York: Columbia University Press.

Metz, Gordon
1996 "Learning to Live without the Enemy." *African Arts* 29 (Winter).

Mnyaka, Nolizwe
1994 "Am I Hallucinated." In *Like a House on Fire: Contemporary Women's Writing, Art and Photography from South Africa.* Compiled and ed. COSAW Women's Collective. Johannesburg: COSAW.

Molefe, Phil
1990 "Culture is Struggle's Weapon-Desk." *Art from South Africa.* Exh. cat. Ed. David Elliot. Oxford: Museum of Modern Art.

Mtshali, Mbuyiseni Oswald
1980 *Fireflames.* Pietermaritzburg: Shuter & Shooter.

1986 "Hector Petersen—The Young Martyr." In *One Day in June: Poetry and Prose from Troubled Times.* Ed. Sisa Ndaba. Craighall: Ad. Donker.

Murdoch, Iris
1977 *The Fire and the Sun: Why Plato Banished the Artists.* Oxford: at the University Press.

Ndebele, Njubulo
1991 "The Rediscovery of the Ordinary." In *Rediscovery of the Ordinary: Essays on South African Literature and Culture.* Fordsburg: COSAW.

1998 "Memory, Metaphor and the Triumph of Narrative." In *Negotiating the Past: The Making of Memory in South Africa.* Ed. Sarah Nuttall and Carli Coetzee. Cape Town: Oxford.

Ndlazi, Mandla
1986 "June's Blaze." In *One Day in June: Poetry and Prose from Troubled Times.* Ed. Sisa Ndaba. Craighall: Ad. Donker.

Newman, Thelma
1964 *Plastics as an Art Form.* London: Sir Isaac Pitman & Sons, Ltd.

Nkosi, Sokhaya Charles
1994 "Teaching Strategies and Experience as an Art Teacher." In *African Institute of Art: A Decade.* Johannesburg.

Ntuli, Pitika
1993 "Fragments from under a Telescope: A Response to Albie Sachs." *Third Text* 23 (Summer).

Nuttall, Sarah, and Carli Coetzee
1998 *Negotiating the Past: The Making of Memory in South Africa.* Cape Town: Oxford.

Oliphant, Andries Walter, ed.
1993 *Culture and Empowerment.* Johannesburg: Congress of South African Writers.

Oliphant, Andries Walter, and Ivan Vladislavic
1991 *Ten Years of Staff Rider: 1978–1988.* Johannesburg: Congress of South African Writers.

Ormond, Roger
1985 *The Apartheid Handbook.* Harmondsworth: Penguin.

Papane, Matime
1986 "Soweto Is Burning." In *One Day in June: Poetry and Prose from Troubled Times.* Ed. Sisa Ndaba. Craighall: Ad. Donker.

Pauw, Jacques
1997 *Into the Heart of Darkness: Confessions of Apartheid's Assassins.* Johannesburg: Jonathan Ball.

Payne, Stephen J.
1993 "Keeper of the Flame: A Survey of Anthropogenic Fire." In *Fire in the Environment: The Ecological, Atmospheric, and Climactic Importance of Vegetation Fires.* Ed. P. J. Crutzen and J. G. Goldhammer. Chichester: John Wiley & Sons.

1997 "Frontiers of Fire." In *Ecology & Empire: Environmental History and Settler Societies.* Ed. Tom Griffiths and Libby Robin. Pietermaritzburg: University of Natal Press.

Penn, Nigel
1996 "Robben Island 1488–1805." In *The Island: A History of Robben Island 1488–1990.* Ed. Harriet Deacon. Claremont: David Philip, and Belleville: Mayibuye.

Philips, Tom, ed.
1995 *Africa: Art of a Continent.* Exh. cat. London: Royal Academy of Arts.

Picton, John
1997 *Image and Form.* London: School of Oriental and African Studies, University of London.

Pityana, N. Barney, et al., eds.
1990 *Bounds of Possibility: The Legacy of Steve Biko and Black Consciousness.* Cape Town: David Philip.

Plaatje, Sol T.
1986 "An Inflammatory Bioscope Film," 1931. In *Reef of Time: Johannesburg in Writing.* Compiled and ed. Digby Ricci. Craighall: Ad. Donker.

Powell, Ivor
1995 "Self-Construction and the Politics of Modernism." In *Persons and Pictures: The Modernist Eye in Africa.* Ed. Ricky Burnett. Exh. cat. Newtown: Newtown Galleries.

Qwelane, Jon
1997 "Lynching Winnie: it's a rush to judgement." In *Cape Argus* (29 November).

Qwelane, Jon and Thami Manzwai
1997 "Whites Who Remain Recalcitrant Should Think of the AK47s in the Townships." In *Sunday Independent* (21 December 1997).

Raschke, Carl
1992 "Fire and Roses: or the Problem of Postmodern Religious Thinking." In *Shadow of Spirit: Postmodernism and Religion*. Ed. Philippa Berry and Andrew Wernick. London: Routledge.

1999 "Reality Check Supplement" *Cape Times, The Star, The Mercury, Pretoria News, Diamond Fields Advertiser, Sunday Independent* (April 28).

Reynolds, Andrew, ed.
1994 *Election '94 South Africa: The Campaigns, Results and Future Prospects*. London and Cape Town: James Currey and David Philip.

Richards, Colin
1990 "Desperately Seeking 'Africa.'" *Art from South Africa*. Exh. cat. Ed. David Elliot. Oxford: Museum of Modern Art.

1991 "About Face: Aspects of Art, History, and Identity in South African Visual Culture." In *Third Text* 16/17 (Autumn/Winter).

1997a "Graft." *Trade Routes: History and Geography*. Exh. cat. South Africa: Greater Johannesburg Metropolitan Council.

1997b "Tropics of Ice." In *Contemporary Art from South Africa*. Exh. cat. Oslo: The National Touring Exhibitions.

1999 "Bobbit's Feast: Violence and Representation in South African Art." In *Grey Areas*. Ed. Brenda Atkinson and Candice Breitz. Johannesburg: Chalkham Hill.

Rosengarten, Ruth
1995 "Inside Out." In *Frieze* vol. 23:45, 49. London.

1996 "Between the Lines." *Don't Mess with Mister In-Between*. Exh. cat. Lisbon: Culturgest.

Sachs, Albie
1990 "Preparing Ourselves for Freedom." In *Art from South Africa*. Exh. cat. Ed. David Elliot. Oxford: Museum of Modern Art.

Sack, Steven
1988 *The Neglected Tradition: Towards a New History of South African Art (1930–1988)*. Exh. cat. Johannesburg: The Standard Press.

Schärf, Wilfried, and Baba Ngcokoto
1990 "Images of Punishment in the People's Courts of Cape Town, 1985–87: From Prefigurative Justice to Populist Violence." In *Political Violence and the Struggle in South Africa*. Ed. N. Chabani Manganyi and André du Toit. London: MacMillan.

Siopis, Penny
forthcoming "Home Movies: A Document of a South African Life." In *Divisions and Diversions: The Visual Arts in Post-Apartheid South Africa*. Ed. John Picton and Jennifer A. Law. London: Eastern Art Publishing.
1996 "Shadow Casts—Mostly Women and Children." In *Fault Lines: Inquiries into Truth and Reconciliation*. Unpublished conference paper.

Sondheim, Alan
1977 *Individuals: Post-Movement Art in America*. New York: E. P. Dutton.

Stoller, Robert
1985 *Observing the Erotic Imagination*. New Haven: Yale University Press.

Straker, Gill, with Fatima Moosa, Risé Becker and Madiyoyo Nkwale
1992 *Faces in the Revolution: The Psychological Effects of Violence on Township Youth in South Africa*. Claremont: David Philip, and Athens: Ohio University Press.

Thoreau, Henry David
1993 *Walden* (1854). New York: Barnes & Noble.

Thornton, Robert, and Rita M. Byrnes
1997 "The Society and Its Environment." In *South Africa, A Country Study*. Ed. Rita M. Byrnes. Washington, D.C.: Federal Research Division, Library of Congress.

Till, Christopher
1995 "Foreword." *Africus: Johannesburg Biennale*. Exh. cat. Johannesburg: Greater Johannesburg Transitional Metropolitan Council.

Tisdall, Caroline
1979 *Joseph Beuys*. Exh. cat. New York: Solomon R. Guggenheim Museum.

Tucker, Michael
1992 *Dreaming with Open Eyes: The Shamanic Spirit in Twentieth Century Art and Culture*. London: HarperCollins.

Turner, Victor
1977 "Symbols in African Ritual." In *Symbolic Anthropology*. Ed. Janet Dolgin, David S. Kemnitzer, and David M. Schneider. New York: Columbia University Press.

Van Wilgen, Brian W., and Robert J. Scholes
1997 "The Vegetation and Fire Regimes of Southern Hemisphere Africa." In *Fire in Southern African Savannas: Ecological and Atmospheric Perspectives*. Ed. B. W. van Wilgen, M. O. Andreae, J. G. Goldhammer, and J. A. Lindesay. Johannesburg: Witwatersrand University Press.

Verstraete, Frances
1989 "Township Art: Context, Form and Meaning." *African Art in Southern Africa: From Tradition to Township*. Johannesburg: Ad. Donker Ltd.

Weinberg, Eli
1981 *Portrait of a People: A Personal Photographic Record of the South African Liberation Struggle*. London: IDAF.

Wheelhouse, Frances
1983 *Raymond Arthur Dart*. Sydney: Transpareon.

Williams, Pat
1991 *Bill Ainslie*. Exh. cat. Oxford: Museum of Modern Art.

Williamson, Sue
1989 *Resistance Art in South Africa*. Cape Town and London: David Philip and the Catholic Institute for International Relations.

1990 *Resistance Art in South Africa*. New York: St. Martin's Press.

Williamson, Sue and Ashraf Jamal
1996 *Art in South Africa: The Future Present*. Cape Town: David Philip Publishers.

Younge, Gavin
1988 *Art of the South African Townships*. London: Thames and Hudson.

1990 "Inventing South African Art." *Art from South Africa*. Exh. cat. Ed. David Elliot. Oxford: Museum of Modern Art.

Zajonc, Arthur
1993 *Catching the Light: The Entwined History of Light and Mind*. Oxford: at the University Press.

Zulu, Sandile
1997 *Artomic Project*. Exhibition pamphlet (18 June–12 July). Sandton: Sandton Civic Gallery.

1998 "Artist's Statement." *FNB VITA Art Prize and Exhibition*. Exh. cat. Sandton: FNB and Sandton Civic Gallery.

The Museum for African Art